Modernism in Art,
Design and Architecture

Modernism in Art, Design and Architecture

CHRISTOPHER CROUCH

St. Martin's Press
New York

MODERNISM IN ART, DESIGN AND ARCHITECTURE

Copyright © 1999 by Christopher Couch

St. Martin's Press, Scholarly and Reference Division, 175 Fifth Avenue, New York, N.Y. 10010

First published in the United States of America in 1999

This book is printed on paper suitable for recycling and made from fully managed and sustained forest sources.

Printed in Hong Kong

ISBN 0–312–21830–3 clothbound
ISBN 0–312–21832–X paperback

Library of Congress Cataloging-in-Publication Data
Crouch, Christopher.
Modernism in art, design and architecture / Christopher Crouch.
p. cm.
Includes bibliographical references and index.
ISBN 0–312–21830–3 (cloth) . — ISBN 0–312–21832–X (pbk.)
1. Modernism (Art) 2. Art, Modern—19th century. 3. Art, Modern—20th century. I. Title.
N6465.M63C76 1998
709'.04—dc21 98–28318
 CIP

Contents

List of Illustrations

Acknowledgements

The author wishes to thank **Jane Pearce** for her help in the writing of this book, **Kathryn Kiely** for her help with illustrations, and The Art Gallery of Western Australia.

C.C.

Introduction

This book is about the ideas that lie behind images and objects of the twentieth century, more than it is about the images and objects themselves. The practice of making images, of making objects, of exploiting the visual, goes far beyond the act of manufacture – important though an understanding of materials is. Practitioners, whether artists, designers or architects, need to understand how their culture works in order to communicate successfully to their audience. Unless those engaged in acts of communication, in this case visual, understand the expectations of their audience, unless they have carefully considered who their audience might be, unless they are aware that they are in fact engaged in a complex dialogue, then the objects they create will have resonance for themselves but not necessarily for others. Practitioners cannot afford to work in an intellectual vacuum; to do so would be to undermine the power of their work to communicate to others. Architects, designers, photographers and artists all work in a culture that conforms to certain ideological principles (sets of governing ideas) which determine the way in which objects and images are both presented and understood. Only by understanding the context in which they are working can visual practitioners make complete sense of how they fit into the culture that surrounds them. Only by understanding the culture that surrounds them can they communicate ideas about it – and their perceived place in it – to others.

Equally, just as it is important for the producers of culture to understand their environs, so too the consumer of their images needs to be conscious of the complexity and depth of their cultural surroundings. How we view our past, as well as how we view our present, are important parts of the cultural communication process. We are connected by intellectual threads not only to what is happening around us, but also with what happened in the past, and the way that it colours the present. History undergoes constant and continual revision by all cultures. Things that were once considered beautiful change their value and are deemed ugly, and vice versa. The bronzes of Benin, once considered curiosities of a primitive African culture,

1

are now more highly valued aesthetically than the products of the imperial British culture that originally consigned them to the museum of ethnography rather than the art gallery. The megalomaniacal paintings of Stalin's Soviet Union and Hitler's Germany are seen as ridiculous now that the cultural structures that originally ascribed them with value have disappeared. Throughout the twentieth century advocates of abstraction and figuration in painting have conducted ideological skirmishes in the pages of specialist journals and in the mass media. Similar debates continue still, for conceptions of history are part of a culture's ideological structure, and help define the present.

Historical views and interpretations are presented and confirmed by writers on art and design, some of whom are artists themselves. These views are often presented as 'truths', incontestable facts, observations that are the result of total objectivity. The interpretative views of such writers can confirm or deny the importance of cultural artefacts in a culture. In this way a single individual can determine the way that large sections of a consuming audience understand their culture by acting as mediators between them and cultural information and the producer practitioners' artefacts. It is arguable that cultural values and expectations are too important to allow other people to intercede between us and the objects and images of art and design, too important for us to see them always as second-hand, pre-digested things; for this is what happens when we rely on other voices who have access to the 'truth' to tell us how to understand things. This is why this book has been written – to explain how ideas have evolved in the hands of writers and practitioners of the visual arts in the twentieth century, and to provide a path through the tangle of ideas for those who are strangers to them.

This is an introductory text; it makes generalisations, and the route it plots through the ideas associated with the art and design of the past hundred years is just one of many that would take the reader in pretty much the same direction. There is simply too much information to cram into a book this size – its particular version of history is as suspect as any of the sets of ideas I take to task in the following chapters. But, hopefully, by acknowledging that I have shed much detail in order to provide a graspable version of Modernism for the reader, the information that I provide can be seen as a simple guide to the territory, and not as its definitive mapping. Many artists and designers and architects have been left out of my text, and no doubt their exclusion will cause much bewilderment, and some looks of

astonishment. All I can say is that this is one version of the facts, and there are many more. I have tried where possible to refer to works that are readily tracked down by the reader new to the subject, and from what I have already said it should be clear that this book is simply a first guide to other reading and has no pretensions about standing on its own.

I have used a number of terms in the book that need some explanation for the reader new to the debates that are to follow. I have tried to keep jargon to a minimum but it is impossible to talk about the issues that are discussed without some sort of specialised vocabulary. Of all the terms that are used *ideology* is probably amongst the most important (and perhaps difficult for those introduced to it for the first time). I have used the term to describe sets of cultural ideas that are held by certain groups. Ideologies are those sets of ideas that are socially assumed and which cannot be objectively tested. The word describes the form of thought that reflects a social consensus or belief. Dominant ideologies both reflect and mould the thinking of an individual or a society. If we can understand how sets of ideas – ideologies – are formed, and used, then an understanding of the effect they have on cultures is much easier to understand, and, if the reader is a practitioner, to modify.

It is the case that the world of ideas can be divided into two. There are those ideas which are testable against the material world, which are objective; and those which cannot be tested – ideologies – which are subjective. Some ideas emerge from practical, material, circumstances. These objective ideas can be tested against a reality. So, the grower of roses will learn about roses and their cultivation as he grows them, testing out new fertilisers, changing watering patterns, pruning and transplanting. The ideas he has about how to grow roses successfully comes from his store of knowledge based on his practical experience. These ideas can be tested practically; if the rose grower's ideas about the cultivation of roses is wrong, then they don't grow. But there are other sets of ideas about roses, about how they should look, about which colours are the most beautiful, about which has the most exquisite scent. These ideas *cannot* be tested, for they are subjective, related to sets of ideas which are formed through a group consensus. The more people adhere to these ideas the stronger (and more dominant) the suppositions become, and the more real they appear to be. It is these ideas, that are connected to the material world but which are at the same time at one remove from it, that we can characterise as being ideological.

In culture, ideology permeates everything. Art and design are based on many untestable suppositions – the most obvious being that of the idea of beauty. It is impossible to measure beauty, impossible to devise a 'beautometer' that can be held up to images and objects, to watch the needle twitch and observe, 'yes! that's got some beauty in it!' All we can hope to do is to identify the sets of ideas that stimulate artists and designers to make things the way they do and, in design particularly, to distinguish function (the practical aspect of an object or building) from ideology (its principles of styling). Ideology also influences the cultural context in which ideas are permitted and in which images are read. What is acceptable to one culture is not necessarily acceptable to another. This is the basis of censorship, the ideological policing of ideas. Ideas about race, gender, sexuality and identity are all ideological, all of them are culturally constructed, none are fixed and all are open to critical interrogation.

If we understand ideology then we can understand the relation of ideas to the material world, and separate that which is objective from that which is subjective. If we are able to do this, either as producer or consumer then we are freed from all sorts of intellectual constraints. However it is not enough to understand that ideologies exist. If we are to develop a critical understanding of ideology, we must consider how it operates structurally in a society.

The society in which the artist and designer work can be split into two parts; the cultural superstructure and the economic base. These two parts are intertwined in varying degrees, and both are straddled by the artist and designer. The economic base is the foundation upon which a society is built. The more sophisticated and developed a society's economy is, the more surplus cash that it produces for groups of people within that society and the more likelihood that there is a variety of art and design. This ability to produce consumable things does not mean that all affluent societies necessarily produce art and design that is successful either morally or visually, simply that a surplus of spendable money from the economy goes into the production of luxury items which have an ideological value rather than a practical use. The ideological values that are ascribed to the artefacts produced within the economic base are debated in the cultural superstructure. This phrase 'cultural superstructure' describes the set of ideas that give order to and interpret a society and its objects. The 'cultural' in cultural superstructure refers to all the ideas and artefacts that a society uses to communicate, so it is not just 'high' art like the opera which is culture, but all means of communication,

such as television, film and magazines. It is mainly in the cultural superstructure that the artist exists, dealing as he or she does primarily with ideas. The artist is dependent upon the economic base though, because a subsistence economy of whatever sort cannot afford the time that the luxury of aesthetic and cultural debate requires. The designer works primarily in the economic base, designing or making objects which can be commodified – for example, page layouts for magazines or buildings. The designer is also subject to the ideological pressures of the cultural superstructure that determine what is acceptable in the styling of consumable objects. This relationship can either enrich or denude the designer's practice depending upon their understanding of such ideological issues. We shall be looking at this phenomenon in more detail in the main body of the book where we examine buildings and cars and the way their appearance moves between the ideas of function and styling. The cultural superstructure and the economic base interact with one another in varying degrees, at varying times, in varying cultures. This will become evident as we progress with our cultural examination of the twentieth century.

The core of cultural ideas which this book will examine are those sets of ideas which are collectively known as Modernism. We shall only be looking at the effect of Modernism in the visual arts, although they were evident in many different intellectual disciplines. The origins of Modernism can be traced back to the development of scientific thinking in seventeenth-century Europe during the process we now identify as the Enlightenment, and came to an identifiable focus in the middle of the eighteenth century when the processes of industrialisation transformed the nature of the economic base in Britain. At the end of the nineteenth century and at the beginning of the twentieth, Modernists wished to break with past traditions and to set cultural agenda for the future. They privileged the idea of progress before any other, whether they were economists, chemists or designers. Our contemporary society is still in the process of coming to terms with the consequences of this century's cultural experimentation based around these ideas.

From its beginnings as an intellectual force for cultural change, there was a fundamental contradiction in Modernism. On one hand it was transgressive (it broke established cultural paradigms or rules) and argued for the emancipation of the individual from the oppression of industrialised society, while on the other it often promoted this act of liberation through a culture of technological control by

uniformity and collaboration. These two seemingly opposing atti-
tudes could very well be held simultaneously by any individual as we
shall see as the book progresses. At the core of this conceptual
dilemma is the relationship between those who privileged the indivi-
dual voice and those who valued the collective voice. This dialogue
between the 'individual' and the 'universal' is a recurrent theme
throughout the twentieth century, represented at its crudest in the
ideological struggle between the two superpowers, the USA and the
USSR, during the Cold War.

To discuss Modernist culture without an understanding of the
political history of the times is difficult. This book's size does not
allow a retelling of history, but an understanding of it is necessary.
Modernism emerged from European thought, supplemented though it
was by ideas and artefacts from other cultures acquired through trade
and war. During the period of this book's investigation, from the end
of the nineteenth to the end of the twentieth century, Europe has been
at constant war within its boundaries. The three big imperialist
powers, France, Britain and Germany, have been engaged not only
in colonial struggles throughout the period but also in two major
European wars that became global struggles for power – the First
World War of 1914–18 and the Second World War of 1939–45. These
wars resulted in a shift of global power as the European nations
exhausted themselves with military spending and confronted the
military devastation of their urban communities and fabric. In
Europe, between the wars, a number of forms of totalitarianism
emerged. In 1917 the Russian Communist Revolution promised a
socialist utopia. Its socially progressive, radical years were short-lived.
Torn by civil war and the intervention of British and American
troops, the young Soviet Union became a totalitarian society under
the heavy hand of Joseph Stalin's Communist Party. Mussolini's
Fascist Party in Italy and Hitler's Nazi party in Germany completed
the set of European totalitarian states in the 1930s, their obsession
with uniformity and cohesiveness a disturbing off-shoot of the
Modernist utopian dream of a universalist society.

The post-Second World War years saw the preeminence of the
United States as the global military power, engaged in an arm's-
length, armed ideological struggle with the Soviet Union in countries
like Korea, Vietnam, Cambodia, Angola and Nicaragua. This period
came to an end in the late 1980s as the former Communist states of
Eastern Europe dismantled their old totalitarianism and embarked on
the investigation of other cultural structures.

The centre of economic power, as opposed to military power, now lies in the countries of Asia. It is here (or 'there' depending on your global position) that the powerhouse of industrial production lies and where, it appears, it will remain for some time. This shift away from the North American/European axis has been further hastened by the growth of transnational corporations whose annual budgets exceed those of many nation states. This phenomenon is creating a new dialogue about cultural and national identity as the world loses the old eurocentric colonialism, only to discover another: the economic colonialisation by global businesses that casts further shadows on the relationship between the cultural superstructure and the economic base, between producers and consumers of culture.

As we have just seen in our brief look at ideology, ideological premises are not stable things. This is why an understanding of the relationship between the cultural superstructure and the economic base is essential to an understanding of Modernism. The arts were seen by Modernists as not only reflecting the world around them (this was a radical departure in itself, in a world where the arts often provided, as they still do, an escape from reality), but also helping to alter the structure of society. Artists, designers, photographers, film-makers and architects often worked alongside one another in declared agenda of social action. This was to make the Modernist age an age of manifestos. Manifestos and their ideas emerge from physical conditions, and because of this they sometimes lose their relevance as conditions change. This has been the case with the ideas of Modernism. Ideologically we now live in a postmodern society. This lived reality alters our perception of Modernist ideas. As the industrial society of Europe has changed into a post-industrial one, as industrialisation proceeds elsewhere in the world, and as the mass media become increasingly powerful in moulding the consciousness of large groups of people, so then the ideas of the first part of the century become slowly irrelevant. These important new, contemporary circumstances will be examined in the later chapters of this book.

The ideas of Modernist designers in the first part of the century who saw good design as emulating the functionality of the machine, have been superseded by contemporary ideas that encourage a constant change in the appearance of designed goods to stimulate consumer demand. Whereas the Modernist designers thought that industry could be used to further Modernist ideology (that the economic base could be fundamentally altered by the cultural superstructure), contemporary transnational industry has simply used the

designer to perpetuate its own values. In a similar process of ideological change, the wider ideas of the Enlightenment and of the Industrial Revolution, the radical and often destabilising contributions to shaping the modern world from individuals like Marx and Freud (whose ideas will be examined more closely in subsequent chapters) become absorbed into the mainstream of cultural life. The absorption and mutation of once revolutionary ideas now pose new problems of interpretation.

In contemporary culture not only are the ideas of Modernism being revised, but new material conditions and their new technologies create their own particular issues that need investigation. One obvious example is the way in which progress in the new electronic technologies, and the related creation of an information society, is placing new demands on artists and designers. This new culture is different from the old industrial/Modernist culture but has emerged from it. It is therefore a postmodern culture. Initially Postmodernism differed from Modernism in that it had no agenda, no declared set of aims for the future, no programme for cultural action. Some Postmodernists saw themselves in opposition to the ideas of Modernism, others as developing them. In some ways the confusion of the late nineteenth century, from which the attempt to construct a Modernist society emerged, is duplicated in the mainstream work of the late twentieth century. Confronted with new conditions, with potential ideological chaos, artists and designers often retreat into the stylistic security of a nostalgic past. We find ourselves at a juncture in our cultural development where Modernist ideas are no longer sufficient to help explain and reflect the complexity of what is going on around us.

The Modernist period was the period of the avant-garde. This is a phrase used to describe the idea of an elite within the intelligentsia who were to force the pace of cultural change. We have already established that the agenda of Modernism was cultural and social transformation. The preparation for this transformation was the task of the avant-garde. Part of the avant-garde's activity was the transgression of the paradigms of existing society. The contemporary plethora of information in wealthy postmodern societies, and the multiplicity of different cultural forms available to us, means that it is more difficult than previously to break cultural paradigms. The artist and designer have an increasing range of cultural forms from which to choose. If all are valued equally then a culture of multiple choices negates the early twentieth-century model of cultural and social

transformation. How is it possible to transgress when everything is permissible?

The reality is that even within this Western culture of choice, privileged by economic prosperity and fuelled by consumerism, some cultural issues which were raised by Modernist thinkers remain unresolved. Design still has not resolved the problem of the relationship between function and style, and the relationship between the individual and the collective culture he or she lives in is still undefined. Whilst it may be clear that the methods of Modernism were unable to resolve these issues, and in the later chapters of this book we shall examine why this was the case, there *is* a cultural cutting edge outside the mainstream of postmodern work. Out on this edge are artists and designers working with issues of gender and sexuality, with notions of cultural identity, and with environmental design. It is on this cultural body of investigation, rather than the Postmodernism of the economic base, that the future's cultural experiments will stand or fall.

Chapter 1

The Cultural Background to the Machine Age

In order to understand the issues of art and design practice in the twentieth century, we need to understand the many sources from which its different threads emerged. There is a need to understand where ideas about progress came from – why should *progress* be valued by Modernists rather than *tradition*? We need to understand why there was an ambivalent attitude towards technology – why some artists and designers saw it as a threat, others as a blessing. And we need also to understand the cultural roots that provided one set of practitioners with an intimate, private and individual view of art and design, whilst others wanted a practice that embraced ideas of the collective. We can trace the origin of the ideas of the Modern Movement back as far as the Renaissance. But largely they stem from that period we call the Enlightenment, when scientific discoveries liberated the intellectual classes from a view that the past held a repository of knowledge that needed to be uncovered and restored, and allowed the intelligentsia to see the future as a place of potential growth and development. Access to these ideas was to be gained through experimentation and investigation of the unknown, rather than the careful sifting and codification of what might already exist.

What is probably the most influential of the key histories of Modernism in art and design, Nicholas Pevsner's *Pioneers of Modern Design*, identifies the Great Exhibition of 1851 at the Crystal Palace in London as one of the pivotal points in the unfolding of Modernism. This investing of a single event with symbolic importance does a number of things. First it draws attention to the geographical and cultural site of what was then the world's most formidable industrialised state, the United Kingdom. It is no coincidence that Frederick Engel's study of the condition of the industrialised working class was based in Manchester which, like other British industrial cities, was an

urban cultural organisation new to the world. In the middle of the nineteenth century Manchester's 'progress' 'was reflected in the newness of its buildings and in its squalor'.[1] Second, the 1851 exhibition can also be seen as a symbol of a culture in which the relationship between human society and the natural world had become formalised through the mediation of science and the processes of mechanisation. The use of industrialised materials – glass and iron – in the construction of the exhibition hall, the rapid erection of its prefabricated parts, its encompassing of mature trees already on the site within its structure, all imply a culture embarking upon a search for functional, technological solutions to material conditions.

We can look at the Crystal Palace purely as the product of its designer Joseph Paxton and his interest in, and investigation of, structure and materials. Or, we can view the finished building as a 'growth' produced by a whole society, a physical manifestation of a society's cultural attitudes. Whichever choice is made, and the two are obviously closely linked, the building still needs to be located in a conceptualised chronology. Was the Crystal Palace the culmination of one set of events, or was it the progenitor of another? The logical answer is that it is both, but this raises problems and indicates why objects are often reduced to symbolic representations. If the Crystal Palace is a symbol of the beginning of Modernism, then where did the ideas themselves come from? Where, in the never-ending network of cultural cause and effect, can we start to examine the ideas that we consider to be 'modern' enough to have formed the view of our technologically driven culture?

I want to go back much further than this symbolic point in 1851 and examine the origins and ideological assumptions of the indus- trialised world. How did nineteenth-century scholars, travelling by train, reading mass-produced newspapers and books, communicating by electric telegraph, view themselves? How did they see the burgeon- ing mass of industrialised objects historically? The Crystal Palace was considered an interesting curiosity but inspired no great enthusiasm in the intelligentsia of the period. Curiously, it was the Renaissance that provided many with a coherent intellectual framework for their activities. Industrialised building methods, industrialised goods and scientific developments ran parallel to their vision of themselves as the inheritors of an aesthetic tradition rooted in Liberal Humanism. The Utilitarianism of Jeremy Bentham, the Rationalism of John Stuart Mill and the Utopian Socialist experiments of Robert Owen, which we would now define as being intrinsic parts of what constitutes our

cultural history, were seen by many, along with the process of industrialisation itself, as *separate* from culture. The publication of Charles Darwin's *On the Origin of Species by Means of Natural Selection* and of Karl Marx's *Communist Manifesto*, which we now see as fundamental to our understanding of the evolution of our culture, were not seen as such by the majority of educated Europeans.[2] *Culture* was perceived to be the arts, and they were used to make industrial life bearable – to embellish, perhaps even to disguise it.

Walter Pater, the English critic and writer was not a Modernist. He saw the arts as 'producing pleasurable sensations' rather than acting as the vehicle for social commentary or change. This view of art practice as a form of aesthetic commodity, somehow separate from everyday life, was a view quite commonly held at the end of the nineteenth century. Pater saw the arts as timeless. To him, cultural artefacts were largely unconnected to the material social conditions which produced them. The beautiful object was sufficient in itself, it had no need to refer to anything other than itself. Pater saw his role as a cultural commentator, identifying and separating

> from its adjuncts, the virtue by which a picture, a landscape, a fair personality in life or in a book, produces this special impression of beauty or pleasure . . . [the cultural commentator's] end is reached when he has disengaged that virtue, and noted it, as a chemist notes some natural element for himself and others.[3]

Pater then, wanted to separate art from life, to extract it and secure it in an arena of its own. It is intriguing however to see Pater use the simile of a chemist, drawing images from his industrial surroundings whilst simultaneously retreating physically from them.

Others saw the past as a means to stabilise their unruly present. Edward Poynter, then a well-respected English artist and cultural commentator, saw the display of the past's artefacts in museums and galleries as a way in which it would be possible to raise consciousness about good design, and influence the aesthetic standard of manufacturing production.[4] In the middle of a burgeoning industrial world the search into the past for formal languages for design also served to define a route by which the present could be validated. Once a style or styles have been defined, a value is established, comparisons can be drawn, and decisions made about the aesthetic worth of the physical appearance of things. The Crystal Palace, in its rejection of the past and its aesthetic values, can be seen as an example of design

appropriate to the new industrial conditions. And it is its exploitation of the scientific and technological that makes the Crystal Palace an important symbol of early Modernism. If we are to continue with the task of contextualising it, however, we need to turn to the Renaissance as a starting point for the ideas about rationality that Modernism was purported to hold.

The raw material of history can be seen as a map by which any number of routes can be plotted into the present. Poynter and Pater, amongst others, saw the Renaissance as legitimising a set of ideas about art as something isolated from a tawdry reality. With a different ideological agenda we can see that ideas emerged in the Renaissance that can be seen as creating that reality, from which those critics wished to escape. The Renaissance was really defined by Victorian scholarship as a distinct cultural period and was retrospectively endowed with all sorts of civilised virtues by the late Victorians.[5] It was of course like all other times; the good rubbed shoulders with the bad, and the successful with the unsuccessful. For the purpose of tracing the origins of a modern scientific technological culture, what made the period interesting was the distancing of scholars and scholarship from Christianity. This sidelining of the creation myth allowed the development of new ways of thinking based on objective, rational measurement of the natural world. The natural rather than the supernatural was seen to be the source of information that could help to order human society.

The key to the negation of Christian ideology was the development of Humanism and rationalist philosophies. Humanist ideas held that not only could humankind improve itself and its condition without supernatural assistance, but was also under a moral obligation to do so. In Italian Renaissance humanist terms, humankind was both at the centre and at the pinnacle of the natural order due to the emphasis that humanists placed upon education and the ability of the rational intellect to resolve issues. The full notion of progress however remained unfulfilled because of humanism's retrospective interest in the classical cultures of ancient Greece and Rome as a cultural paradigm. This is a long way from Modernism and its ideas of progress through science, but the humanist emphasis was firmly placed upon social groups, and the way in which the group itself should determine about which cultural direction should be taken. In examining the classical past, and placing it into a contemporary cultural context, the Renaissance scholar was establishing an idea of history, by legitimising their culture's aspirations in exactly the same

way that the Victorian scholar did. Scholars placed on the culture of antiquity what Sem Dresden called an 'autonomous significance'.[6] The classical past was seen as a sort of fixed raw material from which all cultures could be constructed.

In association with this use of classical philosophy as a paradigm for practice, the visual arts adopted a rationalistic naturalism in the quest for an objective evaluation of the natural world. This practice, which necessitated a formalised, codified, visual language, allowed the depiction of human beings as both typical (of social or cultural groups) and specific (like portraits). This pictorial language where 'real' people exist in 'real' space was to become the dominant language of the visual arts until Modernism redefined notions of the individual and the universal, and developed new visual forms.

The Renaissance architect too was looking for forms that could best express the growing cultural sense of the rational. The unexpectedness and dynamism of the Gothic building, where structure was 'dematerialised', was replaced by the clarity and logic of geometrical forms derived from the study of Roman architecture. An aesthetic code and theoretical framework was developed by the Renaissance architect which attempted to express the relationship of architecture to mathematical laws. The architect Leonbattista Alberti had a vision of the ideal city in which a geometrically pure architecture had both aesthetic and utilitarian functions, related to a defined social framework. Thus the city itself became a metaphor for an ordered secular life. The idea of geometry as a symbolic visual expression of social order was to reappear in the early years of the twentieth century.

The Renaissance technological development of printing meant that by the end of the fifteenth century most of Europe was at last introduced to the printing press. As the new humanist secular culture developed, the Roman typeface, rather than the Gothic black letter based on the scribe's hand, became the dominant letter form. The ideological relationship between information and the form in which it was conveyed, so important to the humanists in the distribution of their ideas, was to be of equal significance to Modernist typographers.

We can see many ideas emerging in the Renaissance which enabled the industrial societies of the nineteenth century to evolve, and which acted as their cultural foundation stones. However, it was the values ascribed to the Renaissance – a love of learning, and the promulgation of a set of ideals about what constituted beauty – that were most attractive to liberal nineteenth-century scholars. These values were seen by writers and critics like Pater to be 'outside' the industrialised

culture in which they were living. The implication was that beauty existed autonomously and that cultural objects had values that were somehow independent of cultural conditions. Pater wrote:

> all periods, types, schools of taste, are in themselves equal. In all ages there have been some excellent workmen, and some excellent work done. The question he [the critic] asks is always: In whom . . . did the genius, the sentiment of the period find itself? Who was the receptacle of its refinement, its elevation, its taste?[7]

The individual creator plays a central role in the production of beauty in a view like this. Inherent in the quotation is the assumption that social conditions can be transcended by the individual (a profoundly un-Modernist way of thinking) and that the cultural productions of a society are 'consumed' individually in the same way that they are produced. This led to the idea of connoisseurship, where an aesthetic commentator like the American Bernard Berenson (who wrote extensively on Italian art of the Renaissance) was able to describe himself as a 'consumer of the art product'.[8] What distinguishes early Modernists from their contemporaries was the emphasis they placed upon *production* rather than *consumption* forming cultural consciousness. This is why the members of the Arts and Crafts movement of the late nineteenth century who argued about the aesthetic and social benefits of manufacturing the work of art are considered a component part of early Modernism.

Renaissance ideas attempted to formalise and rationalise the natural world and are the intellectual base upon which a lot of modern thought rests. A profound difference exists though between the Renaissance view of the world and the modern view. It is this difference that perhaps explains why the Renaissance was so attractive to those nineteenth-century men and women who wished to escape from the world in which they lived. These artists, designers and architects ultimately looked to the past for inspiration. Their aim was to recreate a golden age, to take the remnants of the classical world and to reconstitute them into a coherent cultural structure. The 'modern' artist, designer and architect saw progress through the acceptance of the present as their cultural starting point. This idea of emancipation from the past began in the period that we call the Enlightenment.

The European Enlightenment is like all terms that describe historical periods, better suited to describing attitudes of mind rather than chronology. It is a period sometimes called 'the age of reason', though

in reality reason held sway over a small dominion. The early seventeenth century had seen the certainties of the past start to slowly disintegrate. There was open debate about the interpretation of established law and ideology as defined by the Bible. Descartes, a mathematician as well as a philosopher, separated the world into two distinct parts, the spiritual and the material. He considered both were interconnected and in his view what had once been 'sin' could be redefined as human 'miscalculation'. Barach de Spinoza developed the ideas of Descartes, and whilst like Descartes still adhering to the notion of some sort of universal and infinite god, he reasoned that the Old Testament was a history of the Jews rather than a divine revelation, and as such was as unreliable as any history. It was becoming increasingly clear to the intelligentsia that, to paraphrase Francis Bacon's words, humankind had been kept back from progress in science because of an excessive reverence for antiquity and its mindsets. This understanding that the unknown could also be defined as the undiscovered rather than just the unknowable, implied that cultural structures could be constructed to aid that process of investigation and discovery.

It was two English scholars who enabled the ideas of progress and discovery to be formalised. That formalisation itself was to take place in France, for the Enlightenment reached its peak in the 1750s and 1760s in Paris. In Britain, John Locke rejected the Cartesian view that ideas were innate and instead argued that ideas were the result of 'sense impression'. This idea that material conditions govern human behaviour brings the ideas of Modernism still closer, as it created debate about how societies were constituted and how they could best function. Isaac Newton's discovery of gravity finally paved the way for the objective rationalisation of natural phenomena. Newton's view of the material world, and Locke's of the mind, were to exert a profound influence on thinking in Europe. Scientists were now to use experiment as a means of investigating the unknown. The unknown was no longer something to be investigated to confirm reasoned deduction; the unknown was now seen as the potential holder of all manner of information. In Sweden Carl Linnaeus published important botanical texts after expeditions of discovery categorising and formalising the study of flora. Denis Diderot undertook the immense task of editing the first encyclopaedia of 20 volumes, finally completed in 1765. The world was now being investigated and objectified in a way previously unthought of.

Just as the natural world was investigated at a microcosmic level, so too it was investigated at a macrocosmic level. Cultural anthropology and sociology became an important area of investigation and discussion amongst scholars who viewed their European societies increasingly as one among many global others, abandoning to some degree a purely eurocentric view of civilisation. Both Gottfried Leibnitz and Voltaire were promoters of Chinese culture which they saw as being an ordered civil society based on a set of rational hierarchies. Leibnitz even went so far as to suggest that China should send missionaries to Europe. Part of the fascination with Chinese culture, whilst it was static and repressive, was that it appeared to be free from the social disruption caused by religion in Europe.

The investigation of other cultures led also to conclusions about the similarities of human organisation and attitudes, as well as their differences. David Hume came to the conclusion that humankind was so similar that all history could do was to discover a set of universal principles governing human nature. This opinion reinforced views that nature was unable to do anything wrong. Everything beautiful or ugly had a purpose. Everything that existed, existed as it should. The consequence of this philosophy when applied to human cultures suggested that if human societies were shaped by natural forces then there was little scope for cultural change. This position led to the development of logical utilitarianism. This austere and reductionist view of culture, where cause and effect are seen as fixed and unchanging, is characteristic of what is known as mechanical materialism. In part it can be seen as the base from which Modernist ideas about design emerge. The notion of 'form following function' makes the same assumptions about fixed values in design, and allows little scope for the communication value of ideologically derived forms.

In opposition to this deterministically defined view of a world with 'universal' fixed values, Charles Montesquieu proposed that nature and its structures needed to be negotiated with by human society. Whilst he did not articulate it in the words we would use today, Montesquieu proposed that both the ideological and the natural shape human societies. This prefigures the basic methodology, if nothing else, of Karl Marx's ideas about dialectical materialism. Within this set of philosophical ideas, physical circumstances which form consciousness can be altered by a change in ideological attitudes. Thus a complex dialogue between interpreting and making comes into play, each feeding into the other and implying, once again, the

notion of progress and the possibility of change. (Marx's ideas were to have a profound effect on art and realism. We shall be looking at this aspect in more detail in Chapter 6.)

In the visual arts the formal languages established during the Renaissance were still in common currency in the eighteenth and nineteenth centuries, but used in ways which constantly stretched their limits, both conceptually and formally. The language of geometry expanded to encompass increasingly abstract structures such as Boulée's proposed vast spherical *Monument to Newton* in 1780, to Goethe's more intimate *Altar of Good Fortune* that he designed for his garden in Wiemar in 1777. In this piece, a sphere of carved stone represents restless desire fixed on a stone cube, symbolic of virtue. Artists and designers such as these were not conscious of the dawning of a new industrial age, but then few were. Even the economist Thomas Malthus ascribed the growth of the population of England at the end of the eighteenth century to advances in agriculture and not the newly formed industries. Artists and designers were more influenced by theories of genius, examining ways of explaining why some individuals seemed not to be the product of their environment, but to transcend it. This idea of genius meant that designing for a particular environment was seen as somehow inartistic, and a separation between the 'fine' and the 'applied' arts becomes quite obvious. How did this division of productive and creative intelligence take place?

In rejecting a mechanically determined world in favour of societies with education at their base, philosophers saw the individual as increasingly autonomous. Jean-Jacques Rousseau identified individuals alienated from societies that were corrupt or unequal, unable to find fulfilment in a collective interest that contradicted man's 'natural instincts'. Rousseau thought these instincts were fundamentally good. Humanism had rejected a system of divine moral judgement in favour of a system of moral judgement based on socially determined legal codes. Rousseau argued that these codes were not necessarily 'moral' and began to argue that morality came from the individual, from what he called an 'inner voice'. This is what allowed the individual to realise that they may live in a corrupt society, even though that corruption may be sanctioned by a ruling class. It followed that beauty, like morality, was seen as resting in the individual's consciousness. Immanuel Kant in his *Critique of Judgement* of 1790, argued that the 'imagination' created beauty out of nature, and that beauty came from sources other than rules of proportion determined

by the natural world. Nature here is no longer a governing force, but a place in which the individual goes to discover beauty. Once again the individual is seen as separate from their environment.

These two opposing cultural positions emerging during this period were to have a profound effect on modernist thought. On one hand the collective view of culture acknowledged material conditions as the determining factor of social and cultural life. In opposition to this were ideas which proposed that the individual's struggle against, and transcendence of, material and social conditions was the key to what Hegel called the 'truth'. Hegel argued that society should

> lay aside the false position, which has already been remarked upon, that art has to serve as a means for moral ends . . . Against this it is necessary to maintain that art has the vocation of revealing the truth in the form of sensuous artistic shape.[9]

Whatever the position of the artist, architect or designer at this stage, and there were many variations and combinations of views, most of them worked within a style derived from the fine arts. It was the Industrial Revolution that was to provide new forms, materials and purposes for the practitioners of the visual arts.

The Industrial Revolution started in Britain. In the thirty years leading up to 1790 Britain established itself as the mechanised hub of Europe. This process was assisted by the erosion of the power of the monarchy and the aristocratic classes, and the growth of an educated middle class. The rising middle class created a rudimentary meritocracy, and as this model of the bureaucratic state was duplicated in Europe, it actively promoted the development of the new industries. These industries were the power base of this rationalising, scientific, trading class.

The Ironbridge, at Coalbrookdale, an early industrial centre in the British Midlands, was erected in 1779. It was the first cast-iron structure in the world and the precursor of the industrialised architecture of the future. By the turn of the century prefabricated cast-iron structures were being shipped from Bristol and Liverpool to America and Australia. The year of 1826 saw the completion of the Menai Bridge, a suspension bridge with a span of nearly two hundred metres. The new iron technology allowed greater distances to be spanned architecturally than ever before, and the development of the railways gave rise to the development of city stations with their great iron and glass sheds. These materials and these building techniques were the sources from which Paxton's Crystal Palace emerged. (See Ill. 1.1.)

20

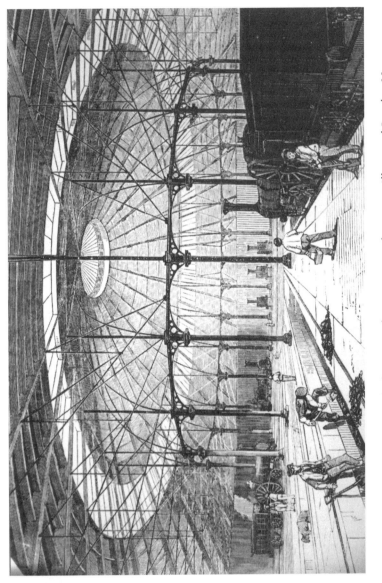

Figure 1.1 The Engine Shed at Campden Town, London, 1847. *Illustrated London News.*

The railway was important to the modern world. It became culturally indispensable, transporting goods and people, starting the erosion of regional differences within the physical confines of its lines. Charles Dickens captures the atmosphere of this technological innovation in *Dombey and Son*, where the beginnings of the modern world are starting to coagulate.

> Members of Parliament, who, little more than twenty years before had made themselves merry with the wild railroad theories of engineers . . . went down into the north with their watches in their hands, and sent messages before by electric telegraph, to say they were coming. Night and day the conquering engines rumbled at their distant work, or, advancing smoothly to their journey's end, and gliding like tame dragons in to the allotted corners grooved out to the inch for their reception, stood bubbling and trembling there, making the walls quake, as if they were dilating with the secret knowledge of great powers yet unsuspected in them, and strong purposes not yet achieved.[10]

The railways were the product of the new economic infrastructure, creating at the same time a modern cultural superstructure responsible for a new mechanised, industrialised information network. The world of information was no longer confined to the worlds of the scientific or literary scholar – newspapers, journals and books were available as mass-produced commodities. Printed information could be distributed to wherever a railway line might lead. This inevitably meant a change in the relationship between different commercial, intellectual and political centres, and a gradual homogenisation of cultural expectations. The concept of a universal industrial culture, so loved by many Modernists in the twentieth century, can be seen as having its material roots here.

The Industrial Revolution introduced new technologies that increased the capabilities of manufacturing. The advances in scientific knowledge became increasingly commodified, and marketable industrially produced objects began to be made in larger numbers than ever before. The places in which these objects were produced were intimately related to the new industrial culture. They were functional buildings like mills and factories, designed to be efficient rather than to convey notions of status, and were unadorned architecturally. Brick, iron and glass were used in skilful, intelligent and economic ways, but in ways which contradicted the 'historicist' styling which other architecture exploited. By the time that Walter Pater was writing there were two distinct attitudes to architecture. On one

hand there was 'architecture', decorated and embellished using the formal languages of Renaissance and Gothic architecture in varying quantities and proportions. On the other hand there was 'building'. Despite its technological magnificence the Crystal Palace was still a 'building'. Building was seen as unaesthetic, commercial and undignified. In contradiction to this received opinion however, the new industrial architecture was constantly expanding its repertoire of forms derived from engineering and structural principles. An increasing understanding of the new materials led to a new set of forms which were governed by architectural function.

The division between high and low art evident in architecture in the middle of the nineteenth century was also an issue in manufacturing design. The new technologies enabled machinery to duplicate aspects of hand manufacture that previously had been the craftsman's preserve. Machinery could now form goods with a degree of finish that had previously been impossible. Whereas in architecture the relationship between the new materials and technologies and the old styles was slow in being consummated, in manufacturing this process proceeded rapidly. New materials and new processes meant that objects which previously could have been considered utilitarian were able, with the addition of ornament, to become 'works of art'.

In architecture 'high' and 'low' art were kept at arm's length, in manufactured goods they were combined. How is this explainable? The answer lies in the increasing power of the capitalist economy. We have already mentioned that new building technologies enabled the cheap and rapid erection of structures. As in most cases industrially related buildings were purely utilitarian they did not need ornament – to decorate them would have been to make them uneconomic. However, to decorate the mass-produced objects that came from those unadorned factories was to increase their value by giving them the appearance of luxury – to use style to place the object into another context. We are seeing here, at this mass level, the same sort of thinking that made architects choose a historical style for their banks, shops and commercial buildings. These buildings needed decoration, existing as they did more 'publicly' than the factories. They were seen to serve a more sophisticated social and cultural role. Styling was able to make objects significant. Whether or not the styling was appropriate and the significance real is a matter for ideological debate. That debate was to take place most coherently at the turn of the century. Generally speaking manufacturers followed the principle that the

greater the ornamentation of an object, the greater the likelihood of selling it. Materials like papier mâché, gutta-percha (a natural resin) and metals were moulded, pressed and produced in all manner of style and forms.

The opening of the Crystal Palace exhibition, the 'Great Exhibition of the Works of Industry of all Nations in 1851', was, after some initial misgivings about the safety of the building a resounding success in terms of mass appeal. By the end of the year over six million people had visited the exhibition. However, for a minority of people – designers, artists and educators – the show was a disaster. It was Richard Redgrave, an artist and educator, who observed on behalf of a British government inquiry that that machine ornamentation on mass-produced objects was 'degraded' and that this was partly the result of the ability of the machine to provide the manufacturer with the facility to produce ornately overdesigned and decorated goods as cheaply as simple forms in order to satisfy what we would now call the mass market.[11]

What this view tells us is that design was seen as the prerogative of the manufacturer rather than the designer, and that Renaissance values about the autonomy of the artist/designer and their relationship with a patron had become irrelevant. Not only had the notion of the artistic individuality of the producer and consumer been eroded, but also the individuality of the object itself. Inherent in Redgrave's observations is the idea that there is a correct and incorrect use of materials. This idea is in direct opposition to the *transformation* of material, and suggests that materials have an intrinsic quality that should not be transgressed if an object is to retain some sort of aesthetic worth. John Ruskin, whose ideas and influence we shall examine in the next chapter, put it most succinctly:

> In proportion as the material worked upon is less delicate, the execution necessarily becomes lower, and the art with it. This is one main principle of all work. Another is, that whatever the material you choose to work with, your art is base if it does not bring out the distinctive qualities of that material.[12]

The industrialisation of manufacture was then successful in economic terms, but was seen by the artistic and design community as largely unsatisfactory. It had become clear to many practitioners that they had become bound up almost entirely in the economic substructure, whereas before they had remained part of the intellectual

superstructure. Their aesthetic dissatisfaction however pales when compared with the alienation experienced by those who worked within the industrialised structure manufacturing the goods.

A system of thought had started in the Renaissance which proposed the objectification of the natural world. This had developed during the Enlightenment as a philosophy that saw scientific progress as beneficial. By the end of the nineteenth century in Britain, these ideas had mutated into a cultural and social system which alienated the majority of people working within it. So widespread was this understanding of social unrest that concern was expressed during the 1851 exhibition that excessive numbers of industrial workers visiting the exhibition from the industrialised north could well take to the streets of London, ransacking houses and causing civil unrest. It was still fresh in the mind of those in the metropolis that it had only been a few years previously that troops had been dispatched north to keep urban order. As it was, the year of the exhibition passed without incident. Crowds were dazzled and entertained by the splendours at the exhibition. This is an early example of the power of the industrialised society to control and diffuse social dissent through the desirability of its artefacts. It is an early example of what Guy Debord was to call in the 1960s 'the spectacle'. Industrial societies can sometimes be interpreted not by how things are *produced* but also how they are *consumed*. (This relationship between production and consumption continues throughout the debates of Modernism.) Often the commodified objects of a society seem more real and carry more weight than the experience of those people who produce the objects in the first place. This is what Debord means by the spectacle, and this is what happened with the Great Exhibition. Despite the alienation caused by industrialised labour, many millions of those alienated workers came to look at the things they made, and felt part of the excitement created by bringing so many new objects under one glazed roof. The exhibition was a tremendous success and crowds were lulled by visions of plenty. Debord says of this phenomenon:

> The spectacle presents itself as something enormously positive, indispensable and inaccessible. It says nothing more than 'that which appears is good, that which is good appears'. The attitude which it demands in principle is passive acceptance which in fact is already obtained by its manner of appearing without reply, by its monopoly of power.[13]

There is always a challenge to the monopoly of power however, always opposition to a dominant ideology, and in the middle of the

nineteenth century there was opposition to the existing industrial structure in Britain. Opposition to the capitalist state became characterised by the name 'socialism'. The first socialist ideas were Utopian ones. The modern utopian paradigm was established and defined by Thomas More in his book *Utopia* published in England in 1516. Utopia was the name of the perfect fantasy state and More described the Utopian way of life as having eliminated the root causes of ambition, political and cultural conflicts.[14] This idea of socialised living, of a collective, collaborative culture, saw itself in opposition to the competitive capitalist one. We can see those ideas working within both the economic base and the cultural superstructure.

Within the economic base, Robert Owen, a successful industrialist, observed that as the natural world became increasingly within the control of the human will, there should be no reason why people should not, given the correct enlightened physical and cultural environment, become physically and culturally enlightened themselves. To this end he created a model community based around his mills at New Lanark in Scotland. Fundamentally cooperative in his approach, he hoped a new social consciousness surrounding the process of work, and the objects it produced, would slowly build a greater momentum for a socially progressive culture. Though his own attempts to create socialist communities within a capitalist framework were never entirely successful, as the historian E. P. Thompson notes in his book *The Making of the English Working Class*, 'Owenism was the first of the great social doctrines to grip the imagination of the masses in this period'.[15]

It was a German who was to transform cultural ideas about social organisation. Karl Marx developed ideas about the relationship between consciousness and the material world and formed a set of philosophical principles that attempted to both interpret and change the material conditions of social life. Unlike Owen who saw the future in opposition to the present, Marx saw the future existing within present conditions. Together with Engels, Marx published *The Communist Manifesto* in 1848. They proposed a new society where the experience of the industrial working class would generate socialised alternatives to the unsocialising processes of capitalism.

The relationship between the individual and the group in this proposed society was to be fluid. Theoretically, in gaining autonomy through an egalitarian socialist culture, the liberated individual would be able to enter into a world of diversity, freed from the alienating effects of being a part of a mechanised society that took away from

the individual any autonomous control over his or her life. Marx called this alienated trade between the individual's labour and capitalism's need for it 'wage slavery'. The majority of the highly decorated objects and artefacts available to the industrial consumer of the period came from out of this economic relationship.

Ideas about the debilitating and alienating nature of manufacturing processes were to be very influential in the world of British design in the late nineteenth century. William Morris, for example, was a correspondent of Engels, and read Marx in French before his texts were translated into English – we will examine this in more detail in the next chapter. But even away from the world of manufacture and design, the new socialist ideas of egalitarianism and cooperation were picked up by other artists and writers. We need to remember that socialist ideas were still utopian at this time; the horrors of the totalitarian state were still a long way away. The poet and playwright Oscar Wilde's view was that the renunciation of the mechanised world, which many Arts and Crafts practitioners wished for, was untenable. For him, as with the majority of socialists, the problem lay with the ownership and use of industry:

> there is something tragic in the fact that as soon as man had invented a machine to do his work he began to starve. This, however, is, of course, the result of our property system and our system of competition . . . The one man secures the produce of the machine and keeps it, and has five hundred times as much as he should have . . . were that machine the property of all, everybody would benefit by it.[16]

We may now consider these ideas to be excessively romantic but as Wilde was also to say, 'a map of the world that does not include Utopia is not worth even glancing at'.

The last great technological innovation of the nineteenth century that was to transform art practice in the twentieth was the development of photography. Photography was to alter both ways of seeing the world and the way that it was represented in the arts and sciences. The camera is a machine, a scientifically derived device, that records the world through the aid of mechanical structures and an understanding of the light tolerance of certain chemicals. There is no room here for a history of photography but it *is* necessary to understand how the technical exploitation of materials allowed the representation of the world to become increasingly complex. If we compare the first daguerreotypes of city scenes in the 1840s with city views of the 1890s this process becomes evident. Early photographic images needed long

exposures, and the street scenes in these images are devoid of move-ment, people and carriages. The crudity of the light-sensitive chemi-cals used in the manufacture of these early photographs meant that they were simply unable to record fast-moving objects. By the time that the American photographer Alfred Steiglitz was working at the turn of the century, the technology was available to allow him to capture the most dynamic of New York scenes in dramatic atmo-spheric and lighting conditions. Indeed, by 1895 the Lumière brothers had developed cinematography and their newsreels were playing to eager audiences hungry for novelty all over the industrialised world.

The relationship of photography and the visual arts was a complex one. The two practices fed closely into one another. New under-standings of movement developed by scientific photographers like Edward Muybridge, who produced several systematic analyses of animal and human movement through sequential photography, were to exercise a profound influence upon the depiction of motion in painted space. The whole notion of freezing time, of taking tiny slices of it and presenting them as self-contained units, was important to painters throughout Europe, whether they were academic painters or otherwise. The Impressionist painter's conception of time, of the fleeting moment, was greatly influenced by the camera. Photography reinforced both the quest for detail and the gradual dissolution of a Renaissance conception of space based upon the exclusive use of linear perspective. Time rather than just space became a subject for art practice.

Painting was also to influence the use of photography. Some photographers worked alongside the artistic community. Felix Nadar photographed Rodin's sculpture, interacting with traditional imagery in an *ad hoc* partnership with the sculptor. More commonly, photographic practice can be seen responding in a way that aped the practice of painting. These 'pictorialist' photographers built studio sets in which complex narrative episodes from history or literature were photographed, often using multiple exposures and the composite use of separate negatives. Set against this, the publication of Peter Henry Emerson's *Naturalist Photography for Students* in 1889 set up a documentary route for photography, where the camera was not used to construct imagery as had been the traditional academic practice, but was used to capture 'real' scenes as objectively as the camera would allow. This documentary approach was one that had always existed, but which had been considered to be unaesthetic. Only a few years later (1891) Emerson published a pamphlet called

the *Death of Naturalist Photography*, but by this time he had created an attitude to photographic practice that was not to be lost. The division in photographic practice between real time and a constructed space, between a practice centred around personal artistic concerns and a dispassionate objectivity was also reflected in the use of moving imagery. The cinematic practices of Georges Méliès were rooted in the illusionistic traditions of the theatre, whilst the Lumière brothers' films used the moving camera to capture objective representations of the urban world.

The first halftone newspaper photograph appeared in 1880 in an edition of the *New York Graphic*. The industrialised world of the 1890s saw still further proliferation of photographically produced, mechanically distributed images in newspapers and journals, and the mass production of the Kodak camera. The production of this camera and the provision of mass picture-developing facilities took photography away from the world of elite expertise and made it a mass medium. A late-nineteenth-century traveller could buy a Kodak camera in the USA, photograph the high-technology buildings of Chicago and New York, spend a week on an ocean liner and have developed photographs when the ship finally docked in Europe at Liverpool or Hamburg. The modern world was one of rapid communication, of the global transport of groups of people, facilitated by an ever increasing technological infrastructure.

The early modern world was the product of the new technology and a scientific outlook, entering into a dialogue with a set of established aesthetic values and forms. The two sat awkwardly together. The world of mechanically produced objects was seen as being without a legitimate aesthetic voice, the producers themselves being seen by some as the soulless objects of a barbarous new age. The arts were equally under pressure, unable to provide a language of expression that could adequately voice the concerns of this new world. At the turn of the nineteenth century Britain was the world's most powerful industrialised state, its position beginning to be challenged by the more recently industrialised USA and Germany, and only sustained by a rapacious imperial structure which ensured a constant supply of cheap raw materials from its colonies for its manufacturing industry. It is this largely closed, introverted society, rather than the dynamic cosmopolitanism of New York or the intellectual *élan* of Paris, that provides the first stage in understanding the evolution of an integrated art and design practice in the twentieth century.

Chapter 2

The Arts and Crafts – Revolution and Rusticity, New Languages for Design

In Britain, by the late 1890s, the ideas of the Arts and Crafts movement had become part of the educational establishment. This could be considered an odd occurrence, to have in positions of power and influence designers whose ideas about hand manufacture, it would appear at first glance, were at odds with the demands of an advanced industrial manufacturing nation. This is one of the many contradictions that the ideas of Modernism seem to thrive on. It is from this meeting of opposites that ideas are generated, and although the ideas of the Arts and Crafts movement were not to continue to influence ideas in Britain, they were to become an important part of the development of Modernism in Germany.

The ideas and the practitioners of the Arts and Crafts movement are often seen as belonging to a coherent body. This is a received opinion, and an inaccurate one, based probably on the powerful influence of a few strong individuals. There was no single Arts and Crafts movement. The many constituent bodies, the regional Art Workers' Guilds, the Arts and Crafts Exhibition Society, the Century Guild and so on, that are seen as part of the movement were not allied together in any form of federal party grouping. The many different organisations agreed with one another about certain issues with regard to design and the industrialised society they were living in, but their general concurrence on certain principles does not mean that these designers were in agreement over even the most basic of issues. There was no shared or unified cultural or political policy – some designers like William Morris and Walter Crane were socialists, others like Voysey and Baillie Scott were not. A designer like Arthur Penty whose socialist principles cannot be doubted, based his ideas so

strongly in the concept of a national rural culture that the German Nazi Party was to enthusiastically promote his work in the 1930s.

It is generally held that the artists and designers of the Arts and Crafts movement turned their collective back on the industrialised world in favour of handcrafts. It is not really correct to say that they were totally anti-machine (although some of them were), but rather that they were against the social and artistic consequences of ill-considered machine use. Hand skills were valued because they expressed the individuality of the worker, that individuality that the machine, by its very nature, suppressed and oppressed. Group working was valued because it meant that a collective style, what the architect Philip Webb was to term a 'commonplace' style, freed designers from having to compete in order to be fashionable. Fashion was resented because it reduced all designed objects to the level of commodities that were to be traded and valued solely for their appearance, with little concern as to how functional they were, or how well the designer had used the materials from which they were made. This last idea is known by the shorthand expression 'truth to materials'. Implied in this phrase are a number of issues, the strongest amongst them being the idea that each material has a specific intrinsic quality that is not shared by other materials. Gold, for example, because of its softness and elasticity, can be worked in a way that iron cannot. Different woods respond well to different structural tasks. In addition to this idea of a 'correct' working method for each material in response to its individual qualities, there is the idea of the correctness of form – so that how a material responds when worked will also determine its ultimate shape. One of the reasons that industrial production was so disliked was because it ignored this principle. In this way, gutta-percha and papier mâché, nineteenth-century equivalents of plastic, were used to simulate other more precious materials and so break two tenets of 'truth to materials', that material form should be determined according to the material's own intrinsic qualities, and that the value of an object stemmed largely from the creative input of its maker.

If the phrase 'truth to materials' seems familiar, it might well be because of its similarity with the Pre-Raphaelite painters' ideal of 'truth to nature'. Both the Arts and Crafts movement and the Pre-Raphaelites had their origin in the ideas of John Ruskin whose writings on art and design during his long life, whilst sometimes contradictory, remained consistent in expressing his aversion to industrialisation.

Ruskin saw a solution to the problems of creating a relevant contemporary architecture by ignoring the phenomenon of industrialisation altogether. He disliked the way that contemporary capitalist design was competitive, and looked back to the Gothic past as an age in which there was a collective design principle. In this view of the medieval past no single individual was responsible for the design and construction of architecture, rather, teams of masons and other craftspeople worked collaboratively to create the great cathedrals of the period. It is not difficult to dismiss this romanticised view of the past, but in doing so we must be careful not to lose sight of what Ruskin was trying to say through the medium of history.

Ruskin was not a revivalist or a stylist; he saw no point, as did many architects of the day, in simply reproducing the styles of the past. He was an interpreter of aesthetic history and saw no reason for a dogmatic view of architectural style, thinking that a single 'correct' architectural style was as unproductive as 'a universe in which the clouds were all of one shape, and the trees of one size'.[1] What fascinated him about the Gothic object was the way in which it was made. In relating the nature of the designed object to its manufacture, Ruskin created a new definition of an ideal object. This definition was also linked to the object as the direct result of a need, rather than a premeditated want with all its associated affectations of stylistically coded status. The more repetitive a task of manufacture, the more degraded the worker became in Ruskin's eyes. What industrialisation had achieved in all the design disciplines was to remove repetitive manual tasks from a social context and place them entirely into the context of successful economic performance. His ideas about the way that industrial work alienated those engaged in it ran parallel to similar ideas of Karl Marx. It was this, and his social conception of art practice, that led some of his contemporaries to view him as a 'radical' and as 'having communistic tendencies of no uncertain colour'.[2]

Though never presented in precisely the following terms, in effect it could be said that Ruskin was arguing for a philosophy of design that had an ideological, rather than an economic, value. This interpretation was taken up readily by his contemporary followers. W. G. Collingwood, when writing about Ruskin's ideas, proposed that the state should 'undertake education and be responsible for the employment of the artist and craftsmen it produced, giving them work on public buildings', and that the reestablishment of the medieval guild system 'would be of great service, especially in substituting a spirit of co-operation for that of competition'.[3]

We can see here how on one hand Ruskin's ideas run counter to those of Modernism in his distrust of industrialisation, yet on the other hand his concern that art and design should have a social function and that design should be an anonymous, collective activity finds echoes in the work of the young Soviet Union. These contradictions do not end here. In terms of visual appearance Ruskin had an open view of how things should look if designed in a 'Gothic manner'. The Gothic style as defined by Ruskin was the result of methodology – a style of cooperative labour. It was a vivacious style because of its combination of many workers' personalities expressed through their work. A Gothic object was made up from many disparate parts which would 'indulgently raise up a stately and unaccusable whole'. The social significance generated from this communal approach was a 'freedom of thought', for Ruskin argued that the Gothic was not a style to be associated solely with churches (as some architects working in the Gothic revival style argued), rather it was to be a secular art 'for the people', for homes and for houses. It was the Gothic's flexible pragmatism that was to make it a fit stylistic base for the modern world. Ruskin did not want a retrospective solution to design problems, but new ones, based on design practices rather than styles. The design methodology of collaboration that Ruskin identified with the Gothic seemed to Ruskin to be an appropriate solution to the demands posed to the contemporary designer. Ruskin identified these issues in a passage written in 1857 that seems remarkably modern for a man so opposed to the consequences of industrialisation:

> in these experimental days [it is] incumbent upon the architect to invent a new style worthy of civilisation in general; a style worthy of our engines and telegraphs; as expansive as steam, and as sparkling as electricity.[4]

As an undergraduate at Oxford, William Morris had been greatly influenced by John Ruskin's *The Stones of Venice*, in particular the chapter 'The Nature of the Gothic'. He was so impressed with it that it was amongst the first publications of his Kelmscott Press, a press that specialised in hand-printed fine-quality works. In his introduction to the text published in 1892, Morris called the work 'one of the few necessary and inevitable utterances of the century'.[5] Morris identified its importance in its provision of an ideological base for art production.

Morris can be considered as a progenitor of the Arts and Crafts movement, but not necessarily its representative voice. In focusing attention on aspects of Ruskin's work, he took from the Gothic

revival and transcended its historicism to build a wider conception of art practice. It was this foundation, based upon the intrinsic social and cultural value of hand labour that the Arts and Crafts movement in turn developed in an *ad hoc* way. Morris had no sympathy for 'stylistic' design, and viewed the copying of the past as a pointless activity. He made a great distinction between style and usage, and echoed Ruskin in his admiration of the pragmatism of the Gothic designers.

His own work can best be described as modest, not in its aims or its achievements, but in its methodology and imagery. He drew upon a range of natural imagery in his wallpapers and textile design that came from careful observation of the natural flora of the countryside. Indigenous forms without any associated cultural references other than that of the commonplace, such as willow leaves and daisies, were woven into intricate and often dazzling nets of repeat patterns. His furniture was like that of other designers of his outlook, based on traditional rural forms and processes of manufacture. Simple chairs with rush seats located a design practice in handcrafts, and were rooted in a vernacular rural tradition (see Ill. 2.1.) They were not experimental in form, but exploited a functional solution refined by usage of a long period of time. This use of a pragmatic traditional solution to design, one that emphasised hand labour, sits awkwardly with the industrial world that existed around Morris. However, he was not unaware of this contradiction as we shall see.

For Morris, design innovations were to come from practice, through working with materials and from considering functional design issues, rather than from experiments in conscious style. It is for this reason that Nikolaus Pevsner, in his book *Pioneers of Modern Design*, identifies Morris as the 'true prophet of the twentieth century'.[6] Without Morris, Pevsner argues, the 'ordinary' house would not have become an object worthy of the artist's and architect's attention. This perhaps overstates the case, as no doubt the economic benefits of increasingly sophisticated domestic design would have eventually made itself felt with or without the ideological push of Morris. It is always easy to overvalue the contribution of individuals to ideas in the cultural superstructure which in turn occupy a complex relationship with the economic substructure.

Morris was aware of this dilemma. As he grew older his interest in the political economy overtook his interest in the decorative arts. When the younger Charles Ashbee visited Morris in December 1887 in search of Morris's approbation for Ashbee's proposed Guild of

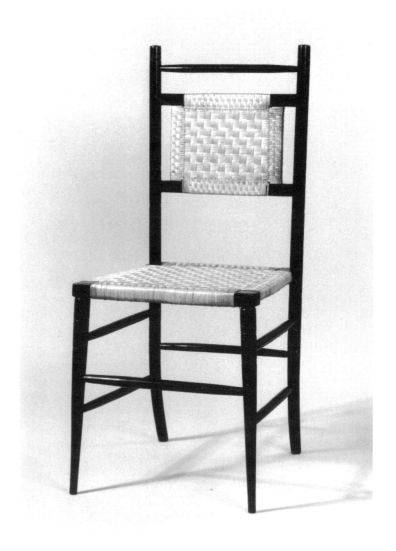

Figure 2.1 Edward William Godwin, side chair, 1887. Ebonised wood.
Collection, Art Gallery of Western Australia.

Handicraft, the recent killing of political demonstrators by police on 'Bloody Sunday' had reinforced Morris's conviction that only the complete transformation of the social structure could create the conditions for aesthetic renewal. Ashbee noted in his diary:

> William Morris and a great deal of cold water. Spent last evening with him – by appointment – apropros of Art Schools. He says it is useless and I am about to do a thing with no basis to do it on. I anticipated all that he said to me . . . I could not exchange a single argument with him until I granted his whole position as a Socialist and then said, 'Look, I am going to forge a weapon for you; and thus I too work with you in the overthrow of society', to which he replied, 'The weapon is too small to be of any value.'[7]

Morris's importance to Modernist design is his opening up of the social agenda for art. His emphasis upon manufacture also meant that by the 1880s his followers had substantially departed from the historicism and eclecticism of the previous years and had begun to look for a design base rooted in local design traditions of materials and functions. The practical problems that this attitude was to generate were economic. Walter Crane pointed out in the catalogue for the 1890 Arts and Crafts Exhibition Society show that to produce cheap goods manufactured by hand was well nigh impossible, because unless the designer/maker's labour was exploited the cost would have to be transferred to the purchaser. The Arts and Crafts designers wanted a mass market, and therein lay their dilemma, for their intention was not to design, as Morris put it, 'for the swinish luxury of the rich'. They wanted handcraft to be the mass provider of artefacts in their utopian vision of a self-supporting community. However, economic reality conspired against the ideological intentions of the Arts and Crafts designers, and they either accepted the reality of an elite market, or accepted that the industrialised world was there to stay and made some attempts to accommodate it. Even Morris went so far as to suggest that should the designer be engaged in designing for machine production then the object should look as mechanical as possible.

William Lethaby, who was deeply influenced by Morris, thought a great deal about the relationship between workmanship and the machine. He thought that a machine-made thing could never be a work of art. Lethaby defined (not altogether convincingly) a work of art as something made by a human being for a human being, but he argued that there was no reason why it should not be good in a way that echoed the well-designed nature of the machine itself.[8]

Providing that machine-produced objects did not pretend to be anything other than what they were, he argued that they were perfectly acceptable. It is clear that he was still thinking about a division between the fine and the applied arts. He argued pragmatically though that although a wedge, 'a great wedge', had been driven between the craftsman and his market by large-scale machine production, it was possible neither to go backwards in time, nor to stand still. He, like Morris, was no lover of nostalgia. He disliked the social effect that connoisseurship, and the collection of antiques, had on the contemporary perception of what constituted good design. If the past and its design styles were highly valued by an economically powerful elite, it followed that craftsmen would be unlikely to develop new styles or initiate new design solutions when the economic market was so prescribed. This further meant that machine production would end up providing a poor substitute of elite taste in order to satisfy the requirements of a deformed social market.

The many designers who followed Morris, both intellectually and chronologically, also modified his ideas. What was radical in the 1870s was codified during the 1880s and had become a substantial part of the art and design establishment by the 1890s. The Art Worker's Guild founded in 1884 emerged from the circle of designers who had been trained in the office of the architect Richard Norman Shaw. By 1888 there were Art Workers' Guilds in Birmingham, Liverpool, Manchester and Edinburgh. These were informal, loosely organised groups where practitioners of the visual arts would meet, read papers on, and discuss aspects of, their profession. They were in effect self-help groups trying to set up a network of information exchange in the absence of a useful art education system. It was understood that:

> Everyone freely reveals all he knows and keeps back no secrets. The usefulness of this interchange of information is beyond price. Whatever one might want to know about any process, one was pretty sure to be able to learn from a brother worker in that craft, and the methods of the different arts so freely discussed could not but have a harmonising result.[9]

The guild was in part a substitute for a visible art and design educational structure. (It is interesting also to observe in this quote the idea of harmony, both social and artistic, underlying the collective exchange of ideas. It is an idea that was to be picked up on by many Modernist artists and designers. This is another reason why the Arts and Crafts movement is credited as containing the beginnings of

Modernism.) The other aspect of the guilds was their economic purpose, where they attempted to regulate the process of employment for the craftsman and to egalitarianise business practice. There were many guild collectives; 1882 saw the founding of the Century Guild by Arthur MacMurdo and Charles Ashbee founded the Guild of Handicraft in 1888. The individual guilds centred around the production of artefacts, and organised themselves as they perceived the guilds of the Middle Ages organised themselves, with masters and apprentices working alongside one another. This process of learning the craft through practice was in direct opposition to the attempts to rationalise art and design education by the British state. The Arts and Crafts Exhibition Society, an informal grouping of guilds and other associations, showed handicrafts of varying degrees of professionalism from 1889 for a decade.

Much of the handcraft of the Arts and Crafts movement was contradictory in the same way that Morris's work was, but whereas Morris's work had an aesthetic quality that gave it a life of its own, much of the handcraft of this period was without the stylistic panache of Morris, without the ability to build on the traditional and to vivify it, and was overly reliant upon rustic forms and on the imagery of the past. Thus lamps took on the appearance of ancient coaching pieces, jewellery became excessively dependant upon quotations from Celtic design, and the relationship between function, the use of materials and the symbolic styling of the objects was in many cases weighted towards a stylistic coding of nostalgia. As the British establishment vacillated between expressions of nationalism through the use of the Gothic style (such as the Houses of Parliament) and expressions of the urbane through the use of Renaissance styles for many of its governmental department buildings, the Arts and Crafts movement located itself in a bucolic utopia. Many guilds not only drew their styling sources from traditional rural design, but also based themselves away from the towns and in rural communities.

The guilds and their members had an agenda – to revitalise the handcrafts as a means of both aesthetic and social renewal. Alongside this small-scale, personalised attempt at change was a parallel path which attempted to alter British national institutions. This educational programme, flawed though it was, must be seen as an important part of the long-term agenda of Modernism, capitalising on the much used early-nineteenth-century radical motto – 'Knowledge is Power'. The national art and design education structure was in dire straits. Henry Cole's national South Kensington System of Art

Education emerged from the debate about design education after the Great Exhibition of 1851. Many of the industrial manufactures exhibited were not only bizarre in conception, but also impractical. As we have seen, the designed objects embarrassed many involved in the arts, but more pragmatically, British design skills were seen as woefully inadequate for the task of export. It was obvious that the skills of British artisans in both manufacture and design needed to match those of her continental rivals, France and Germany. This, rather than aesthetic considerations, was the motivating factor behind a national design education system. Whilst well-intentioned, the Kensington System was very much a prototype education system. Its intellectual origins were in mechanical materialism, a crude structure of cause and effect, based on a seemingly endless number of self-referential tasks that bore little resemblance to the realities of design. Lethaby likened it to learning to swim in a thousand lessons without ever entering the water, and those involved in the Arts and Crafts movement were not the only people concerned as to its inadequacy as a model for learning to design objects. George Moore was a critic and writer associated with the Aesthetic Movement and involved with painters, such as Whistler, who argued the case for art on purely intrinsic grounds. Like Walter Pater, 'Art for Art's sake' was their rallying cry. Moore also thought little of the national design education system, as the following passage makes abundantly clear.

> The [art] schools were primarily intended as schools of design, wherein the sons and daughters of the people would be taught how to design wall papers, patterns for lace, damask table cloths, etc. The intention, like many another was excellent; but the fact remains that, except for examination purposes, the work done by Kensington students is useless. A design for a piece of wall paper, for which a Kensington student is awarded a medal, is almost sure to prove abortive when put to a practical test . . . That is the pitfall into which the Kensington student falls; he cannot make practical application of his knowledge . . . So complete is the failure of the Kensington student, that to plead a Kensington education is considered to be an almost fatal objection against anyone applying for work in any of our industrial centres.[10]

Even allowing for the hyperbole that Moore is using to make his point, it is clear that the system devised by Cole was by no means well-loved. Like all structures and situations it was not all negative; alongside the very prescriptive teaching was a programme of establishing museums with an educational purpose, so that people would

become acquainted with the best examples of design. This was an important factor in taking aesthetic debate away from the private sphere and putting it into an open social domain where it becomes subject to public debate. This process of course still relied on a notion of what was 'good' and what was 'bad', but the decision-making about such things was slowly becoming more socially dispersed, not just in Britain, but throughout the industrialised world.

The great gap between the theoretical and the practical in design was a real one. It was identified by those in the Arts and Crafts movement who filled the gap with guild associations; this approach was taken still further in the 1890s with the establishment of educational institutions teaching integrated design courses. These municipal, as opposed to government, funded institutions eschewed the mechanistic transmissive Kensington System, and built on the master/apprentice relationship of the guilds and the French Beaux Arts Atelier system. It was a system of teaching that was fundamentally practical. What took this system away from the guild approach was the mixing of disciplines and the breadth of experience that the student had. He or she was exposed to a variety of art and design disciplines, all of which were seen as contributing to a rounded aesthetic education. It was this integrated approach to teaching that was to be developed by the Bauhaus in Germany in the 1920s.

The first of these institutions founded in the UK was the City of Liverpool School of Architecture and Applied Art, inaugurated in 1895. A year later in London, the Central School of Arts and Crafts opened its doors under the directorship of Lethaby. Walter Crane was appointed principal of the Royal College of Art in 1898 from his post as Director of Design at the Manchester College of Art. This indicates how the ideas of the Arts and Crafts movement were becoming increasingly important in formal art education, and how what was once seen as oppositional to an industrial culture was becoming a component part of it. This slow infiltration of ideas into the British cultural establishment is put into a wider perspective, however, when one examines how continental Europe responded to the initiatives in design that emerged from Britain. *The Studio*, the magazine which in effect became the voice of the Arts and Crafts movement, was held in great esteem in Europe, a situation that was duplicated in the way that British designers were regarded. The Scottish brothers-in-law, Charles Mackintosh, based in Glasgow, and Herbert McNair, based in Liverpool, had substantial successes in Vienna and Turin that were never duplicated in Britain. British

designers briefly held the privileged position of being seen at the cutting edge of the transformation of European design, and were to have far more influence in Germany than they were ultimately to have in their own culture (see Ill. 2.2.)

In 1898 Hermann Muthesius was sent by the German government to investigate British solutions to housing. In the big industrial cities British mass housing was of an appalling quality, but there was a gradual move towards the idea of planned towns and suburbs, the Garden City Movement. The idea was twofold, to turn the bleak industrial cities greener through a network of garden suburbs, and more radically to completely alter the way in which cities were designed. The garden city was to be designed around the quality of life for its inhabitants. This idea was given a focus by the publication in 1898 of Ebenezer Howard's book *Tomorrow: A Peaceful Path to Real Reform*. Many Arts and Crafts designers were involved in these architectural projects. By the time of Muthesius's return to Germany in 1903 these architectural schemes of garden suburbs surrounding the old urban areas were beginning to become a reality. He was to return home and on the basis of his experiences write *The English House*, which was to exercise a powerful influence in Germany. Muthesius was greatly attracted by the idea of a vernacular style of design, that exploited materials in a workmanlike and unpretentious way. The German authorities saw the implications of Muthesius's observations on design and began to develop their own art and design education system, further encouraging the movement towards greater practical study by designers. This is a great irony as during the 1880s many British designers saw the German education model as a substitute for the creaking British system. In 1907, when he held the position as Head of the Prussian Board of Trade for Schools of Arts and Crafts, Muthesius helped to form the Deutscher Werkbund (a loose confederation of artists, designers, manufacturers and government) with the purpose of improving the quality of German industrial design. This organisation was to generate the ideas that were to be so influential when formularised by the Bauhaus.

I have already mentioned that the Arts and Crafts movement was not a unified or coherent one. Many designers worked in many styles, sometimes simultaneously. Alongside the ideas that could be characterised as progressive, in that they conformed to the social agenda seen as part of the development of Modernist thought, there were aspects of the Arts and Crafts which do not fit so neatly into this argument. The vernacular, the sort of design that emerges unselfcon-

Figure 2.2 Charles Rennie Mackintosh, *Willow*, 1904. Ebonised wood.
Collection, Art Gallery of Western Australia.

sciously through everyday use, was used to present a modest and coherent design philosophy, one that encouraged egalitarianism and cooperative labour. However, in its exploitation of traditional, rural styling it can be also seen as a large contributor to a sense of design that is nostalgic and escapist. For every designer who used rustic materials in a way that was developing the idea of an evolutionary design principle, where constant use determines the revision of the form of the object, there were designers who simply used the superficial codings of rusticity and tradition to provide an escape from the industrial present without attempting to change a perception of it. In the hands of such designers, the object is destined to remain a cultural toy, a thing that entertains but can never comment or intercede in the wider cultural debate.

The Arts and Crafts are also associated with Art Nouveau, though there was great antagonism from some Arts and Crafts practitioners to what they called 'the squirm'. L'Art Nouveau was the name of a shop that opened in Paris in 1895, and has since become the eponymous title for a style that had a different name in different countries. The Art Nouveau style is linked to the Arts and Crafts movement because it would not have existed without the new vocabulary of form that Arts and Crafts methodology gave to objects. Glass had always been blown, but the idea of 'truth to materials' meant that the physicality of glass, the way that it stretches and hardens, was open to interpretation in a new way. Because of this widening of conceptual expectations, 'new' forms emerged. In Tiffany glass the form of its construction is clearly expressed in its appearance. In this way Art nouveau can be seen as a development of previous ideas.

In another way the style simply plundered Arts and Crafts imagery, as the past had been used previously, as a source for form. In using this range of imagery, it was using it in a different way. No longer were images of the organic seen as being oppositional to a mass industrialised culture, rather these images were part of a commodified escape into the 'natural'. The natural and organic became a form of visual recreation, serving the same function in the visual arts as the park did in the city. The organic ceases to be outside of, and an alternative to, the industrial; it is seen as running parallel with and refreshing the mechanised world. The act of commodification of the art object and the absence of a social agenda for Art Nouveau also separate it from the more progressive elements of the Arts and Crafts (see Ill. 2.3.)

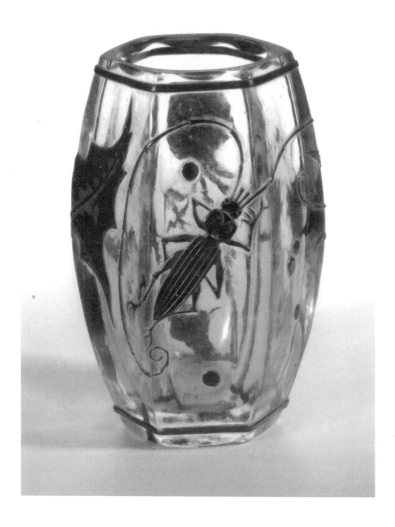

Figure 2.3 Emile Gallé, *Vase de Tristesse*, 1890. Carved glass. Collection,
Art Gallery of Western Australia.

Like the Arts and Crafts, Art Nouveau used organic forms and motifs. Unlike the Arts and Crafts the use of such decorative and stylistic devices was in opposition to either the material from which the object was manufactured, or the functional nature of the object. Here the question needs to be asked whether an electric table lamp styled as a medieval lantern is any different from an electric table lamp styled as a plant. Obviously they are different physically, and their styling signifies different things, but both are similar in their disguising of the reality of their functional origins, and the technology of electricity – which was a technology that was without functional or formal precedent. A similar thing happens with the design work of Hector Guimard. His ornate and organic cast-iron entrances to the Paris Métro contradict the technology of the train and also work in opposition to the material. Iron can be cast in any form, as an elephant or as a geometrical solid. In using the imagery of the tree for a structural support, however, Guimard is saying something quite particular about the relationship of the natural world to the urban.

The most profound distinction between Arts and Crafts nostalgia and Art Nouveau styling however, is when the forms of Art Nouveau break all precedents and expectations about the appearances of objects. When this happens it is not the result of diligent and anonymous team craftsmanship that aspired to a collective or universal design style – rather it is the supreme individualism of the creator throwing off all constraints in the quest for personal expression. Such a designer was Antoni Gaudi whose work exploited organic forms and which created a new personalised formal vocabulary. His work can be considered as a heroic struggle against artificial constraints, or, alternatively as Pevsner refers to it, 'amazing, fascinating, horrible'.[11] We are confronted here with an ideological question. At what point does the expression of individualism become incoherent and destabilising in a communal culture?

This was the dilemma at the turn of the century, the problem of creating what Clive Bell in his book *Art* called 'significant form'. Bell was referring to the artist's search for the correct form to express an aesthetic emotion, and the way that expression was not necessarily tied to the representational world. The parallel in design is clear – 'truth to materials' can perhaps be substituted by the phrase 'relevant form' to convey the idea of a search for a new design style coherent enough to express the new times. The Arts and Crafts had gone some way towards creating a new ideological justification for design that Roger Fry summed up in his essay 'Art and Socialism' written in 1912:

Under the present system of commercialism the one object, and the complete justification, of producing any article is, that it can be made either by its intrinsic value, or by the fictitious value put upon it by advertisement, to sell with a sufficient profit to the manufacturer. In a socialistic state, I imagine . . . there would not be this same automatic justification for manufacture; people would not be induced artificially to buy what they did not want, and in this way a more genuine scale of values would be developed.[12]

The artists and designers active in the Arts and Crafts movement had tried to create a shared design style based on the vernacular as a way of creating 'relevant form' that could communicate certain values. Whilst failing in that aspect of their work they opened up the possibilities for the formal appearance of design. The sheer variety of form used during this period meant that it was paradise for those artists and designers who wished to develop a personal language. The problems of this stylistic eclecticism led to a difficulty in visual communication, a situation we will see occurring a hundred years later in the 1980s and 1990s. The debate between the adherents of individualism and those who advocated a 'universal' approach to design is clearly articulated in Germany within the Deutscher Werk-bund, with which we start the next chapter.

Chapter 3

The Machine Ethic – Functionalism and the Collective

The machine, the culture it had produced, and the culture that it *might* produce became of vital importance in the first few decades of the twentieth century. Those artists and designers who agitated for a developed technological culture saw one of the main benefits of such a culture being a negation of the excesses of individualism, both socially and artistically, and the development of a rational, directed culture. The Arts and Crafts movement's ideal of cooperation led to further investigations about a collective art. There was to be much talk of the 'universal', a word which had many shades of meaning, but which was mainly used to describe a position that was opposed to the expression of the single subjective voice, and which implied a set of fundamental systems of communication and understanding. A further extension of Arts and Crafts philosophy, that of 'truth to materials', was to continue and to develop alongside the idea of the primacy of function in design. This was to be a confused area of discussion, because ideas about what constituted function and the constant concern with a new 'universal' language of form did not always sit comfortably together. Sometimes the appearance of an object, its clean geometric lines, belied its impossibility of use. The social context in which art found itself was of great importance to these artists. The ideas of Marx, that the purpose of philosophy was not to interpret but to change the world, found many echoes in the practice of art and design. Many designers saw their role as emancipating themselves, and art practice, from the whims of the history of aesthetics, and in the words of Hannes Meyer 'the art of felt imitation is in the process of being dismantled. Art is becoming invention and controlled reality.'[1] It is the artists and designers who admired technology, who struggled with ideas concerning the individual and his or her relationship to the collective, and who tussled with the

formation of a new visual language considered appropriate for the new times that we shall be examining in this chapter.

The pivotal point of our debate can be located in Germany. Hermann Muthesius identified much of what was being discussed in Arts and Crafts practice and education in the UK as being relevant for the German industrial state. A year before the Deutscher Werkbund was founded Muthesius was calling for a new form of design that did not simply decorate but which would 'provide a form of social training' and which 'might be called a new style of living'.[2] Muthesius's argument was not just one to do with aesthetics, or a form of social utopianism. It also had its roots in economics. Muthesius proposed an idea of fitness of form and its relationship with function which he had expounded in his analysis of the English house.[3] There he observed that form developed purely from function was often so expressive that an appreciation of functional success differed little from what was traditionally though of as aesthetic pleasure. The rationalism of this design position translated easily into economics. New economic and political conditions in a newly unified Germany demanded new design solutions. Objectively resolved, the argument went, functional design would present aesthetically pleasing solutions, which had an economic value for the user of such objects and which would ultimately benefit the economic well-being of the state. Style was to emerge from the use of materials (an argument that should not be unfamiliar and that will present itself again . . .) and was to have no historical or cultural references in its appearance. Muthesius remarked, 'it is already becoming possible to point out that the modern movement is by no means a commercially unsound proposition. The large number of industrialists who followed the new path as a logical decision have obtained significant financial success.'[4]

This argument, so compelling in the words of Muthesius, was not universally accepted in German art and design circles. Although the founding of the Deutscher Werkbund can be seen as the product of Muthesius's ideas, it was not by any means an exclusive vehicle for them. The 'compelling logic' of Modern Movement ideas was in some quarters seen as neither compelling nor logical. By 1914, the debate within the Werkbund had become polarised between ideas about the role that the individual artist or designer should play within a social context. What Muthesius and other advocates of the Modern Movement proposed was the primacy of a design logic that came from an 'inevitable' and functional use of materials. This was seen by its

opponents to diminish the role of the artist as a distinctive and individual creator.

In 1914, (just before the outbreak of the First World War, which was to disrupt the continuity of the Modern Movement, and which was in itself the direct consequence of mass industrialisation, and whose atrocities were those of a 'scientific', 'rational' culture), the Werkbund held a conference in Cologne. This is of particular interest as the conference discussion was a debate of oppositions, of the individual and his or her concerns positioned against notions of the universal or the collective, and the importance of the handmade object compared to the mass-produced one. What we have in microcosm at this conference is an examination of the relationship of the artist/designer to an existing cultural environment and how the act of manufacture is seen as having a direct and calculable effect upon the culture in which the artist/designer works.

Muthesius proposed that architecture was the mother art around which other visual disciplines should gather and learn. Particularly relevant were those architectural ideas which promoted standardised or 'typical' form.[5] This in Muthesius's view would produce design of a 'universally valid' quality. In opposition to this view, designers like Henry van de Velde argued against a standardisation or rationalisation of design from a position of extreme individualism. 'By his innermost essence', says van de Velde,

> the artist is a burning idealist, a free spontaneous creator. Of his own free will, he will never subordinate himself to a discipline that imposes on him a type, a canon. Instinctively he distrusts everything that might sterilise his actions and everyone who preaches a rule that might prevent him from thinking his thoughts through to their own free end, or the attempt to drive him into a universally valid form.[6]

Two distinct routes are clearly articulated. The first proposes an ultimately collective and collaborative route. This line of argument suggests the artist and designer work according to a visual and formal language that emerges through an understanding and application of the appropriateness of functionalism. Peter Behrens made this point when he remarked that 'it is quite evident . . . that if a department store is strikingly designed so as to express its purpose, it will be a better piece of architecture than if it looks like a castle'. The other point of view locates the creative process not as one in which there is negotiation with material conditions, but entirely within the individual creativity of the artist/designer. Robert Bremer, who charac-

terised the Werkbund as an arranged marriage, and by implication unhappy, between schoolmasters and artists, held the view that 'the artist is never wrong and the majority, when not wholly opposed to what he does, is very seldom right. The majority must listen or at the most advise; it has absolutely no right to criticise or attempt to influence the artist.'[7]

It is clear that for the culturally aware artist/designer to operate within an industrial society at this time, there were the issues of understanding, appropriating and contributing to a new technological future, or remaining on the outside and acting as a radical, oppositional, and often lone, voice. At this time, there was no clear division between the political right and left as to which was the 'correct' position to adopt.

This was also the case in terms of styling. Function was seen to be very important by Modern Movement designers, who saw the new technologies in industrial and commercial architecture ultimately influencing the construction of 'civic' architecture. The new technologies were seen by Muthesius (and others) as breaking down cultural barriers, transforming traditional environments, and internationalising culture. The same clothes, Muthesius pointed out, were 'being worn from the north to the south pole'.

The new building technologies that were transforming both the intellectual and physical environment in Europe were derived from the engineering skills of the previous century. Whilst there was technological and design innovation in European building there was nothing that matched the scale and rapidity of the economic development of the American cities. The urgent economic need for rapidly constructed large buildings and the developing economy of the United States meant that buildings were becoming larger and taller. The technology available for this turn-of-the-century building boom was in effect a refinement of techniques and materials that had been used internationally in office, factory and exhibition construction for several decades, but it was the destruction by fire of most of the city of Chicago in 1871 that developed 'skyscraper' building and opened a debate as to how these structures should look.

The first skyscraper is generally considered to be William Le Baron Jenney's ten-storey New York Home Insurance Company building in Chicago in 1885. Whilst the same height as Burnham and Root's Montauk Building completed two years previously in the same city, Jenney's structure was not built using load-bearing walls, but gained its structural integrity from an iron and steel frame. This meant that a

design issue needed to be confronted; the traditional devices of support of a building's roof had become codified into a variety of decorative forms. Thus the classical column which had once held up the roof became a pilaster, and the structural elements of Gothic architecture became decoratively familiar. Their use by architects was well understood in terms of the visual dynamic of a building and the way that they related to an understanding of how the building was perceived. This of course was the 'problem' with functional architecture – it had no visual codes of its own in which to communicate anything other than the fact that it was a functional building. This is why of course the Modern Movement found them so exciting.

A building with an internal iron or steel structure meant that the walls were no longer 'functional' in their traditional way. They no longer held anything up. The wall surface which used to describe how the building was constructed no longer did that. It was a skin, a cladding, with no design or decorative precedent. It was the first time that this problem was encountered, how to make these enormous buildings read in a way that was acceptable to a set of well-established design conventions. The sort of clients that commissioned these buildings were not of the mindset to commission an architect who might hold to van de Velde's point of view – '. . . the majority must listen or at the most advise; it has absolutely no right to criticise or attempt to influence the artist'– or to commission an architect who wished to strip the skyscraper down to its bare functional façade. They wanted big buildings, but ones which would communicate in a traditional way as banks and department stores did. The confusion of style for these new structures is perhaps most easily illustrated through a competition that took place as late as 1922, the Chicago Tribune Tower competition. Design solutions ranged from neo-Gothic to neo-classical (complete in one design with a Greek temple perched on top of the building like a vast bird coop), and from Baroque palace to an edifice in obelisk form capped with a pyramid.

It was in the 1890s that designers in the USA made their first attempt to control signification in their large-scale building. The World's Columbian Exposition in 1893 saw a use of 'presentation' architecture within the exposition that was as influential as the Crystal Palace had been. The centrepiece of the exposition was the Court of Honour, a vast white complex, Beaux Arts in style. Whilst the neo-classical style may be considered inappropriate to a discussion about the Modern Movement, the style was adopted because it indicated a transnational, transcultural approach to design. It was a

style that was seen as having a civic quality. It could be read as rational and ordered.

The international success of the architecture at the Exposition, in particular the work of McKim, Mead and White, needs to be looked at carefully in its contribution to Modernism because important lessons were learned. Like the Arts and Crafts movement's adoption of the Gothic, the Beaux Arts style was chosen for ideological reasons. It was a style of common currency, it meant the designer worked within a defined language and that the excesses of stylistic individualism could be avoided. The design triumph in the Chicago Exposition came from the scale of the show, and its coherence in terms of plan and styling. Daniel Burnham, later responsible for the internationally influential city plan for Chicago in 1909, wrote:

> There are two sorts of architectural beauty, first that of an individual building; and second, that of an orderly and fitting relationship of many buildings; the relationship of all the buildings is more important than anything else.[8]

His point, and the architectural ambitions of his like-minded compatriots, are readily comparable to the design assumptions of European Modernists despite their different stylistic assumptions. Planning, rationality, stylistic unity, the subordination of the individual unit to the coherence of the group, all these are ideas that spring from a common material base: that of industrialisation and the need for order within it. The Beaux Arts style gave a communal understanding of the new building technologies and their potential as modular design units. It is interesting that the Beaux Arts style in America was adopted as a social, or civic, style; as a way of making communal experience valid. This idea of 'social legibility', of making social design readable and functional to as wide a group as possible, was also something that many designers within the Modern Movement were to promote.

The profound difference between the Beaux Arts and the Modern Movement, despite their many similarities, was their approach to history. Whilst using the technology which was the product of the present, the language in which the Beaux Arts designers worked was of the past. There was a perceived need by these designers for a stability, perhaps even a sense of cultural identity, that came from the past. In Europe the interest was in the future, of shedding a past that was weighing down the many attempts to come to terms with their contemporary industrial conditions in as productive a way as possible.

Breaking with the past, rupturing social tradition and cultural history, was the activity of the avant-garde artistic circles of the European centres. It is difficult now, nearly a century later, to look at the innovations in painting in France and fully understand their enormous disruptive qualities. When Pablo Picasso and Georges Braque took the picture surface, rearranging ideas about its illusory reading and its surface qualities, they were breaking violently with a way of presenting visual information that the Impressionists, for example, had not. The Impressionists, for all they upset people with their subject matter and their technique, still exploited the Renaissance idea of the picture as a window into a visual experience. That 'window' vanished with Cubism, and the picture became a surface, a surface that was emphasised still more by the literal application of found materials which played with the reading of space. No longer did still lifes exist in a secure, illusory three-dimensional space. In Cubist pictures, objects were fragmented, slipped behind and in front of one another, existed on the picture plane (the physical surface of the picture) and in a shallow illusory space behind it. In 1915, the gallery owner Daniel-Henry Kahnweiler (the dealer responsible since 1908 for disseminating Picasso's and Braque's work to Germany, Russia and the USA), wrote about these paintings:

> Just as the illusionistic art of the Renaissance created a tool for itself in oil painting, which alone could satisfy its striving for verisimilar representation of the smallest details, so Cubism had to invent new means for an entirely opposite purpose, For the planes of Cubist painting oil colour is often unsuitable, ugly, and sometimes sticky. Cubism created for itself new media in the most varied materials: coloured strips of paper, lacquer, newspaper, and in addition, for the real details, oilcloth, glass, sawdust, etc.[9]

This was a radical departure from the tradition of pictorial organisation and of picture-*making*. As such, it must be viewed along with the design initiatives coming from Germany as part and parcel of a small but highly vocal body of practitioners in the visual arts breaking with past methods of artistic production in an attempt to reorganise the present.

To the aesthetic avant-garde the present consisted of the production of objects in a new industrialised environment: 'catalogues, posters, advertisements of all sorts. Believe me, they contain the poetry of our epoch.' This was Guillaume Apollinaire's view as a poet and critic. He also characterised the attitude of the new Modern Movement that we

have already heard Muthesius refer to – 'One cannot carry everywhere the corpse of one's father'.[10]

History was seen as a dead weight by the Italian Futurists, whose name itself conjured up images of cities full of machinery, of a mechanised society of whirring wheels and motion. Not for these artists and designers the stabilising force of the neo-classical Beaux Arts. This is ironic if we consider the dynamism and growth of the American cities compared to those stable and established Italian towns from which the ideas of Futurism emerged. Even Milan, which was the centre of Italian industrialisation, could claim the one-time residency of a certain Leonardo da Vinci.

At the start of 1909, before Cubism was the talk of Parisian avant-garde circles, F. T. Marinetti announced, on the front page of Paris's *Le Figaro*, the formation of the Futurist movement. In language that came from the Symbolist movement, full of phrases like 'And we pursued Death with his black pelt spotted with pale crosses, streaking across the violet sky so alive and vibrant',[11] a set of ideas were expressed which whilst showing an affinity to the ideas of Expressionism rather than the Deutscher Werkbund, nevertheless proposed an art that threw away history and immersed itself in the marvels of the present. Marinetti proposed an artistic and aesthetic sensibility based upon a love of danger, of speed and machinery, in which beauty emerges from struggle and 'no masterpiece [is] without the stamp of aggressiveness'. War and militarism were 'the only true hygiene of the world', a chilling precursor of Fascism. The 'female' and 'feminine' attributes were to be despised in a *Boy's Own* world of arsenals and docks, factories and bridges, filled with aeroplanes, locomotives, cars and bicycles.[12] This world of new technology was seen in metaphorical and allegorical terms. Indeed, utilitarianism, which was such a key issue in the debate about form and function in design, was characterised as 'cowardice'. The technological world was not fully rationalised, nor its issues considered – far from it. Rather, the industrialised city was turned into a theatrical arena in which the artistic individual used its imagery to make observations about his (and I use the masculine form deliberately) cultural stance: 'Erect on the summit of the world, we once more hurl forth our defiance to the stars.'

It is no coincidence that ideas like this emerged from outside the exclusively industrial city. As I have previously observed, industrial cities like England's Manchester, the raw material for Engel's study on the condition of the working class, were in reality grotesque,

alienating, depressing places. The majority of people who generated the industrialised objects that made such cities wealthy desperately wished to escape from them. Marinetti is talking about a utopian mechanised city, in the same way that the English Arts and Crafts movement located their utopia in a non-industrialised world, in the same way that the American Beaux Arts advocates located their new and raw cities in a Parnassian paradise.

The manifestos of Futurism were produced regularly. There was also a journal *Lacerba* (published in Florence), in which the radical ideas of Futurism were presented. At the core of the Futurist movement was the writer and poet Filippo Marinetti; its main personalities were in large painters, Giacoma Balla, Umberto Boccioni, Carlo Carra, Luigi Russolo and Gino Severini (see Ill. 3.1). Fortunato Depero (1892–1960) produced typographical and other design work, and Antonio Sant'Elia (1888–1916) provided a Futurist vision of the city. Russolo experimented with noise machines creating performances of mechanically generated music. These were often combined with theatrical events and poetry readings. Whilst there was a manifesto explaining futurist photography and film,[13] it was not until 1916 that the first full-length Futurist film, *Perfido Incanto*, was shown. There were many different concerns amongst the Futurists; different media were being exploited, sometimes with different intentions. Not everybody always signed the manifestos, and sometimes manifestos were individual concoctions. A curious phenomenon, the individual group manifesto! There are of course a number of issues that link the varying concerns of all the artists. The most important of these is that 'science', and the products of industrialisation, were given almost metaphysical attributes.

In the *Technical Manifesto*, published in 1910, the seventh of nine final declarations stated that 'universal dynamism must be rendered in painting as a dynamic sensation'. This phrase as it stands is close to impenetrable, but underlying a lot of Futurist ideas was the Heraclitian idea of the constant change evident in both social and natural structures – 'everything changes swiftly'. Whilst there is little indication, other than Carra's, that there was a more sophisticated understanding of this concept through contemporary developments in philosophy, nevertheless the Futurists as a group had an intuitive grasp of this notion. Thus, pictorially, travellers in a 'motor bus' became examples of Brownian motion. As passengers and bus blended visually into a unified whole they became 'persistent symbols of universal vibration'. The world is seen as a fragmented and

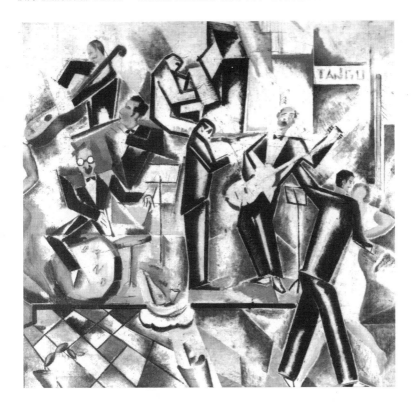

Figure 3.1 Gino Severini, *Musicians*, 1912. Oil on cardboard. Collection, Art
Gallery of Western Australia. © Gino Severini, 1912/ADAGP.
Reproduced by permission of VI$COPY Ltd, Sydney 1997.

'dynamic' place. This position is both metaphysical and a reflection of
the processes of the 'new capitalism transforming the old economic
and social structures' of Italy.[14] (It can also be seen as a manifestation
of Albert Einstein's ideas about the 'relative' nature of the universe
taking a colloquial form.[15]) The consequences of this quasi-scientific
thinking are that the physical *human*, and the ideology of *humanism*,
are subsumed into the technological, where 'the suffering of a man is
of the same interest to us as the suffering of the electric lamp, which,
with spasmodic starts, shrieks out the most heart-rending expressions
of colour'.

At the core of Futurism (as in other manifestations of Modernist
thinking), there is a confusion between the universal and individual

attributes of the style and its methods. This is most tellingly presented in the phrase 'the dynamic sensation itself (made eternal)'. This suggests that the sensation, or experience, of the vitality generated by living in the new industrial age was to be captured forever. But rationally we know that dynamic things can never be stable and will always change, and that the attempt to fix them through artistic means is doomed to failure. All that is left is a fragment of individualism, a trace of individual experience that can then be shared by the spectator. But the Futurists felt that they were going beyond the personal, into an observation of the fundamental nature of how the modern world operated. What they wished to do was to get at the 'essence' of the experience of modernity: 'Our paintings are no longer accidental and transitory sensations . . . we Futurists . . . bring to the painting an integration of sensations that is the synthesis of the plastic universal.'[16]

If we look more closely at that statement, inherent in it is the idea that there are universal forms of expression. The 'plastic universal' refers to an idea that was common throughout Europe at the time, the notion that modern visual practice was uncovering a set of fundamental or universal (often largely geometric) visual forms. This process of transcribing experience using 'universal forms' is contradicted however when we are told that, 'form and colour are related only in terms of subjective values'.[17] So we have a strange combination of universal and essential experiences transcribed in a purely individualistic way.

On one hand there is the glorification of the mechanised physical world where 'the opening and closing of a valve creates a rhythm just as beautiful but infinitely newer than the blinking of an animal eyelid' a world in which the logic of technology creates Sant'Elia's dramatic vision of the cities of the future. On the other hand, Futurists stress the subjectivity of experience: 'we proclaim that the visible world must fall in on us, merging with us and creating a harmony measurable only by the creative imagination'.[18] The universality of the mechanical, with its functional derived forms originating in the laws of mathematics, is paired with the individuality of the artist recording the processes of this world.

The cleansing war that was so looked forward to by Marinetti effectively killed Futurism, though it was to be kept going under Marinetti's constant personal promulgation of its universal values for several more decades in cooperation with the Italian Fascist state. By 1916 Boccioni and Sant'Elia were casualties of the world's first

industrialised war, and Russolo was badly injured. The remainder of the war saw no artistic activity celebrating the dynamism of machines in motion, though in Paris in 1915, Severini painted *War*, a stylised composition of factory chimneys, winches, aeroplane propellors and electricity pylons that has a static, overformalised quality to it. Conceptually it is a long way from Balla's view of the war as 'the current marvellous little human conflagration'.[19]

The Futurists had a specifically nationalistic vision of themselves. This was their tragedy, allying themselves to the Fascist government of Mussolini which took power in 1922. Already in 1915, in their *Futurist Reconstruction of the Universe*, Balla and Depero wrote: 'No artist in France, Russia, England or Germany anticipated us in perceiving anything similar or analogous. Only the Italian genius, which is the most constructive and architectural, could perceive the abstract plastic complex.'[20] This of course was patently untrue; the conditions that created Futurism, the material base that produced its ideas, was a component part of European culture at that time. The industrialised capitalism of the young century was increasingly creating the same conditions internationally.

Russia was less advanced in terms of industrialisation than most European countries at the time, but the new Modernist ideas were international and travelled easily by train. Russia was weighed down with an autocratic and corrupt monarchy. Its system of government was unwieldy and slow to adapt to the circumstances of the new century. The year of 1905 had already seen the beginnings of a revolutionary challenge to its authority, and in 1917 the Bolshevik Revolution gave power to Vladimir Lenin. Despite his own conservative aesthetic sensibility, Lenin's artistic policy under the guidance of Anatole Lunacharsky meant that the new ideas of the Modern Movement became the visual language of the young Soviet Union.

The first exhibition to indicate a specifically Russian notion of Modernism was the 'Donkey's Tail' show in Moscow in 1912. It was a deliberate attempt by its main protagonists, Mikhail Larianov, Natalia Goncharova, Kasimir Malevich and Vladimir Tatlin, to assert a synthesis of a number of European influences, including those of Expressionism, Futurism and traditional Slavic forms. The adoption of traditional peasant imagery was an important ideological position that indicated a search for a language rooted in the vernacular, in the same way that the Arts and Crafts attempted to do so in the UK. The paintings were social as well as aesthetic statements. It was Larionov[21] who was responsible for the Rayonnist manifesto, another

European voice welcoming change through mechanisation, welcoming the idea that machinery could somehow provide a universal visual language. Larionov wrote:

> We declare: the genius of our days to be: trousers, jackets, shoes, tramways, buses, aeroplanes, railways, magnificent ships – what an enchantment – what a great epoch unrivalled in world history. We deny that individuality has any value in a work of art.[22]

The manifesto goes on, as manifestos often lengthily do, to describe in detail the new approach to painting that was enshrined in Rayonnism. The style itself was short-lived, an amalgamation of a variety of current approaches to painting, but it is important in demonstrating a move towards a new art practice. Goncharova was painting Cubistic/Futuristic pictures of industrial objects. Her picture of *The Cyclist* shows a man in stylised workers' clothes speeding futuristically past shop windows covered in commercial typography and imagery. In the same way the poet Vladimir Mayakovsky was observing the phenomenon of the industrial city: 'He saw the letters O and a French S skipping on the rooftops advertising watches. He saw the signboards and read these iron-backed books. He admired the china teapots and the flying rolls pictured on tavern shutters.'[23]

It should be unsurprising then that artists such as these welcomed the Bolshevik Revolution with its agendum of 'Electricity plus the Soviets equals Communism!' To think of a united front of artists in support of the revolution though is a romantic notion. What the revolution provided was a radical change in the configuration of practice and education in the visual arts. In the journal *Art of the Commune*, Mayakovsky wrote that 'The streets are our brushes, the squares our palettes.'[24] Initially it was in the State Free Studios where avant-garde ideas about art practice were discussed. They were radical institutions in that anyone could attend classes, and in that a variety of approaches and methods were taught within the institutions. For the first time within Europe it was possible to attend an art school and learn about non-academic art practices. However, in terms of structural form, they were still modelled on the old academies, the fine arts were still considered to be at the cutting edge of practice, and students opted to work within the studio of a particular master. It was an anarchic, exciting time to be an art student, but the 'Free Studios' were still perpetuating the idea of the artistic 'individual'. It was 1920 before a coherent state structure for art and design education that

emphasised the collective, and the need for social artistic production, began to emerge in the Soviet Union.

The VKhUTEMAS (the Higher State Artistic and Technical Workshops) linked fine art with the applied arts. Their role was the development of a broad artistic creativity and its application to the production of industrial goods. This experiment in combining the artistic with the industrial was all over by 1930 when specialist institutes took the place of the VKhUTEMAS. For ten years however the Soviet State committed itself to a broad-based artistic education in which the student studied the relationship between form, function and material in all disciplines. Within the various schools, artists/designers like Aleksandr Rodchenko, Gustav Klutis, El Lissitzky (see Ill. 3.2), Vladimir Tatlin and Vavara Stepanova taught a design based on material culture that echoed the ideas of the Constructivists and crossed the artistic disciplines working in typography, textiles and clothing, theatre design, and architecture. One other artist needs brief mention here, and that is Kasimir Malevich, whose work was vitally important in establishing a purely abstract visual language.

At its inception the Constructivists were a small organised group, part of the wider complex of visual culture in the Soviet Union. It has now become a term which encompasses an approach to art and design that examined the basic aspects of spatial and material form and attempted to relate to its intellectual and social environment. Whilst drawing on the abstract visual language that emerged from formalist aesthetic experiments, Constructivists saw themselves reflecting, and instigating, social change.

This opens up a problem in their work. On one hand the functional and material-based elements of design were emphasised, on the other this approach was to 'reflect' the new conditions. What emerges is a dialogue between the symbolic – the representation of the new – and the new itself. Perhaps this dilemma is best examined in the saga of Vladimir Tatlin's *Monument to the Third International* (Ill. 3.3). Tatlin was known for his 'Counter Reliefs'. These were three-dimensional, abstract pieces of intersecting planes and wires that projected from wall and corner spaces. The *Monument to the Third International* was Tatlin's first essay into making his aesthetic investigations socially tangible. The monument, planned to be taller than the Eiffel Tower, never got beyond the model stage, but it became a powerful symbol of modernity. It was to have three main functional spaces enclosed in glass. At the base of the structure a cuboid space was to be

Figure 3.2 El Lasar Lissitzky, *Proun*, 1923. Lithograph with collage. Collection, Art Gallery of Western Australia. © Lasar Lissitzky, 1923/Bild-Kunst. Reproduced by permission of VI$COPY Ltd, Sydney 1997.

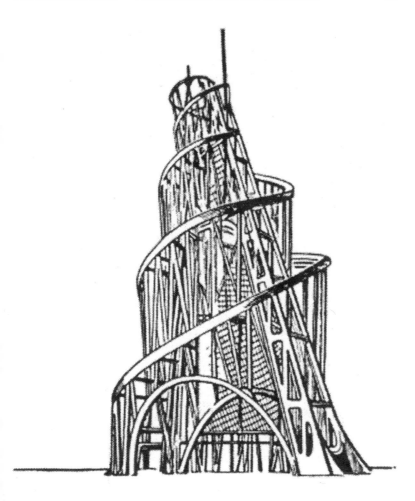

Figure 3.3 After Louis Losowick, *Tatlin's Monument to the Third International*, 1920. Woodcut.

used for 'conferences of the International and sessions of international congresses and of other large official assemblies'.[25] This enclosed space was to revolve around its axis yearly. The next space, an administrative centre, was to be pyramidical and revolve monthly. The final space, a cylindrical one, was to rotate daily, and was to act as 'an information bureau, a newspaper, offices for public proclamations, pamphlets, and manifestos − in short, all the various mass

media for the international proletariat, in particular telegraph, pro-
jectors for a big screen located on the axes of a spherical section, and
radio transmitters, whose masts rise above the monument'. In an
earlier description of the project Nikolai Punin also wrote; 'in
accordance with the latest invention, one part of the monument is
to be equipped with a projector station that can write letters in light in
the sky . . . with such letters, it would be possible to compose different
slogans in connection with current events'.[26]

It can be seen that this structure was not a modest undertaking. In
Tatlin's eyes it was a necessary counter to the individualism of
previous design in which the unity of the visual disciplines had been
eroded by artists and designers expressing 'purely personal habits and
tastes', in the process 'degrading' and 'distorting' material.[27] As we
have already seen, the Bolshevik revolution had provided a social
context for the new art forms of Modernist experiment. Tatlin saw
the industrial materials of iron and glass, 'the materials of modern
Classicism', as potentially 'uniting purely artistic forms with utilitar-
ian intentions'.

The technical specifications of the project were never fully realised.
It would have been impossible; just acquiring the raw materials would
have been beyond the technological capabilities of the young Soviet
state. The 'utilitarian intentions' of this vast symbolic structure were
in reality at odds with the feasibility of its construction. It remained a
potent symbol of the new technological utopian future to which the
Constructivists aspired, but it was riddled with contradictions as both
a symbolic structure and a functional one.

Leon Trotsky finally laid the scheme to rest in 1924 with a pertinent
analysis of its shortcomings.[28] Agreeing with the Constructivist
material and formal analysis presented by Tatlin, he then makes the
point that 'Tatlin has still to prove that he is right in what seems to be
his own personal invention' The monument lacked the simplicity and
lightness one would expect from a piece of industrially motivated
design, and the symbolic aspect seemed to outweigh its function:
'Meetings are not necessarily held in a cylinder and the cylinder does
not necessarily have to rotate.' Industrial forms had established their
own structural vocabulary and Tatlin's complex spiral structure had
more to do with 'expression' than anything else – the expression of
modernity, the expression of 'technology', the expression of monu-
mental triumphalism. The potency of this expressive form should not
be underestimated. A stylised elevation of the monument was pub-
lished as a poster, because of its popularity, and a photograph from

the 1926 Leningrad May Day Parade shows a simplified version of Tatlin's structure on the back of a float.

By the mid-1920s, whilst many architectural schemes remained on paper, architects like Grigory Barkin, Konstantin Melnikov and Moisei Ginsburg were producing the occasional building in Modernist style, like newspaper offices, workers' clubs and mass housing, funded by government money and with a defined social purpose (see Ills. 3.4 and 3.5). By now, Constructivism had become part of the International Modernist style. Groups in Poland, Hungary and Czechoslovakia published their own journals pursuing and developing the idea of Constructivism as a 'system of methodological collective work regulated by a conscious will' dependent upon 'the mechanisation of the means of labour' where the 'character of the created object' is directly related to the material used by the artist/designer.[29]

Holland escaped the debilitating physical trauma of the First World War that was to act as the catalyst for the Russian Revolution. It was Holland's neutrality that made it a vital cultural centre in the development of Modernist ideas. As the war started, those artists and writers studying abroad came home, and watched aghast as the industrialised war waged around them. I want to concentrate on the role that a small magazine, *De Stijl*, played in further developing ideas about the potential for a 'universal' art practice. In the last issue of *De Stijl* in 1932, the painter Piet Mondrian, referred to this period of isolation from the horrors of the European war:

> the depression and anguish of war extended inevitably there where no fighting occurred. In spite of everything, in Holland there still existed the possibility of being preoccupied with purely ethical questions. Thus art continued there and what is particularly remarkable, is that it was only possible for it to continue in the same way as before the war; that is to say moving towards an abstract expression.[30]

Mondrian can only speak for himself, but what is clear is a new concern about a universal form of visual expression – a moral, or even spiritual, imperative. There is a strongly perceived need for a universal visual language to assist the development of an integrated and rational society, and Mondrian's concerns were also those, to a greater or lesser degree, of the artists and designers associated with *De Stijl*.

The centre of *De Stijl*, both as a magazine and as an approach to art and design practice, was Theo van Doesburg. It was he who in 1915 contacted the artists and architects that were to be associated

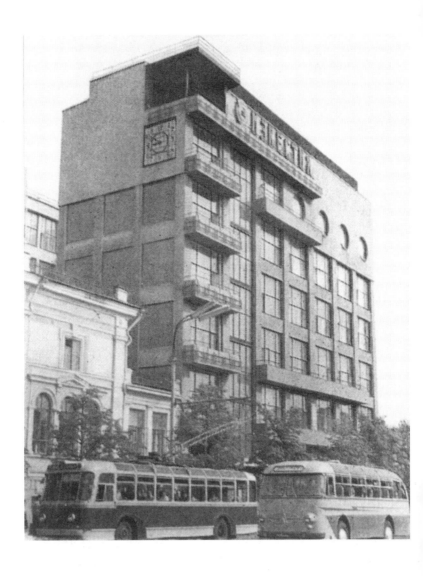

Figure 3.4 Izvestia Building, Moscow, 1925. Grigory Borisovich Barkin.

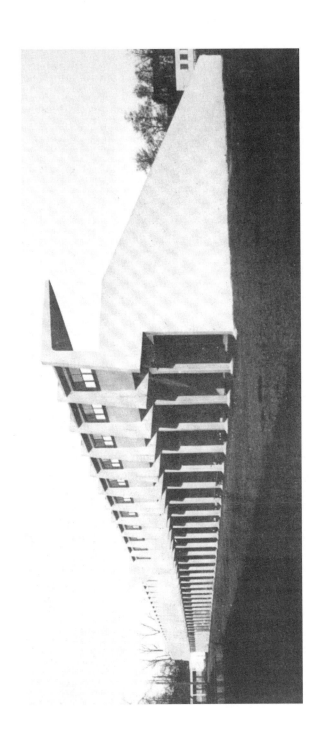

Figure 3.5 Red Sport International Stadium, Kharkov, c. 1928. A. Nicholsky, K. Kashin.

with *De Stijl*, most principally Mondrian, Bart van der Leck, Gerrit Rietveld and J. J. P. Oud. After 1921 the contributions to the magazine came from all over Europe as van Doesburg began to internationalise its content and extend its influence. Van Doesburg himself was tireless in travelling to Paris, Prague and Weimar in order to locate himself where he thought *De Stijl*'s influence might be most effective.

The artists and designers associated with *De Stijl* were never a unified group, but they adhered to a similar set of aesthetic and ideological principles. These principles are similar to other ideas about the 'correctness' of visual appearance that Modernists elsewhere were developing. The language of geometry was seen as totally appropriate to the new machine age, particularly the straight line and the rectangle. Designed objects from the smallest kitchen utensil to the largest building were to be without decoration. There was a leap of logic in their pursuit of rationality though. Machine-led production was seen as possessing a sort of clarity and purity of form. This idea, which by no means was exclusive to the artists and designers of *De Stijl*, ignored the fact that machines are not autonomous. The respect for the abstract notion of machine production is the reverse view of the disgust for machine production exemplified in nineteenth-century Britain. While both views oppose one another, both are similar in their location of machine production outside of the human. This approach of those associated with *De Stijl* is in part due to their idealised intellectualised view of the 'universal'.

The 'First Manifesto' published in *De Stijl* in 1918 talked of a 'new consciousness', of a 'balance between the universal and the individual'. If we go back to an earlier edition of *De Stijl* we can acquire a better understanding of what this balance might entail. In the first issue van Doesburg talked of artists serving a 'general principle far beyond the limitations of individuality'. The balance of the individual in relation to the universal was one of the individual working within a defined style: 'As soon as the artists in the various branches of plastic art will have realised that they must speak a universal language, they will no longer cling to their individuality with such anxiety.'[31]

The 'universal' then might be considered to be a renunciation of the 'wilfulness' of individuality, the opposite of the deliberate distancing of one person from another, and a conscious effort to submerge differences in a shared set of values and codes. In this particular instance, the universal attributes to which individuals should aspire were determined by the abstract rationality of the machine. A further

feeding of this notion of universality came from Mondrian's interest in theosophy, an attempt by Madame Blavatsky to unify the metaphysical and spiritual concerns of the global religions into one essential belief system. This needs to be seen in the same context as Professor Zamenhof's creation of Esperanto in 1888 as a universal language.

The universal values and attitudes that the envisaged machine-produced culture of the future were to bring were seen as socially liberating. The machine was to be both the producer and product of a new form of what van Doesburg called 'spiritual discipline'. This 'discipline' was the discipline of aesthetic order, of order within the built environment, a manufactured utopia in which the lack of nature was a positive thing. Man (once again we have a vision of the future which is masculine) 'will build cities, hygienic and beautiful . . . Then he will be quite as happy indoors as outdoors.'[32]

Oud's Kiefhoek housing estate in Rotterdam, built during the second half of the 1920s, gives us a glimpse of how the future was to be. Minimalist, undecorated industrial terraced housing stops short of bleakness because of Oud's skill in the placing of the barest details. The aesthetic effect is however wholly dependent upon an understanding of the discreet visual codes used. The estate's aesthetic coherence, and its continuing social success, is due to Oud's ideological commitment to what he was doing. These refined houses are the result of a search for a sophisticated, anonymous form in which the individual becomes part of a much grander 'universal' scheme. They are not industrialised units produced in order to house people cheaply. They are, to use Le Corbusier's[33] phrase, well-designed and well-produced 'machines for living in'.

Another key structure is Gerrit Rietveld's Schröder House, whose interlocking and intersecting horizontal and vertical planes articulate a dynamic exterior space, which may well reveal and articulate the interior space, but which primarily acts as a signifier of dynamic modernity. The house itself, whilst appearing to be made of reinforced concrete, is in fact rendered brick. As in Grigory Barkin's Izvestia building of 1925 in Moscow – whose rendered concrete geometric facade presents itself illusorily as a complete 'industrialised' unit – there is more than design function in these early Modernist buildings. Decades later this was often overlooked by architects. It is also worth reminding ourselves that large-scale buildings in the American cities which were using techniques and materials at the cutting edge of technology were continuing to dress the result in

traditional European styles. The importance and complexity of the relationship between style, technology and ideology cannot be under-estimated.

The Bauhaus is often seen as the paradigm of Modernist design. This is largely due to Nikolaus Pevsner's *Pioneers of Modern Design*,[34] first published in 1936 as *Pioneers of the Modern Movement*. This book is an important document because it locates the architect Walter Gropius, who was the Director of the Bauhaus from 1919 to 1928, as a key figure in the evolution of the Modern Movement. In the concluding chapter of his book Pevsner writes of Gropius as the archetypal Modernist. Pevsner presents a strange contradictory set of ideas about the universal and the individual, which is unsurprising when we look at the nature of the Bauhaus in the following pages. Pevsner's position is an unresolved one in which powerful individuals create a rational universal style. This style is presumably rooted in the logic of mechanised production, but is at the same time symbolic and expressive.

> The architect, to represent this century of ours, must be colder, cold to keep in command of mechanised production, cold to design for the satisfaction of anonymous clients . . . However genius will find its own way even in times of overpowering collective energy, even within the medium of this new style of the twentieth century which, because it is a genuine style as opposed to a passing fashion is universal . . . It is the creative energy of this world in which we live and work and which we want to master, a world of science and technology, of speed and danger, of hard struggles and no personal security, that is glorified in Gropius's architecture.[35]

There is nothing in this analysis that we have not already encoun-tered; the attempt to reconcile the act of individual creation within a universal style, the identification of technology as the central theme of the new century, and the dialogue between function and style. In retrospect we can see that this last dilemma was never fully rationa-lised as a problem. We have seen all these issues raised in a trans-European debate, and yet the Bauhaus is seen often as the cradle and focus of Modernism.

We have identified one reason for this view, the sanctification of Gropius by Pevsner in a book that is central to the study of this period. The other reason is to do with the central geographical position of Germany within Europe. Van Doesburg could visit Germany from the west with as much ease as those Soviet artists

like Kandinsky and El Lissitzky could from the east. Indeed, the change in ideas at the Bauhaus can be seen as reflecting the change in ideas about art and design across Europe. This historic coherence however does not make it unique. It is one reflection of a common set of the period's aesthetic and ideological concerns.

The Bauhaus was initially based in Weimar, founded in 1919 with an expressionistic manifesto image by Lyonel Feininger, *Cathedral*, that looks profoundly Gothic if we compare it to the images of Tatlin's tower. The Bauhaus's initial concerns were those of the Arts and Crafts traditions fed by the immediate German interest in Expressionism. (This ideology of the individual will be examined in more detail in the next chapter.) It was not until 1923, partly due to the politicising of van Doesburg in Weimar, that Gropius adopted the slogan 'Art and technology – a New Unity' and the school began to produce work that we would now consider to be typical of the institution. Wassily Kandinsky had joined the school direct from the Soviet VKhUTEMAS system, Herbert Bayer was responsible for typography, Marcel Breuer began to design chairs deeply influenced by De Stijl, and the Hungarian Constructivist László Moholy-Nagy took control of the basic course from the more spiritual Johannes Itten. Moholy-Nagy was a socialist, and saw socialism being bound up intimately with the machine; 'it is the machine that woke up the proletariat. In serving technology the worker discovered a changed world.' In Moholy-Nagy's eyes the machine was an absolute:

> Before the machine, everyone is equal – I can use it, so can you – it can crush me and the same can happen to you. There is no tradition in technology, no consciousness of class or standing. Everybody can be the machine's master or its slave.[36]

His teaching centred around a definition of Constructivism, which like the machine was without any historical lineage. It was pure form, direct colour and 'pure substance – not the property of one artist alone who drags along under the yoke of individualism'. This was a considerable development of the Bauhaus's original intention to unify the arts in one combined practice. It was also a move away from the founding manifesto's definition of the artist who 'in rare moments of inspiration, transcending the consciousness of his will, the grace of heaven may cause his work to blossom into art'.

In the same year as Moholy-Nagy's appointment, the institution was identified by right-wing nationalist politics in Weimar as a threat, and with the fall of the provincial socialist government that had

supported the institution, armed troops searched Gropius's home. By 1925 the Bauhaus had been closed down in Weimar for political reasons.

The school opened again under the patronage of the Dessau provincial government in 1925, and by 1926 the school was housed in a new complex in Modernist style, designed by Gropius. When the Soviet writer Ilya Ehrenburg visited the Bauhaus at this time, he wrote that it was 'the first time the world has seen a cult of unadorned reason'.[37] There was still much that was contradictory about the Bauhaus's approach to art and design education. Paul Klee's work was whimsical and spiritual, and even his *Pedagogical Sketchbooks*, published in 1925 under the auspices of the Bauhaus,[38] whilst it does struggle to define a set of basic visual laws, is as much about his highly personal insights into the nature of creativity. This ambivalent position with regard to a functional and rational approach to design and technology was further clarified with the appointment of the architect Hannes Meyer. His views that 'our communal consciousness will not tolerate any individual excesses', and that 'the community rules the individual'[39] can leave the reader in little doubt as to his cultural position.

It was Meyer who was nominated Gropius's successor on his resignation in 1928, and it was he who was responsible for the Bauhaus's involvement with exhibition design, and its closer links with local lighting and wallpaper industries, providing them with prototypes for production. That the production of wallpaper designs was the most tangible sign of the Bauhaus's institutional success after nearly ten years of existence is a sobering thought, for much of the Bauhaus's reputation is built upon the personal reputations and success of its staff.

The Bauhaus was an elite, avant-garde institution, despite its aspirations otherwise, but despite its lack of immediate importance in the commercial and industrial sphere of art and design practice, the school was, nevertheless a potent symbol of left-wing internationalist ideology as far as the increasingly powerful Nazi Party was concerned. Meyer was dismissed from his post at the end of 1930 and replaced by the more politically cautious Mies van der Rohe. Even this was not enough to save the institution which left Dessau in 1932, and opened briefly as a private art school in Berlin before it was finally raided and closed by the Nazi government in 1933.

What the Nazi Party objected to in the work of the Bauhaus was the institution's potency as a symbol of 'cultural bolshevism'. The

styling of its art and design was, ironically enough, the most important issue in this form of cultural criticism, because Nazi Germany was to be a ruthlessly collectivised and highly industrialised state, just as Stalin's Soviet Union was becoming. By 1929 Lunacharsky had resigned his post at Narkompros, dismayed at the reversal of the Leninist 'hands off' policy with regard to the arts. By the mid-1930s art and design in Germany and the Soviet Union, those initial powerhouses of the Modern Movement, was firmly in the control of the totalitarian governments of Adolf Hitler and Joseph Stalin.

Chapter 4

Individualism – The Expressive Voice and the Unconscious

In his writings in the decades after the Second World War, the American critic Clement Greenberg legitimised the ascendancy of American Abstract Expressionist painting through an argument which emphasised the formal, 'abstract' aspect of art-making at the expense of pictorial content. This was not only a consequence of the practices that we have examined in the previous chapter, but also a particular reading of them. We will be returning to his arguments in a following chapter, but it is a good example of how the interpretation of cultural history can be selective, and can often exclude many things which happen, simply by deciding that they are unimportant. In emphasising the development of the picture surface, of the use of colour and material, formalist critics like Greenberg do two things. They take early Modernist paintings out of their social and ideological context, and further neglect another aspect of Modernism, that of figuration and pictorial content. The figurative and narrative element in picture-making has become increasingly important in contemporary practice, and has its parallels with other aspects of contemporary design practice, where visual signs are often used to convey much information about the role of the object. We need to understand the evolution of these sets of ideas, and be able to locate them culturally.

Whilst those artists at the turn of the century who adopted technology as their theme for cultural practice were struggling to find a collective voice, using an increasingly abstract visual language, there were other artists who were also breaking with traditional forms of representation. They, however, were using figuration and were drawing from the cultural tradition of Romanticism – the struggle of the individual against an alienating and unsympathetic world. This idea, one of the key perceptions of the human condition, was being

given increased credibility because of the alienating processes of industrialisation, and was being further legitimised intellectually by the writings of the philosopher Friedrich Nietzsche and the psychoanalyst Sigmund Freud. In their different ways these two men believed in the idea of 'inner essence'. They believed that some form of essential quality of the individual's existence could be identified. Nietzsche's main influence upon the intelligentsia was through his book *Thus Spake Zarathustra*[1] in which he expounded in complex and poetic imagery a set of ideas that encouraged the individual, liberated from past religious codes by the Enlightenment, to transcend 'his' environment through acts of supreme spiritual self-determination. It is from Nietzsche that we have the idea of the 'Superman'.[2] In *Beyond Good and Evil* he presented what he called a 'fundamental thought', 'we must make the future the standard of our valuations – and not seek the laws for our conduct behind us'.[3] This idea should not take us by surprise, as we have already been introduced to this common theme of the new century. What was different about Nietzsche was the quasi-mystical, visionary nature of his writings, a quality which was highly valued by the German Expressionists.

Freud's influence operated on a different level. He provided a codified way of approaching obsession and trauma. He proposed that sex and aggression were the driving forces of all human beings, and that a conflict was set up in every individual between their wants and their need for them to be sublimated to satisfy social convention. In effect, he suggested that everybody is potentially suppressed and oppressed by their environment. He also proposed the idea of the 'unconscious'. As he defined it, society's task was to take a primitive creature, driven by sex and aggression, and socialise it. All the thoughts and emotions that are associated with these primal instincts are therefore suppressed during the course of development, become accepted as forbidden, and become part of the unconscious. The individual is then split between what he or she 'is' and how they have to cope with external reality. This analysis also implied that 'creativity', like 'personality', is locked within the individual and given the right conditions could be opened up. Freud published his *Interpretation of Dreams* in 1900, and was to exert an enormous influence over the Surrealists.

It should be clear that we are looking at ways of responding to the world which emphasis the individual, and his or her subjective response to it. The Symbolist movement in France at the end of the nineteenth century is a good example of this form of subjectivity. At

first a literary movement, the symbolists rejected the objective social realism found in the novels of the period, by authors such as Emile Zola, and retreated from the objective representation of social relationships into an intimate world of feeling and sensation. The Symbolist manifesto was written by Jean Moreas in 1886. Moreas was part of the circle of poets and writers associated with Stephane Mallarmé. Mallarmé's analysis of Europe's new conditions was the same as that of most other observers – new material events had caused a rupture in aesthetic practices, the benefit being that the individual was now able to develop his or her own forms and means of communication. Mallarmé, like Nietzsche, was a lover of metaphor and allegory and illustrated this point ornately:

> for the first time in the course of the literary history of a people, in rivalry to the great organs of past centuries where orthodoxy is exalted in accordance with a hidden keyboard, anyone with his individual execution and hearing can make himself an instrument.[4]

In association with this rejection of past aesthetic structures and a highly complex metaphorical and allegorical language came the ideas expressed in J. K. Huysmans' highly influential novel *A Rebours*, published in 1884. The hero of this novel, Des Esseintes, was a neurotic aesthete of aristocratic lineage who escaped the 'vulgarity' of the world by retreating into a solitary fantasy fuelled by money and a 'decadent' imagination. Thus the individual built a conceptual 'world' that was shared with others only after its construction by that individual. It was not a 'world' constructed collaboratively through, and by, negotiation with others.

Literary Symbolism can be seen as the work of alienated individuals, engaging with the real world only to use its objects and images as a source for their own vivid imaginary alternatives. The adoption of this literary attitude by visual artists changed nothing of its ideological positioning, and this stance is probably best expressed by the critic G. A. Aurier. In his 'Essay on a New Method of Criticism', Aurier took on the challenge presented to an idealist, spiritual view of the world by the 'bastards of science' – the natural sciences. Pure mathematics, because of the clarity of its intrinsic logic, because of its reliance upon abstraction and pure idea, was considered to be superior in comparison with those applied sciences which provided a practical analysis and pragmatic control over the material world. Aurier saw art's role proposing an alternative to what some saw as the banality of philosophic materialism:

It is mysticism that we need today, and it is mysticism alone that can save our society from brutalisation, sensualism and utilitarianism. The most noble faculties of our soul are in the process of atrophying. In a hundred years we shall be brutes whose only ideal will be the easy appeasement of bodily functions; by means of positive science we shall have returned to animality, pure and simple. We must react. We must recultivate in ourselves the superior qualities of the soul. We must become mystics again.[5]

We have to rely upon all sorts of received knowledge of complex cultural assumptions to make sense of this passage. What is a 'soul', for instance? What are its most noble qualities? Because in the above passage there is the suggestion that it has a number. There is also the problem of the soul atrophying. This suggests that the soul is subject to the laws of the material world. How can this be? Are we in fact seeing the soul used a *metaphor* for another way of looking at the world and valuing our response to it? The last observation makes the most sense, but time and time again artists, designers and their critics will talk about the soul as if it is a tangible thing and an absolute in their audience's understanding.

The painter Maurice Denis presents us with this idea in its purest and barely comprehensible form: 'All the feeling of a work of art comes unconsciously, or nearly so, from the state of the artist's soul.'[6] Like all idealist positions, this argument can only be understood by those willing to make the necessary leap into the internal logic of a belief system in order to comprehend it. This is reinforced by the painter Odilon Redon's remark that his works '*inspire* and do not offer explanations. They resolve nothing. They place us, just as music does, in the ambiguous world of the indeterminate.'[7]

It is clear that formal ideas about mystery, or mysteriousness, about ambiguity and the lack of resolution, were part of the vocabulary that the Symbolist painters used to induce a contemplative and 'spiritual' view of the world. It is almost as if the spiritual was seen as synonymous with the unknown. It is certainly the case that painters like Denis and Redon created a visual analogue of the world which was fundamentally rooted in a traditional means of representation, but which was taken to a point of dissolution, and thus disconnected subtlety from the viewer's expectations. This process took place both at the level of the formal construction of the picture and in terms of its content. Denis used large decorative and colour surfaces in his work. Redon populated his ambiguous pictorial spaces with images of equally ambiguous humans.

Paul Gauguin felt obliged to leave Europe and travel to the 'primitive' culture of Polynesia where everything was to his European eyes 'naked and primordial'.[8] He did this to try and discover another pictorial language that was more appropriate to his desire to express himself in an individual way to immerse himself in a culture that was seen (ideologically) as less complicated, and so closer to fundamental human truths. He, like Aurier who was a great advocate of Gauguin's work, felt that

> Art has gone through a long period of aberration caused by physics, chemistry, mechanics and the study of nature. Artists having lost all of their savagery, having no more instincts, one could even say imagination, went astray on every path, looking for productive elements which they did not have enough strength to create.[9]

His perception of the Polynesian culture as 'savage', 'barbaric' and 'exotic'[10] tells us a lot about his ideological preconceptions and little about the Polynesian culture. What he appreciated in this culture was its non-industrial way of perceiving the world and of using their observations of it to create a decorative art of great sophistication. It is also the case that he relished the shock value that such art had in Europe: 'There is not the pettiest official's wife who would not exclaim at the sight of it, "It's horrible! It's savagery!" Savagery! Their mouths are full of it.'[11]

The imagery of confrontation came largely from the personal worlds of artists who were examining their personal torments, or seeing those troubles reflected in the world around them. Edvard Munch used both sources: 'A work of art can come only from the interior of man', and 'Nature is not only what is visible to the eye, it also shows the inner images of the soul, the images on the back side of the eyes.'[12] James Ensor also relished the deliberately unaesthetic in his search for a highly charged personal voice: 'Reason is the enemy of art . . . Fault eludes convention and banal perfections. Therefore fault is multiple, it is life, it reflects the personality of the artist and his character; it is human, it is everything, it will redeem the work.'[13]

What was new, and what was most confrontational in Symbolism and which broke with the (all but moribund) academic artistic tradition was the choice of imagery. It was the imagery of a world posed as both alternative to the industrial reality, and a reflection of its alienating horrors. Metaphorical images were chosen for their ability to convey states of mind. However, despite the relative ease by which these images can be read, Nikolaus Pevsner argues their

importance to the development of Modernism because of their formal and structural innovations. He sees the pictorial work as a move towards an unbroken flat surface, where intense colour and rudimentary shape and form create compositions that have an increasingly abstract significance.[14] This may be the case, but to reduce such complex imagery to a set of formal considerations, as Greenberg was later to do, ignores its aesthetic and ideological context. It is this social location of the Modernist dialogue between the individual and universal, between *what* is being said and *how* it is being said, that makes Expressionism such an important part of twentieth-century art and design. For the sake of clarity I have divided the work of the early Modernists into two areas, the objective and collective response to industrialisation, and the individual subjective response. As we look more closely at the work of the Expressionists, the Dadaists and the Surrealists, we shall see that these views, which I have set up as oppositional, are in fact often intertwined.

Expressionism was part of that move away from naturalism and academism that took place at the turn of the century. Even Impressionism, which was so disruptive to the established means of describing the world pictorially, was concerned with recording it in a 'naturalistic' way. In 1905 in Dresden Die Brücke was founded. Die Brücke was a loosely associated group of artists, most notable among them Emil Nolde and Karl Schmidt-Rottluff, informally led by Ludwig Kirchner. These painters were interested in the intense colouration and structural innovations of painters like Henri Matisse and the Fauves. Nietzsche was a great influence on the artists of Die Brücke, and another idealist philosopher, Henri Bergson, was to influence those artists sympathetic to the Expressionists with his talk of intuition as the driving force behind creativity. He thought that only intuition was able to grasp the inner nature, or 'inner essence', of objects.

This sort of painting was more about the emotional life of the artist than the result of naturalistic observation. Nolde, who was much older than the other artists in Die Brücke and who left the group in 1907, was an artist who was very interested in the idea of a healthy, 'uncorrupted' art, and like Gaugin was interested in the imagery of non-industrialised cultures, visiting New Guinea, but prizing above all the art of Gothic Germany. He was not alone in this identification of the Gothic as a source for a new art practice. It had been a major influence upon the ideas of the Arts and Crafts practitioners in England as we have seen, and the Russian anarchist Peter Kropotkin

had also been influenced by received ideas about Gothic egalitarianism. The writer Wilhelm Worringer, in his enormously influential books *Abstraction and Empathy* (1908) and *Form in Gothic* (1911), proposed that it was an art of instinctual expression in which the opposites of the rational and the emotional were held in a dynamic balance. But there was also a nationalistic element in the German understanding of the Gothic as representing the German essence, and this was very strong in Nolde's particular case. He was anti-Semitic and joined the German Nazi Party, although later his work was amongst other art labelled 'degenerate' and banned. Not all artists and artistic ideas necessarily conform to our ideological notion of the arts as always being on the 'good' side.

In 1910 in Berlin, Herwath Walden founded Der Sturm (The Storm) gallery and newspaper. It is he that is credited with the coining of the term 'Expressionism', and it was under his custodianship that it became a label encompassing a particular German approach to art production, one that was emotional, intuitive and in opposition to a southern European or Latin tradition. In 1912 the artists of Die Brücke moved from Dresden to Berlin, reinforcing the importance of Berlin as a cultural centre for these new ideas. The other artistic group that was to be associated with Der Sturm gallery were those of the Blau Reiter.

The Blau Reiter was Munich-based, and was the name given to two exhibitions in 1911 and 1912, and a book, the *Blau Reiter Almanac,* (published in 1912). It was not a formal grouping of artists, but three painters, Wassily Kandinsky, Alexei Jawlensky and Franz Marc working in loose association. These three artists used the name Blau Reiter as an umbrella for their cultural activities. Because of their base in southern Germany, and perhaps because Kandinsky and Jawlensky were Russians and already cosmopolitans by their transnational study and practice, these artists were more open to the ideas that were criss-crossing Europe than the Expressionists of northern Germany. Kandinsky's programme was one of attempting to unify the rational with irrational aspects of art, linking learned skills with intuition (Ill. 4.1). With his associates he was struggling for a form that could express through the physical, an insight into the 'internal necessity'[15] of the artist. Because of Kandinsky's esoteric views it is difficult to discuss precisely what Kandinsky was arguing for, but it is possible to peek around the edges of his mysticism.

Colour was the first route by which universal and intuitive means of communication could express the 'spirit of the time'. According to

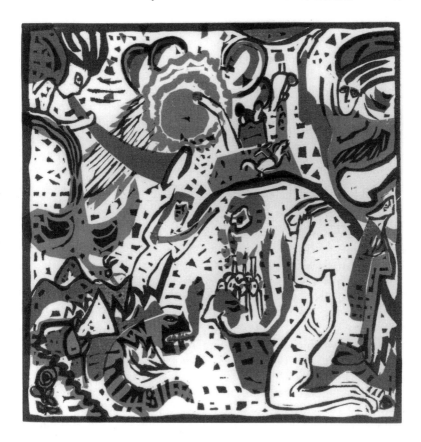

Figure 4.1 Wassily Kandinsky, *The Great Resurrection*, 1911. Woodcut.
Collection, Art Gallery of Western Australia. © Wassily
Kandinsky, 1911/ADAGP. Reproduced by permission of
VI$COPY Ltd, Sydney 1997.

Kandinsky paintings were to be produced that were to elicit the
response from the audience, 'Which of his inner desires has the artist
expressed here?' Colour was to be given its autonomy in the process
of image-making, as was form – by doing this, freeing these processes
from imitating the world, the universal intuitive nature of the artist
was to spontaneously emerge. It is this process of freeing form and
colour from representation that Pevsner defines as so important. This
mystical, non-representational view was to have great influence on

later painters. (American painting in the 1950s was a refinement of this position.)

Kandinsky's argument is based on the premise that everyone has an 'inner force'. Individuals are part of a wider universal force because 'the world resounds. It is a cosmos of spiritually acting beings.' These words only make sense if one is prepared to immerse oneself in the value system from whence they emerged. As such, one either agrees or disagrees with him. What is of more interest to our debate is his attempt to establish a universal pictorial language. However, unlike the formal geometry of other Modernists (though later in life he was to adopt a geometrical visual language), he uses forms that are organic in origin, struggling to find and create 'new and infinitely manifold forms'. He also argued that because of the universal codes of artistic expression, the visual arts should combine with the other arts in creating a total art work, the *Gesamtkunstwerk*. In such a work the languages of music, colour, sound and form should combine in the stimulation of universal emotional reactions. The purpose of this universal language was to prepare society for 'that which is coming'. Presumably he identified that which was coming as a world of spiritual unification similar to the ideas of Madame Blavatsky's theosophy, of which he, like Mondrian, was a strong advocate.

Architecture was as influenced by Expressionist ideas as painting during this period. In 1913, late in his eccentric career, Paul Scheerbart published a book called *Glass Architecture*, the ideas of which were picked by the circle around Der Sturm, particularly the architect Bruno Taut. Glass was to acquire an association with the spiritual. Its qualities were seen to counterbalance those of iron and steel. This goes beyond the formal juxtaposition of materials and the exploitation of physical attributes of materials. Glass was being used symbolically, as a transmitter of light both literally and metaphorically. It was a material that echoed the contemporary use in much contemporary Expressionist literature of the crystal as a symbol for spiritual knowledge and enlightenment.

In the turbulent period after the First World War in Germany, Expressionist architects were as keen to provide the new times with new forms as any of the previous individuals we have discussed. Their proposed language was not based on geometry and the pursuit of the rational thought. Architecture, unsurprisingly perhaps, was seen by these architects as the dominant and unifying art form of the new times. The forms they presented in manifestos and drawings were crystalline, or organic, often enormous in scale to a point of

structural absurdity. It was a kind of visionary architecture. These buildings were never going to be built, rather they were presented as a form of cultural polemic. Many Expressionist architects came from a utopian socialist ideology, and their buildings were conceived on a vast and monumental scale. The buildings that were actually constructed were much smaller than the grandiose paper plans. Bruno Taut's Glass Pavilion at the Deutscher Werkbund Exhibition of 1914 was the size of a decent restaurant. When built, Eric Mendelsohn's Einstein Tower Observatory of 1921 lacked the ambivalent sense of scale of the initial drawings and remained an earthbound, moulded concrete structure.

Perhaps the most grand in scale of the German Expressionist buildings was the Grosses Schauspeilhaus, a Berlin theatre seating 3000. This was designed and built under Hans Poelzig's direction in 1919. It was a restyling of an existing space and structure rather than a complete rebuild. Its function is important, for we see a designer creating an interior that was to lead to the suspension of disbelief, a space that was illusionistic, rather than prosaically literal as much Modern Movement architecture was. The design and coloration of the building's interior was deliberately created to encourage a sense of awe and emotional stimulation, in the same way that the medieval cathedral was designed to create an emotional environment for the worshipper. The auditorium space was hung with tiers of hanging plaster forms resembling stalactites. They could be lit in a number of ways increasing the atmospheric qualities of the space. It was seen by contemporary critics as a truly 'German' and 'Gothic' building.

Poelzig was an advocate of an expressive architecture: 'What after all is architecture all about? Surely it is about form, indeed about symbolic form.'[16] He argued that the functionalism of much Modern Movement architecture was unable to become expressive because of its reliance upon technology and its logic. Technology was to Poelzig an extension of nature. To develop technology as the base for design was to extend nature, but nature could never be art. He was for an architecture that was able to 'transcend the demands of technology and economics'.[17]

As we have seen in the examination of Tatlin's Tower, the ascribing of rational values to *all* of the designs and artefacts of the Modern Movement is erroneous. Many designers were as interested in creating a metaphorical visual language to convey the new times as were the Expressionists. Equally there were as many utopian socialists in the expressionist architectural circles as there were in the Modern

Movement. Indeed many members of the two groups belonged to the same associations, the Arbeitsrat für Kunst and the Novembergruppe. These were broad-based, left-orientated organisations who promulgated avant-garde ideas in the visual arts. By the mid-1920s, the ideas of Expressionism had become well-established in painting, and were to acquire a new political intensity as the Nazi Party increased its power in Germany. In architecture though, Expressionist ideas were too fantastic to be put into operation on any large scale. The ideas of Paul Scheerbart identified and developed by Expressionist architects were divorced from an objective reading of social reality. To read now of glass architecture as a vehicle by which individuals will love 'the infinite universe of which every being is a tiny part', and which would eliminate 'all harshness from the Europeans and replace it with tenderness, beauty and candour'[18], is to marvel at the naive idealism of those designers who saw the future of a socialist Germany built exclusively through art and architecture which were, in their view, 'surely the crystallised expression of man's noblest thoughts of his ardour, his human nature, his faith, his religion!'

Another group of artists concerned with the autonomy of the individual, but less interested in the quest for a coherent universal language, and more interested in exposing the function of traditional visual language as a gag, were the Dadaists. Dadaism was a short-lived movement, partly because it was not a movement at all but rather an attitude of mind and a cultural activity determined by the circumstances of the First World War. Dada was named in Zurich, but it was an activity that was not confined to one place. It had many forms, but what all the manifestations of this particular way of thinking had in common was a distaste for established cultural structures, and a use of forms that was deliberately antagonistic to mainstream thought.

The beginnings of Dada, like Expressionism, came from a belief in the ability of the individual to interpret, transcend and modify the world around the artist. It was a movement that had little bearing on object design, other than to use machines as a potent symbol of dysfunction and absurdity. It was to make profound and lasting impressions on typography however, in its innovative use of type as a conveyer of more than just the meaning of the word it expressed. I shall be looking at typography in more detail in a later chapter.

Without exception the first practitioners of Dada were intellectuals disaffected by the obscenity of the First World War. Its first manifestations were through a pair of artists in voluntary exile in New

York, Marcel Duchamp and Francis Picabia, and a similar group of young poets and painters gathered around the poet Hugo Ball in Zurich, a haven for those disaffected by the European war which included Vladimir Lenin.

Duchamp left for New York in 1915 to escape the war in Europe. Duchamp travelled via Paris. Picabia arrived in New York in 1915 via Cuba. Picabia already had a considerable reputation as a painter, and teamed up with Duchamp who on arrival in New York had been lionised by the city's avant-garde community. His reputation had been established by *Nude Descending a Staircase* shown at the Armory Show in 1913. (This show was the means by which mainstream America was introduced to Abstraction in painting.) Picabia abandoned the painterly styles of his early career and under the influence of Duchamp produced a series of ironic and dry illustrations of mechanical parts. In New York, Duchamp continued to make the ready-mades – found objects such as bottle racks and the (in)famous signed urinal, which had caused so much fuss in Paris. Positioned in an art gallery environment, these objects had the potential to throw light on the relationship between the individual artist and the object that he or she produced, and the relationship between ideas of the aesthetic and the mass-produced object. These objects were interrogative, and whilst they are seen as part of the general shock tactics of the period, they must also be seen as part of Duchamp's examination of meaning and content in art. In New York he continued to work on his *Large Glass. The Bride Stripped Bare By Her Bachelors, Even.*

This work was not made for a public. In Paris he had taken employment as a librarian to free him from the financial burden of producing art for an economic reason, so that he could concentrate on his *Large Glass*. It was a work almost entirely operating within a closed, self-referential system of meaning, in which a common human experience – sexual, emotional and social bonding – is translated into a closed, complex, and mechanised symbolic ritual. In a retrospective set of notes about the work Duchamp wrote, deliberately obscurely:

> The bride, at her base, is a reservoir of love gasoline. (Or timid power.) This timid power, distributed to the motor with quite feeble cylinders, in contact with the sparks of her constant life (desire magneto) explodes and makes this virgin blossom who has attained her desire.[19]

It is an entirely self-contained and self-sufficient work in which even the standard unit of measurement within the piece, *stoppage-étalons*,

was entirely of his own devising. It is in essence an act of supreme and wilful individuality in which the utterly nonsensical is achieved not through stupidity, but through diligent study. The *Large Glass* is a work which we can locate historically because of its similarity in its use of mechanised forms to other paintings of the period. The use of glass has links, albeit tenuous, with aspects of Expressionism and the Modern Movement. But what makes it important is the role that this work had in taking art away from the physical, and placing it in the realm of the purely intellectual, at the same time creating a profoundly unsettling and disruptive practice. It was quite a different approach to those Modern Movement practitioners who wanted to take art-making away from the intellectual realm and back into the material world, using aesthetic experiment as a template for a design practice. Duchamp considered Dada as an extreme protest against the physicality of painting with its emphasis upon materials and mark-making. It was also an attempt to free the individual from his or her physical and cultural environment – in effect to deprogramme the individual.

It was in Zurich that Dada was born as a group activity. The German poets Hugo Ball and Emmy Hennings formed the Cabaret Voltaire in 1916. This was an avant garde variety show in which other voluntary exiles such as the poet Tristan Tzara, the writer and painter Jean Arp, the Zurich artist Sophie Tauber and the writer Richard Huelsenbeck performed outrageous theatrical events, some self-devised, others drawing on the material of Apollinaire and Marinetti. At the Galerie Dada they exhibited their own work and mounted exhibitions of other artists' work that they saw breaking down the false logic of the mechanised world – artists such as Picasso, Picabia, and Kandinsky. Zurich Dada was eclectic, anti-rationalistic, and vocal in its protestations about the oppressive mindsets it saw the ideas of the industrialised world imposing on society. It used chaos, disorder and contradiction to deny the idea of a coherent and stable contemporary culture.

It had no manifesto until 1918 when Tzara wrote the *Dada Manifesto*.[20] This was no usual manifesto; it was an explanation rather than a programme of action, an analysis rather than an agenda. Tzara also spoke as an individual rather than as the mouthpiece of a group. His ideas, and by association the ideas of Dada, ran parallel to those of all the avant-gardes of the period. That is, the past needed to be swept away and a new world created. He spoke of the need to destroy, and in doing so to clean society of its obsession with

aggressive madness. To him Dada was the abolition of all controls on the individual.

The links with Futurism are obvious here, in Dada's will to lose the past, in its desire for a new world. The two sets of ideas differ though in the Dadaists' lack of interest in technology, their view of the war as despicable, and their interest in the seemingly random nature of 'meaning' or 'information' generated by the material world, as opposed to the focused dynamism of the mechanical world. In this respect they can be seen to be sharing ideas parallel to those of Expressionism. Arp was particularly interested in the relationship of man with nature. He identified Dada's urge to destroy as a destruction of ideological unreasonableness. In arguing for the senseless he did not promote the idea of nonsense, but rather the seemingly random and chance-like occurrences of the natural world, which when complete have a sense of undefinable 'correctness'.

The figures of Zurich Dada were largely central European so it should be no surprise that German cities saw regional variations of Dada by the end of the First World War. In Cologne there was Max Ernst and in Hanover Kurt Schwitters. These were relatively isolated cities however and the German centre for Dada was in Berlin where it had a completely different complexion to Zurich.

When Huelsenbeck returned to Berlin in 1917 he returned to a city weakened by war in which the ideas of Expressionism were seen by the intelligentsia as a form of metaphysical salvation for Germany's war-weary culture. As far as Huelsenbeck was concerned, Expressionism had ceased to be a radical style and had retreated into a romantic historicism, a style for people who preferred their 'armchair to the noise of the street'.[21] The old Dada that said in Zurich 'Dada means nothing' was also inadequate for the new conditions that Berlin found itself in. In association with Raoul Hausmann, Hannah Höch, John Heartfield and George Grosz, Huelsenbeck allied the energy of Dada with the Communist movement in Germany. Hausmann, Höch and Heartfield used photomontage. This was a version of collage in which the symbolic and iconic elements of visual information were used in order to convey information. It is this aspect which distinguishes it from collage, in which found materials in the hands of Schwitters and Picasso were used for their intrinsic aesthetic (or non-aesthetic) qualities. Höch saw the role of the Dada photomonteur to give the unreal all the appearances and qualities of the photographed. It enabled a complex play of meaning to take place, as decontextualised images found a new environment in which

to gain fresh interpretations. In *Cut with the Kitchen Knife*, Höch relocated domestic imagery into a political context, and kitchen implements from sales catalogues become a commentary on domestic life other than just illustrations of commodities. This aspect of Dada picture-making had gone beyond the provocative anarchy and disorder of Zurich Dada and into the realm of constructing meaning.

Photomontage was used by the Berlin Dadaists as a means to communicate didactically as well as to illustrate fantasy. Heartfield particularly used photomontage as a political tool for the German Communist Party. There may appear to be a contradiction in this position, a group of intellectuals, concerned with the emancipation of the individual allying themselves to the Communist Party. We need to remember though that during this period the Communist Parties had not yet been deformed by Stalinism and still held to the theoretical Marxist principle that the aim of revolutionary activity was the eventual withering away of the state. Even so, the Dadaists delighted in tormenting even their Communist allies, turning up to political rallies and conferences dressed as dandies and wearing monocles.

The many voices of German Dada were brought together at the Dada-Messe in June 1920. It was a show in which the internal contradictions of Dada were exposed. Exhibited with a pig-faced Prussian officer suspended from the ceiling of the gallery, was a placard proclaiming 'Art is dead! Long live the new machine art of Tatlin', and a number of paintings by Otto Dix of war cripples. It was clear that the agenda of shock tactics instigated in Zurich had acquired another item in Berlin, that of political and social comment, and this political and social commentary was generating a visual language of its own. What five years previously had been a collection of individuals in revolt against a corrupt system had become an increasingly reasoned political critique. The Dadaism that had been entirely oppositional (and was to continue to be for a number of years), the Dada that 'had no fixed idea', changed in Berlin into something else, a Dada that fought 'on the side of the revolutionary proletariat'. As Heartfield was later to observe, the revolutionary proletariat 'probably did not notice much about or think much of these comrades in arms'.[22] However the German state did not approve and increasingly banned political magazines to which these radicalised artists contributed.

Tzara went to Paris in 1919 intent on continuing the Dadaist programme there. André Breton had founded the journal *Littérature* in the same year, and although there were links in the attitudes of the

avant-garde literary circles of Paris with those of Dada, a new development in ideas about the individual and his or her 'essence' was taking place. In Paris, the Dadaists, under the tutelage of Tzara and Picabia abandoned the experimental aesthetic activities that had taken place at the Cabaret Voltaire in Zurich, and concentrated on generalised acts of derision and provocation. This was at odds with the circle that was developing around Breton. This circle was largely literary and had been experimenting with automatic writing. There seemed to be little in common between Tzara's and Picabia's increasingly buffoonish activities and the activities of the *Littérature* group who were trying to develop a new approach to the making and interpretation of content in art. As Dada became increasingly negative, those investigating the possibility of a new positive language became increasingly proactive. This new form of expression became known as Surrealism.

The Surrealist movement was founded in 1924 when Breton issued his Surrealist Manifesto. This was a long manifesto in which Breton reexamined the ideas of Freud and applied them to the creative process. The name 'Surrealism' came from the pen of the poet Apollinaire, but the definition of it was Breton's. It was, in his words, a form of 'psychic automatism in its pure state, by which one proposes to express – verbally, by means of the written word, or in any other manner – the actual functioning of thought'.[23] Not only was this process a negation of traditional cultural forms of expression, it was also amoral, 'dictated by thought, in the absence of any control recognised by reason, exempt from any aesthetic or moral concern'.

In this rejection of social values, both ethical and formal, Surrealism can be seen as being in pursuit of the total liberation of the individual essence. Freud taught that the unconscious was something that was repressed in order that the individual could cope socially. Breton reinterpreted this, and placed the emphasis upon the unconsciousness's role in explaining to us precisely what it is we are. His view was that under the 'reign of logic' contemporary culture had banished an important part of the way in which we understood ourselves. In 'the depths of our minds' were 'strange forces capable of augmenting those on the surface'. These 'forces' were as real as the conscious mind and could lead to an investigation of the world that was totally new. The task of the Surrealist was first to 'seize' these ideas, and then if it was considered necessary, to submit them to the control of reason.

According to Freud the unconscious revealed itself in the form of dreams, and Breton and his circle wished to understand that mechanism, and to place it under control. It is at this point that the contradiction of Surrealism as a study of the individual becomes clear. In articulating the individual's dreams, they become shared, they become communal, and the notion of essence becomes one not of the individual but of the group or the collective. We are back into the struggle of the relationship of the individual with the universal.

Much of Surrealist art was based on the illogicality of dreams, and exploited the idea of the nineteenth-century poet Lautréamont's image of the chance encounter of the umbrella and the sewing machine on an operating table. This technique of combining disparate information in unusual combinations led to the production of imagery that was both playful and exploitative of the contradictions and confusions of meaning that this method produced. However, the theory behind the production of these images was seen in the early stages of the Surrealist movement as being far more significant than the images themselves. The journal *La Révolution Surréaliste* was a quasi-scientific journal, austere and full of the language of science. This may appear to be a strange combination, an interest in the uncontrollable and the constraints of scientific language, but Breton was convinced that Surrealism was more than a vehicle for artistic individuals, and was in fact the basis for cultural revolution.

Breton developed a relationship with Leon Trotsky, the Bolshevik theorist and colleague of Lenin, who had left the Soviet Union and the dictatorship of Stalin. His ideas led Breton to become increasingly disappointed with the use of the techniques of Surrealism for purely aesthetic and individualistic reasons. The painters of the Surrealist movement were largely apolitical (although individuals were caught up in political circumstances) and were more concerned with using Surrealist techniques to help articulate their emotional and aesthetic position. Joan Miró, René Magritte, Salvador Dali and Max Ernst all became distanced from the Surrealist movement as envisaged by Breton in 'The Second Surrealist Manifesto' of 1929.

This manifesto allied Surrealism to the Communist movement (which was never quite sure whether it *really* wanted it or not), and debated publicly the problems of their 'alliance'. Breton wanted the Surrealist movement to 'make for itself a tenet of total revolt, complete insubordination, of sabotage according to rule'.[24] This was a substantial development of the ideas still being pursued five years later by painters like Ernst who wrote:

Since it is well known that every normal person (and not only the 'artist') carries in his subconscious an inexhaustible supply of buried pictures, it is a matter of courage or of liberating methods (such as 'automatic writing') to bring to light from expeditions into the unconscious unforged (uncoloured by control) objects (pictures) whose union one can describe as irrational perception or poetic objectivity, after Paul Eluard's definition: 'Poetic objectivity consists only in the union of all subjective elements whose slave – and not, so far, master – is the poet.'[25]

To Breton the Surrealist revolution was total and not just allied to the arts. The movement continued in an *ad hoc* way into the 1930s, and like all aspects of the Modern Movement in the visual arts had its international adherents, but by the time the Second World War had broken out, and the main body of Surrealists had moved to New York, its importance as a coherent group had gone. However, its influence upon American art was substantial for it is in the work of the American Abstract Expressionists immediately after the Second World War that we see the relationship between the individual and the universal at its most contradictory, or perhaps at its clearest! The Surrealists' radical agenda of social disruption was to some extent modified by the painters of the New York School – they were struggling amongst other things for a pictorial language that was somehow an expression of the essential self. Jackson Pollock, for example, talked about his need to 'express' his feelings rather than 'illustrate' them. But it should not be forgotten in the following brief examination of this American notion of 'expression' and 'consciousness' that the form of painting adopted by the Abstract Expressionists, emerging as it did from the Surrealists' investigations into the depiction of the unconscious, was still seen in some quarters as a radical political act. The painters of the New York School were seen by many in the American political establishment as 'un-American' and 'Communistic'.[26]

In his second manifesto, Breton had called for the creation of a 'modern myth'. It was the Surrealist interest in myth as a way of reconciling the individual to a wider conception of what it is to be human that prompted the American avant garde to paint in a way in which personal obsession and 'universal' myth were combined on the one canvas. In a world perceived as on the brink of chaos (for we must remember that the terrors of the Nazi death camps and the atrocities of the Second World War were seen as nothing to the potential horror of atomic war) painters used 'universal' symbols in an attempt to represent personal angst, and thus imbue it with a wider

significance. It was thought that art needed to say something other
than about itself, its processes and internal logic (although the critical
voice that was to dominate during this period – Clement Greenberg's
– was to argue otherwise). The old pictorial languages were con-
sidered tainted and useless. Expressionism was seen to be as ex-
hausted as academism, and purist abstraction was devoid of the
necessary emotional resonances needed to convey the complexity of
post-war emotional and political life. In taking inspiration from his or
her own emotional world, the artist was able (in theory) to commu-
nicate his or her basic human essence to an audience. Painting was
seen as rooted in a desire for the absolute that would reach universal
man. Barnett Newman talked of Abstract Expressionism

> reasserting man's natural desire for the exalted, for a concern with our
> relationship to the absolute emotions. We do not need the obsolete props
> of an outmoded and antiquated legend . . . We are freeing ourselves of the
> impediments of memory, association, nostalgia, legend, myth, or what
> have you, that have been the devices of Western European painting.
> Instead of making cathedrals out of Christ Man or 'life', we are making
> it out of ourselves, out of our own feelings. The image we produce is the
> self evident one of revelation, real and concrete, that can be understood by
> anyone who will look at it without the nostalgic glasses of history.[27]

It should be clear that in this passage we have a crystallisation of most
of the ideas that we have examined in the last two chapters: the
expression of individuality, the attempt to create an art that is
universal in its appeal, the need for a new language for a new time,
and the rejection of the past as a model for development. What is
missing is the rational formalism of European Modernism, that set of
ideas that related the proposed new world to the logic of machinery
rather than to the expression of the essential self.

. This is what makes Clement Greenberg's critical writings on
Abstract Expressionism so interesting. In writing about the art of
America in the decades after the war, he does not address the idea of
the self, or its relationship with the immediate culture of the
individual and all its contractions in contemporary American society.
Rather, he creates a linear and sequential history in which the baton
of radical painting is seamlessly passed on to the Abstract Expressio-
nists from European Modernism independent of all social, cultural
and political circumstances. The history of art, according to Green-
berg, is the history of the development of the illusionistic depiction of
space to its demise and the location of the spectator in a different

relationship to the picture surface, 'art' is a matter 'of experience not of principles'.[28] In saying this, the *form* of art and design is given prominence over its *content*. The relationship between how and what is expressed is separated and one aspect given prominence over the other. In taking this stance and reading the art of the 1950s and 1960s purely in terms of form and its problems, Greenberg ignores a whole agenda of cultural discussion. This is why, ultimately, there was to be a crisis in Modernism, why its language was seen as sterile and inadequate to express issues and concerns that lay outside of the realm of art-making.

Chapter 5

The Modernist Mass Media

As we saw in Chapter 1, by the turn of the century the technologies and structures that were to provide the international mass media were in place. The printing of newspapers and journals with photographic images was commonplace, and people were used to seeing filmed images of the world. A slow process of transcultural assimilation was taking place; it was possible for the first time to see moving images of New York in Moscow within weeks of their filming. A process of eroding the differences between cultural centres was being established that allowed the early Modernists to talk increasingly of an international urban culture.[1] We need to think of the various components of the mass media as working together to form a series of sets of communication. What was to make the journals and newspapers of the metropolitan centres important was not solely the ideas that were contained within their printed pages, but also that they were readily transportable by train from centre to region. Similarly, without a sophisticated infrastructure that allowed both travel and the transportation of objects, without a network of venues that allowed for the gathering of groups of people, the early cinema would have been impossible. We must constantly remind ourselves of the inter-relationship between technology, the ideas that might be conveyed by it, and the social mechanisms that allow the distribution and consumption of the above.

The mass media differ from the fine and applied arts because the search for longevity and the quest for relevance that tormented so many of the artists and designers of the first half of the twentieth century are entirely missing from the mass media. Within the media there were many talented individuals whose contribution to moulding the forms of the medium in which they worked and whose contribution in forming a group consciousness cannot be under-estimated. The media, before they are anything else, are a commodity, they are attached deeply to the economic infrastructure. The

earliest Soviet film-makers tried to take cinema away from the arena of commodification into social discourse, and artists and designers have used the forms of the mass media and helped to create new languages within those forms. Nevertheless the original intention of the cultural information dispensed by the mass media is different in kind to that of the art and design that exists in the cultural super-structure. It is information that in its individual parts is often, but not always, banal. It is information that is designed to be acceptable rather than confrontational in its meanings. It is information, when it is visual, that is easily read, easily assimilated, and easily forgotten.

It is precisely for those reasons that it is so important. The traditional division between the arts and the crafts, between the fine and applied arts, becomes a division between high and low cultures. Not only does the study of the mass media provide us with cultural insights into the nature of a society, it also identifies the site of the struggle by dominant ideologies to control the cultural superstructure from the economic base. By the 1920s photography was a technique taken for granted by the professional makers of art objects, profes-sional photographers and the mass population who filled their family albums with tiny images of the world around them. It was also the period of time in which the debate that had always been current in photography, whether the photograph was a piece of reportage or a medium for manipulation, became further developed. Photography and its practice (like film and typography, those other areas of mass media we shall be dealing with) were not immune to the programme of Modernism.

It was clear to a number of artists and designers that the process of photography was ideally suited to the marriage of mass communica-tion of social ideas and the march towards a utopian industrialised future. In part this was because of the immediacy of the photograph – it recorded surroundings that could be immediately identified as well as describing places that had never been seen. Man Ray understood this and identified this role of photography as both positive and problematic. The photograph, he said 'demands dissemination and attention from the masses without delay',[2] the problem being that if it does not command that attention immediately then it 'loses its force forever. Nothing is sadder than an old photograph, nothing arouses pity so much as a soiled print.' Ernö Kallai and Albert Renger-Patzsch saw the immediacy of photography and the constant quest for novelty as a problem; 'Send negative prints to the press, the monster eats everything. (Motive: new interesting visual effects)'[3] The photograph

was either reviled for its instantaneous ability to convey information or praised. Either way it was still subject to the debates within Modernism.

One branch of opinion saw the importance of photography lying in its objectivity, its ability to record in a low-key, minimal interventionist way the complexity of the natural world that was slowly being unravelled by scientific investigation. This process had started with Muybridge and his meticulously organised photographs of moving forms that had so influenced the Futurists in their attempts to portray speed. By the time that Vilem Santholzer wrote his brief essay 'The Triumphant Beauty of Photography' in 1925 the camera had extended the perception of the physical world enormously. As Santholzer wrote, 'The beauty of photography from an airplane often has a completely unprecedented effect on the human imagination, and as regards sensationalism it is a great feast. New spatial combinations are revealed in photographs of craters, sea inlets, and high mountain ranges.'[4] He continues to discuss the 'beauties of scientific photography' that exploit the microscope and telescope, making visible the furthest distance and the minutest particle. To such critics the photograph appeared to have every advantage over the 'sentimental' and 'kitschy' paintings of the period; 'one need not be cautious when speaking about the possibilities of photography'.

The work of Albert Renger-Patzsch exploited this idea of objective machine-enhanced perception; his nature photography was admired for its focus and technical perfection. The photographs that he took have a clarity of detail that is both to do with technical expertise and also an awareness of the conceptual power of concentration upon one detailed aspect of the wider visual gestalt. Renger-Patzsch saw the role of photography as independent of painting, of pursuing its own particular means and abandoning the idea of competing with painting. In his view photography was a part of modern life because it was part of the technological infrastructure and part and parcel of the way that technology gave aesthetic voice to itself. He saw objective realism achievable through photography, but never really addressed the issue of the photographer's ability to perceive and organise visual material for the camera.

This was something that Aleksandr Rodchenko was interested in. He was concerned that the material world was brought to the camera, rather than the camera brought to confront material conditions. Whilst new conditions were emerging and subjects being sought by photographers, they were being photographed according to the

canons of past pictorial tradition. His view of photography was that it was bound up in a series of conventions that needed radical reorganisation to liberate it from the static and confining role it played in determining the way that the world was seen. The main constraint that Rodchenko saw operating in photography was what he called the 'belly button' viewpoint. By this he meant the practice, imposed in part by the camera technology available to the photographer of the period, of looking down into the viewer of the camera which was held at waist height. This physical viewpoint created stereotyped images and thinking. According to Rodchenko too much of contemporary photographic reportage gave the impression of a world that was exclusive and eternal. He uses the following anecdote to illustrate the above points.

> I remember when I was in Paris and saw the Eiffel tower for the first time from afar, I didn't like it at all. But once I passed very close to it in a bus, and through the window I saw those lines of iron receding upward right and left; this view point gave me an impression of its massiveness and constructiveness. The belly button view gives you just the sweet kind of blob that you see reproduced on all the postcards ad nauseam.[5]

Rodchenko was arguing for an extension of the way in which photography defined reality. Other artists used photography purely in abstract ways, exploiting its particular qualities as a medium, and also using photography in a way that can be seen as duplicating, or parallelling, formal experiments in painting. Lázló Moholy-Nagy and Man Ray were two such artists. Moholy-Nagy held that photography was the means by which shape was given to light in a form that was already close to abstract. He argued for photographic experiments with paper. chemicals, camera construction, lenses and mirrors so that a 'mechanical imagination' might be developed. Perhaps a clearer way of presenting this idea might be to think of photographic media providing an unprecedented amount of visual information, generated randomly through constant experiment.

The audience for radical photographic theory and its practice was small and limited to those journals that we have already identified as the arenas for Modernist debate. Perhaps the most important photographic exhibition of the period was the 1929 exhibition 'Film and Foto' held in Stuttgart in 1929. It presented experimental photography from France to the Soviet Union and from the United States to the Netherlands. One of the consequences of this show was the awareness that much experimental photography was reaching a stale formalist

period and the renewed interest in photo-reportage can be dated from this point. The use of photomontage is something that I want to discuss after a brief examination of film.

The issues of early cinema can be seen as reflecting the main debate that took place within photography, that is, the dialogue between the idea of the camera as a recording device, and how far that objective role could, or should, be modified. The first moving pictures were records of events captured in real time, and whilst there were games played with reversing film, and speeding film up and contracting time, the idea was of things existing within a real time frame that was captured on film. An early filmed narrative was Lumière's *Teasing the Gardener*, in which a piece of comedic dumb show (a boy persists in standing on the gardener's hose only releasing the water pressure when the gardener quizzically looks at the hose) complete with retributive conclusion (the drenched gardener spanks the boy) existed entirely logically within its filmed timescale. This fundamental temporal realism continued on into the first chase films of the American cinema. Substantially, within these early narratives,[6] a sequence of events took place that were chronologically linked within the period that the film was shown. Temporal editing was at a minimum, the moving camera captured the world as it happened around it, or was organised to happen around it. It was Georges Méliès who was to develop this particular conceptual approach to the function of film and to make it a moulder of experience rather than a reflection.

Lumière approached his films as a scientist, and was unable to grasp the artistic possibilities of the medium. Méliès, on the other hand, with his theatrical background, saw the potential for illusionism and fantasy in film. Not only did Méliès provide fanciful stories such as *An Impossible Voyage*, *The Haunted Castle*, *A Trip to the Moon* (1902), but he also exploited the intrinsic contradictions in film. He grasped that the compelling realism that film seemed to present, its supposed objectivity, was in fact an illusion of huge proportions. He understood that physical resemblance was not the sole criterion of measuring the material world and having understood this, he was able to manipulate the editing process, mixing real action with animation, using double exposures, discovering a whole range of medium-based processes that could be applied to film to present to the audience a view of the world which was unreal yet tethered in the physical appearance of reality. It was the beginnings of an illusionism that went beyond painting, beyond the theatrical, and which was a new phenomenon, an exclusively cinematic illusionism.

It was this dual base from which what we now accept as a cinematic narrative form developed. This is a form of representation of reality largely theatrical in form. Narrative events are played out against a backdrop of studio and real-life settings, the camera's role is hidden and the viewer is absorbed into a seamlessly constructed version of reality. Our familiarity with the codes of cinematic communication and the skill of the film-makers collude to get us to suspend our ability to distinguish between the real and the invented. In this way we concentrate on the events that happen to the characters which are presented to us. The role of the character in this form of cinema is important as it becomes the main focus of audience interest. By the start of the First World War in Europe, early Hollywood cinematic production concentrated on the readily identifiable character, like Charlie Chaplin's tramp, perhaps because the character could act as some archetypal figure, perhaps because rapid identification and familiarity with a character meant greater audiences, and more profit for the producers. The star, and the legacy of cinematic stardom, the character stereotype, was born.

Film-makers continued to pursue the documentary path with films like Flaherty's *Nanook of the North* (1922), and to stretch the boundaries of realism with expressionist films like F. W. Murnau's *The Cabinet of Dr Caligari* (1920), which like *Nosferatu* (1922) was shot entirely in the studio. Artists made experimental films like Ferdinand Leger's *Mechanical Ballet* (1922) for tiny audiences. The most important contribution to an alternative view of how filmic reality could be constituted however came from the work of directors like Dhziga Vertov and Sergei Eisenstein in the Soviet Union. Unlike in the rest of the industrialised world, cinematic production in the Soviet Union was seen not as part of an entertainment industry but as having a didactic ideological role.

What separates Soviet cinema formally from other cinema of the period is its emphasis upon editing, or montage. The first filmic montage was the result of Dhziga Vertov's newsreels. In these documentaries and newsreels images are cut abruptly and tellingly against one another, the juxtaposing imagery creating a powerful visual dynamic. In film narrative Sergei Eisenstein used the ideas of montage taught by Lev Kuleshov to astonishing effect. Kuleshov established in the early years of film education after the Revolution that film editing could create a filmic reality every bit as rich as the complicated theatrical narrative adopted elsewhere. The same image when placed next to different images produced different effects. By

using the same head shot of an actor, and then interspersing it with first a bowl of soup, second a corpse, and third a child, the audience read the actor as conveying three different emotional states, hunger, grief and joy. Not only did this simple technique allow for a very efficient means of creating a complex narrative that could avoid huge studio set pieces to convey emotional conditions, it also allowed for the use of filmic metaphor. By cutting from one image to another, metaphorical associations could be established, and concepts compared and contrasted visually.

In films such as *Battleship Potemkin* (1925) and *October* (1927), Eisenstein used this device of montage with skilful use of quick and slow cuts, alternately slowing and quickening dramatic sequences in his films, and elucidating a directorial point of view. As a Marxist he was concerned that cinema should confront social attitudes rather than escape from them, and he wanted film to promote 'new concepts – new attitudes ... intellectual aims'. He wanted a cinema that would 'encourage and direct the whole thought process', and was aware that this was

> opposed by the majority of critics. Because [my methods are] understood as purely political. I would not attempt to deny that this form [montage] is most suitable for the expression of ideologically pointed theses, but it is a pity that the critics completely overlooked the purely filmic potentialities of this approach ... we have taken the step towards a totally new form of film expression. Towards a purely intellectual film, freed from traditional limitations, achieving direct forms for ideas, systems and concepts, without any need for transitions and paraphrases. We may yet have a synthesis of art and science.[7]

Eisenstein saw cinema outside the Soviet Union as belonging to corporations, and concerned solely with the turnover of capital, aided by the star system. It is hard to refute this argument. By 1929 the era of the silent movies was over, and the film industry began to use sound. National-based cinema industries flourished under this new, language-based system, but were simply unable to compete with Hollywood's production for the United States, where in 1938 the average weekly attendance at the movies was 80 million people. Hollywood soon codified the production of film and the big commercial studios created a series of generic styles to satisfy the consumers of its product. This of course is what industrial production was all about, producing goods in large quantities for a targeted

market. Film was really the first mass commodified visual art. We shall return to this idea soon.

Montage was a technique used in the graphic arts as well as in cinema. It used the wealth of photographic material available to the artist in a new way. One of the first pieces of writing about photomontage has been ascribed by Christopher Phillips[8] to Gustav Klutis, the Russian Constructivist artist. In this first analysis of the technique Klutis observed that 'A poster' on the subject of famine composed of snapshots of starving people makes a much stronger impression than one presenting sketches of the same ... The photograph possesses its own possibilities for montage – which have nothing to do with a painting's composition. These must be revealed.'[9] Klutis cited the first photomontagists as Rodchenko in the Soviet Union, and George Grosz and other Dadaists in the West. In the Soviet Union, photomontage was seen as a way of dealing with enormous amounts of visual information for mass production. Newspapers, journals, book illustrations, posters, all confronted the artist with a problem of how to record events in objective form. The solution appeared to be a combination of expressive elements from individual photographs, combined to be a sum of more than its parts. Vavara Stepanova saw the potential of photomontage as a technique that was appropriate to all areas of artistic and information-based visual production, replacing drawing as a primary communication tool.

> It is quickly catching on in workers' clubs and in schools, where photomontage on wall notices can present a ready response to any topic of urgency. Photomontage is being used extensively in political campaigns, and from anniversary celebrations and parties right down to the decoration of offices and corners of rooms.[10]

The Dadaists on the other hand exploited the metaphorical qualities that this conjunction of imagery allowed, as in the work of Raoul Hausmann and Hannah Höch, sometimes taking the metaphorical aspect into biting anti-Nazi political satire, as John Heartfield did for his covers for *AIZ*, the German Communist Party's magazine.

Typography was also an arena for the Modernist debate, and whilst the Modernist experiments in typographic form and communication were slow to enter the mainstream of printed mass media production, the legacy of these experimentations still profoundly influences the production of the printed mass media today. Contemporary Post

modern graphic designers such as Neville Brody manipulate the languages of typography established during the first third of the twentieth century.

At the end of the nineteenth century jobbing typographers used every single form available. Pages were dense with a variety of faces and styles often so highly decorated that the letters were lost under abstract curlicues or forms deriving from acorns or antlers. In the quest for decoration and novelty, the legibility of letter forms was frequently lost. This created a conflict between the role of type as a vehicle for meaning and the role of type as a signifier of cultural location or status (in this way type forms related to those of the ancient classical world immediately convey a set of indexes which are different from those conveyed if a type form derived from Gothic script is used). The plethora of styles available to the printer led to a devaluing of the role of typography as a clear conveyer of cultural meaning. The Modernist rejection of the past and the encouragement of new formal languages can also be seen in typographic production of the time. Just as early Modernist painters and designers sought new styles through experimentation, so did typographers. In his *Calligrammes* the writer Apollinaire used typographic form to echo the content of his poetry, thus 'Il Pleut' is set typographically in long lines resembling rain. The Futurists and Dadaists used found letter forms to create collages of letters, sometimes abstract in content, sometimes eccentrically transcribing phonetic poems. This was different though, to the systematic study of typographic form and layout practised by typographers like Piet Zwart in Holland, Henry Berlewi in Poland, and Jan Tschichold in Germany. These designers exploited ideas of the dynamism created visually through the use of the diagonal and asymmetry. Traditionally, type had been horizontal and centred. Now it seemed to convey, in its dramatic exploitation of the new visual language of Modernism, a sense of drama and excitement. (See Ill. 5.1.)

The concern of all early Modernist design with the relationship between form and function was seen as being as crucial in the production of typography as in other areas of design. The clearest example of this search for a type-face that represented contemporary concerns is perhaps Herbert Bayer's *Universal* typeface. This typeface was designed in 1925, the same year that Bayer was appointed head of typography at the Bauhaus. It is a sans serif face in which a single circle is the basic unit, halving and quartering giving the scale for detail and establishing internal angles. It has no upper-case form. It

101

Figure 5.1 Varvara Stepanova, *Playbill, c.*1923. Private collection.

has the severity and self-assurance that was considered appropriate for the new technological age. Bayer established a house style for the Bauhaus's publications, and thus a design paradigm for Modernist design for printed mass media. In 1928 he set up a design house in Berlin and introduced new typographic layouts and photomontage into mainstream magazines in Germany. This radical design style was the dominant style in the Soviet publications of the period. It was not to be long before the experiments seen on the covers of journals like *Blok*, *Vesch*, and *Der Dada* were being absorbed into the mainstream of magazine and book production and being codified and taught in art schools internationally.

So far we have looked largely at the way in which formal experiments in the traditional visual disciplines influenced the way in which graphic design for the mass media evolved. We have also looked at a phenomenon that became a powerful language for the new mass media, that of montage and its close links with photography. What we must do now is to examine the way in which the new media operated upon their audience. For the first time artists had the potential to communicate with audiences of enormous size. To gain access to this audience in the Soviet Union, artists had to ally themselves to the ideas and institutional structures of the state. In the rest of the world however, it was the capitalist market that determined the contact between artist and designer and their audience. In order to communicate through the mass media, the artist or designer had to have an idea that could be turned into a commodity and then bought by a consumer – either in a magazine or film. This was to lead to a complicated dialogue in which what was said, and what was heard, was constantly in a process of negotiation between those who were aware that anything could be ultimately sold, and those who saw the mass media as an arena in which only certain ideas were allowed to be consumed. This debate about the acceptability of putting certain ideas into the public arena was obviously not a new one, but the ease with which it was now possible was of course new, and made still easier by the introduction of the television into homes after the Second World War. The debate was/is centred around which ideas are allowed entry into the world of the media and who is allowed to put them there.

The role of the mass-produced artefact and idea was discussed in slightly different ways by two key thinkers of this period, Walter Benjamin and Theodor Adorno. Both were Marxists, but held differing views as to the potential and the accountability of the mass media.

Both were associated with what was to be known as the Frankfurt School. This was originally funded by the millionaire Felix Weil, and founded as the Institute for Social Research in 1923. He was part of a group of Marxist intellectuals whose views about the world were formed during the period of revolutionary activity in Germany after the First World War. Their view can be amply summarised in Weil's words: 'back to the free market or forwards to socialism? That is the question.'[11] The Institute was under the direction of Max Horkheimer and acted as a means of connecting intellectuals of like, but by no means indentical, points of view. The Institute was closed by the Nazis in 1933, its members going into exile and returning to Frankfurt in 1951.

Benjamin held that technology was a force that could be turned towards a constructive and liberating use, but at the same time he was well-aware of its past oppressive role. In *One Way Street*[12] he argued that technology needed to become the means of emancipation from the thinking patterns and cultural attitudes of the past, or technological catastrophes even more horrific than the First World War would occur. Benjamin identified the crisis of the capitalist society of the 1920s and 1930s as one in which technology was still being interpreted in a nineteenth-century way. In the nineteenth century, he said (not altogether accurately), technology was seen solely as the means for the production of commodities.[13] In the same way, many Modernists simply identified in technology a notion of progress, failing to register that it also entailed the dissolution and disruption of a coherent social base. The more that technology developed and became increasingly sophisticated the more difficult it would be for the working class to take possession of it. It was this act of proletarian seizure of the means of production that Benjamin saw as the solution to the problem of social alienation. What has this to do with art and design? A lot, because the culture of technology was not simply engaged *in* the production of things, but also in the preparation of public opinion *for* their production.

The Work of Art in the Age of Mechanical Reproduction is one of the key pieces of writing on the mass-produced image of the early twentieth century and still has importance at the end of the twentieth century as we enter more completely into a world saturated by mass-produced electronic imagery. In this text Benjamin looks at the consequences of, and the role for, mass-produced imagery. The reproduction of a work of art took what he termed the 'aura' away from it. This aura that surrounded the unique work of art was built

up out of traditional views about the location of the work of art – in the gallery where it reflected the status of such institutions, or in the homes of the wealthy and powerful. The aura was also created by the physical manifestation of time upon the object, creating a patina of material in which the uniqueness of the artefact could be understood chronologically, something which a reproduction could never possess, and which forgers try so hard to duplicate. This aura which validates the original work of art and gives it its status is also something which is oppressive, it locates the meaning of the work solely in its physical presence. Reproduction, on the other hand, removes the artefact from traditional understanding:

> By making many reproductions [technology] substitutes a plurality of copies for a unique existence, and in permitting the reproduction to meet the beholder or listener in his own particular situation, it reactivates the object reproduced. These two processes lead to a tremendous shattering of tradition which is the obverse of the contemporary crisis and renewal of mankind. Both processes are intimately connected with the contemporary mass movements. Their most powerful agent is the film. Its social significance, particularly in its most positive form, is inconceivable without its destructive, cathartic effect, that is, the liquidation of the traditional value of the cultural heritage.[14]

We can see that Benjamin is aware of the double-edged nature of this phenomenon. What he wanted to happen was for a mass audience to exchange a form of art which had an aura of untouchability for a work of art that was accessible and touchable. Things may be lost in the process, but things are also gained as 'the reactionary attitude toward a Picasso painting changes into the progressive reaction toward a Chaplin movie'. This 'progressive' reaction is a socially significant immediate fusion of the visual with the emotional enjoyment of a work of art. This immediate and shared mass experience was something that was new and according to Benjamin, 'the fact that the new mode of participation first appeared in a disreputable form must not confuse the spectator', for this experience, this fresh, uninhibited approach to visual information could be used for a politicised aesthetic. Benjamin's vision was one in which the ambivalent qualities of technology could be turned to productive use, but despite this identification of the mass media as a vehicle for progress, he was under no illusions as to how technological culture was actually being used: 'Instead of draining rivers, society directs a human stream into a bed of trenches; instead of dropping

seeds from airplanes, it drops incendiary bombs over cities; and through gas warfare the aura is established in a new way.' Ultimately, Benjamin was suggesting that there must be a progressive mass culture or there would be no culture at all.

Adorno's views were slightly different to those of Benjamin. Benjamin was aware of the pitfalls of the erosion of the aura of the work of art but remained convinced of the potential of mass art. Adorno thought that Benjamin was insufficiently analytical and approached his debate in too broad and 'mythic' a way. He saw Benjamin underestimating the irrationality of the mass-produced art work and its audience, and also insufficiently grasping that the individual work of art has a direct and rational understanding of its technological origins. The considered individual work of art, if aware of its material and cultural origins, will negate its own aura – the trick would be to create a work that could never be assimilated into the dominant cultural ideology. (We will see when we look at some of the ideas of Post-modernism how difficult a task this might be.)

The Work of Art in the Age of Mechanical Reproduction was published in Germany in 1936; Adorno published 'The Culture Industry: Enlightenment as Mass Deception' in the USA in 1944.[15] Five years and a different geographical location were to make a profound difference in the interpretation of how a mass culture operated. Adorno was to criticise the commodification of the aesthetic and its false promise of individuality, to point out the tragedy by which 'personality scarcely signifies anything more than shining white teeth and freedom from body odour and emotions'. Adorno argued that the radical politicisation of the mass media was impossible because it was already so heavily compromised. For Adorno philosophy and art stood shoulder to shoulder, threatened, but confronting the reality of a deformed technological culture, both aiming to shake up 'rigidified forms of perception and behaviour, both aiming to sustain or re-awaken a sense of wonder'.[16] We can see that the individual work of art's 'aura' that Benjamin identified as reactionary is also theoretically able to disrupt ideological consensus, in this case, that of a mass culture.

Adorno uses the term 'culture industry' to describe the new conditions of the cultural superstructure. No longer is there a distinct separation between the economic base and its cultural topping. The commodification of aesthetic and artistic experiences by the mass media creates a new set of conditions where ideas, as never before, are turned into entertainment. The practice of communicating through

artistic forms has been turned into a mass economic exchange, an exchange in which ideas about material reality become illusory, where the ideological substitutes for the real.

Adorno presents a grim picture of the industrialised individual in the heartland of the USA. Compromised by living in mass housing supposedly designed to make them independent on the periphery of big cities, these individuals become increasingly subservient to the 'absolute power of capitalism'. The differentiation of cultural product in film, magazine or recorded music is not there to enable choice, but to ensure that noone escapes the trawl by the cultural industries for consumers' cash. The differentiation of products available to the consumer is about 'classifying, organising, and labelling' them. The illusion of individuality is perpetuated despite the huge contradiction evident between mass consumption of imagery and the impossibility of uniqueness in these circumstances. Adorno says:

> Pseudo individuality is rife: from the standardised jazz improvisation to the exceptional film star whose hair curls over her eye to demonstrate her originality. What is individual is no more than the generality's power to stamp the accidental detail so firmly that is accepted as such. The defiant reserve or elegant appearance of the individual on show is mass-produced like Yale locks, whose only difference can be measured in fractions of millimetres.[17]

The mass media perpetuate a notion of the individual and individuality whilst in reality treating its audience as a mass without individual distinctions other than the most insignificant.

The role that art sometimes has as catharsis – a way of cleansing or purging a culture or individual of an emotional trauma – is also devalued and made fraudulent. Adorno takes the example of laughter, which he says, 'whether conciliatory or terrible, always occurs when some fear passes'.[18] The mass media appropriates this cathartic mechanism and uses it almost indiscriminately. It is used as a device to disguise the fact that 'happiness' has actually been commodified, it is a parody of real laughter. One of the contradictions of the mass media is that they both offer and deprive simultaneously. Solutions are consistently presented but cannot be implemented, love is promised but cannot be guaranteed, sex is offered but always denied. The consumer is never allowed real emotional release, always and only its substitute. This cuts deeply at a fundamental function of a social art practice. Amusement becomes an end in itself, substituting for a search for a deeper understanding of cultural and social events. The

controlling of amusement by the mass media becomes a control
mechanism itself and 'fun becomes a medicinal bath'.[19]

Why does harmless entertainment cause Adorno so much anxiety?
How does it cause this supposedly dreadful rupturing of basic
humanistic culture? It is because the mass media are owned by huge
companies with interests other than entertainment. The mass media
are not the outcome of technological development that allows the
widespread dissemination of information in a dispassionate way, but
a prime function of the economy. Adorno observes that

> movies and radio need no longer pretend to be art. The truth is that they
> are just business is made into an ideology to justify the rubbish they
> deliberately produce. They call themselves industries; and when their
> directors' incomes are published, any doubt about the social utility of
> the finished products is removed.[20]

It was the case in the 1940s when Adorno wrote this essay, and is still
the case today that the culture industry is dependent upon other more
powerful industries that control the raw materials needed for the
manufacture of the objects of the mass media (then records and now
CDs) and their consumption (then record, now CD players). The
whole of the mass media is a complex amalgam of interlocking
industries, stimulating and providing wants, both emotional and
material.

What makes this a problem is the invisibility of the ideology that
suffuses the culture industries. The aesthetic production of films and
books and magazines is often funded by companies with vested
interests in the consumption of manufactured, industrialised pro-
ducts. But they are often presented as being outside or parallel to
their production. Thus advertisements in magazines and on television
and the radio are seen as intruding into aesthetic matters; the intimate
connection between advertisements and the artistic product, their
underlying ideological connection, is disguised through separating
them. But the two functions are fundamentally intertwined.

Ideology is never discussed in the mass media, although the media
themselves perpetuates one. This absence of discussion makes the
dominant economic ideology no clearer, but no weaker either:

> its very vagueness, its almost scientific aversion from committing itself to
> anything which cannot be verified, acts as an instrument of domination . . .
> The culture industry tends to make itself the embodiment of authoritative
> pronouncements, and thus the irrefutable prophet of the prevailing order.[21]

Because of these overwhelming conditions of control that the mass media place on society, Adorno argued that the role of the work of art was vitally necessary in acting as a disrupter and dislodger of expectations. His view of the mass media is a deeply pessimistic one, and all the more so because of the way in which he identifies the scientific enlightenment and the touchstone of Modernism, technological advancement, as the root cause of this cultural tragedy. His argument, that of the Frankfurt School and what is also known as Critical Theory, is difficult to refute, and few opposed to his ideological stance have tried with any success, other than to point out that mass media production is led by market research and the supplying to consumers of what they want. A further problem arises as to whether the visual mass media should be approached wholly as ideological, or whether they might also possess aesthetic value.

The terms the 'Frankfurt School' and 'Critical Theory' have become synonymous. They refer to an analysis of cultural issues based in a pragmatic and flexible use of Marxist ideas. In the area of the visual arts, critical theory adopts a position developed by Adorno and Herbert Marcuse in which the dominant ideology expressed in mass art can only be contested in certain areas of avant-garde practice where established meaning is subverted and new meaning established. In the contemporary debate that continues around this issue, critical theory is still important and presented by Jürgen Habermas, who was Adorno's assistant in the 1950s. He will emerge again in a later chapter as a critic of those Postmodernist attitudes which wish to lose the radical agenda of Modernism.

In the 1950s and 1960s the mass media became the subject of an aesthetic critique of varying quality through what is now known as Pop Art. Artists began to use mass imagery in their paintings, and artists like Warhol (Ill. 5.2), Lichtenstein and Oldenburg drew from mass culture almost as if it was a natural phenomenon. The subject of painting which once had been either nature, or perhaps the pursuit of the pure aesthetic experience, now looked at the imagery of the mass media. To paraphrase the Australian critic Robert Hughes, culture had become nature. Chronologically Pop Art can be seen as a reaction against the elitism of International Modernism. It can also be seen in the hands of some practitioners as a development of the Dadaist agenda; these are issues that must wait for the next chapter. What I wish to discuss here is the way in which it reflected and commented upon what was considered in the 1960s as a commonly shared visual experience – the imagery of mass commodification. The cultural

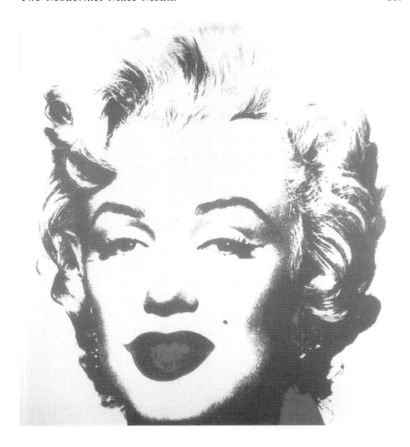

Figure 5.2 Andy Warhol, *Marilyn*, 1967. Screenprint. Collection, Art
Gallery of Western Australia. © Andy Warhol, 1967/ARS.
Reproduced by permission of VI$COPY Ltd, Sydney 1997.

environment in which the then new art was operating was one of
immediately recognisable objects and images, mass-produced, not by
the mass themselves, but by a sophisticated elite. These commercial
artefacts constituted a new potent means of visual communication
and the Pop artist was concerned with scrutinising this strange new
language.

Pop artists shared a set of imagery rather than an ideological
programme. It is possible to see in the work of some artists a critique
of the visual and social environment in which they were operating; in
the work of others, however, the raw material of the mass media is

treated more playfully, even affectionately. It is the difference between Andy Warhol's portrait of Marilyn Monroe, where she is given the same visual treatment and turned into a metaphorical commodity as in Warhol's works featuring the Coke bottle and Campbell's soup cans, and the painting of the rock and roll performer Bo Diddley by the English artist Peter Blake. Warhol's image is a stylised and modified screen print of a photograph, as blank and hard as the images of the mass media. Blake's image on the other hand is a warm affectionate witty painting that humanises the mass media commodity. One is as impersonal and blank as the imagery from which it draws, stressing the mass origin of the original image's production; the other interprets and personalises the consumption of the mass-produced image. One examines the coloniser of mass cultural space, the other responds as colonised. The irony of it all is that the market itself does not distinguish such subtleties; as long as there is a market for imagery, then it can sold – whatever its original purpose as defined by the artist. Despite elements of social criticism evident in some works, Pop art was very saleable. It had the same superficial attraction as much of the material from which it was drawn. The imagery of the mass media, presented as fine art through the gallery system, then became absorbed back into the mass media which absorbed and commodified the criticisms of themselves.

Adorno was well-aware of this dilemma. As early as the 1940s he was noting what the new conditions presented: 'What is new is not that [art] is a commodity, but that today it deliberately admits it is one; that art announces its own autonomy and proudly takes its place among consumption goods constitutes the charm of novelty.'[22] This means that the Modernist assumption that art will always be able in some form or other to disrupt paradigms, to act in an avant-garde, interventionist way, is compromised from the very beginning. The Modernist demand for the new and the radical has been replaced by a commodified version of that stance where the new is the norm and the new does not confront imbecility, but sustains it. Unlike the adoption and exploitation of media technology by the Modernists in the 1920s and 1930s where, perhaps naively, artists tried to control that technology and direct it to a long-term goal, in Pop Art we see an acceptance, albeit on occasion a cynical acceptance, of the contemporary commodification of ideas, and a passive collaboration with it.

The relationship of the mass media to fine art practice has become increasingly complex since the 1960s. The traditional practice of paintings on canvas in galleries has become more diverse as the

dialogue between new technology and the ways in which it can be accessed are absorbed into areas where once only certain materials could signify high-minded seriousness. The photograph, once the antithesis of the aesthetic, is valued as a medium with its own properties. But as this medium, now over a hundred and fifty years old, gains acceptance, a new range of electronic technologies have taken its traditionally subservient role. Electronically generated imagery, used extensively by the mass media, is seeping into art practice. With it come not only questions about the appropriateness of certain media to express ideas, but also about the way in which the new technologies can make and alter imagery. Electronic imagery (more correctly electronically digitised imagery, where visual information is broken down into minuscule parts and can be reassembled in any order desired) can be manipulated so that the incredible can be seen as having the same visual qualities as the credible. The unreal is presented to us via the mass media in such a way that the traditional dialogue between the objective and the subjective – often obscured ideologically, but obvious visually – is now increasingly difficult to disentangle at the most fundamental of perceptual levels. The photographic image, because of its mechanical connection to the world has always been seen as having some toehold, no matter how slight, in helping us understand the physical nature of it. This illusion of technology as a tool of the truth has been shattered by the electronic 'photographic' image's ability to increasingly connect us to the ideal, rather than reflect the material.

Chapter 6

Realism and Objectivity

A partner to the Enlightenment idea of *progress* was the notion of objectivity. As we saw in the first chapter of this book, it was thought by the adherents of the Enlightenment that the rationalisation and objectification of the world was the way in which it could be understood. Once freed from the confusions of ideological assumptions the world could be seen as having a logical and understandable structure. Inherent in this approach is the idea central to all Modernist thought, that humankind can achieve objectivity.[1] In this way art was often a partner of science. In the visual arts the idea of objectivity centred around the supposedly irrefutable nature of physical appearance. From the Renaissance onwards many artists struggled with the idea of the formal, physical representation of the world as a major vehicle for their work – that is, they saw the making of an accurate reproduction of the visible world as a prerequisite part of their ability to communicate ideas about it. Indeed a truthful reproduction of the physical world was sometimes the sole purpose of many paintings. Still lifes, portraits, landscapes may well have had symbolic elements in their content but it was the testable veracity of the depicted image when placed next to the real that often gave them value. Many artists such as John Lewin[2] played an important role in recording scientific information about the world as Europeans began to invade other lands and colonise the globe. In the nineteenth century the Symbolist poet Mallarmé observed, perhaps in a double-edged way, that the depiction of social 'truth' in the contemporary French novels of the time was becoming synonymous with the expression of beauty. We have already talked in Chapter 2 about the nineteenth-century British intelligentsia's obsession with 'truth to nature' in Pre-Raphaelite painting, and the associated ideas of 'truth to materials' in Arts and Crafts design.

The importance of recording the world as it was, rather than idealising it, was however fraught with problems during the early

modernist years. The nineteenth-century European academies of art became the repositories of a deformed notion of objective painting, deformed because the definition of normality it promoted was not an objective assessment of the visible world, rather it was a prescriptive and exclusive one, denying ways of expression other than those based upon a Renaissance tradition. Through their schools and their exhibitions the academies encouraged a visual representation of the world that emphasised an illusionistic reproduction of the world. William Bouguereau was a French Academician[3] and a hugely successful artist, both as a practitioner and teacher. He held a philosophical position which is common in the arts: the assumption that theory is something that gets in the way of making images, that the artist is somehow simply a dispassionate conduit for, in this particular instance, recording the appearance of the natural world. According to Bouguereau, what the artist reproduced when trained solely in craft skills was value-free. He saw the academies producing students who were creating 'objective' works. In arguing, as he did, that 'theory should not enter into an artist's elementary education'[4] he made assertions about the visual representation of the world that assumed that content (the subject matter) and form (the way it was represented) in a painting were indistinguishable: 'There is no such thing as symbolic art, social art, religious art or monumental art; there is only the art of the representation of nature whose sole aim is to express its truth.'[5]

If we examine this idea and look at collections of images from the academies of this period like the British *Magazine of Art*'s annual supplement, in this particular case from 1899,[6] it does not take long for us to realise that pictures of landscapes, pictures of military exploits and portraits of worthies all share enormous skill in the illusionistic representation of the material world. That should not blind us however to the content of these images, for they have a particular agenda, a social context that relates directly back to the way in which the objects are formally depicted. Landscapes, for instance, show a British countryside untouched by industrialised farming methods, and happy healthy people living placid robust lives. *Peace and Plenty*[7] shows a harvest being brought in by a handful of relaxed farm workers, surrounded by contented chickens, with a church spire in the distance. *The Peaceful Highway 'Hallowed by six centuries of quiet usefulness'*[8] shows a view of a stone bridge with horses ridden over it whilst a boy fishes on the bank. Both images are painted with a high degree of illusionistic skill, but need to be

contextualised in a Britain that was largely industrial and involved in enormous social transition. Back in France, the painter Maurice Denis criticised Bouguereau for painting 'nature seen through a temperament'.[9] We can go a step further and say that these sorts of paintings are not just subjective because they relate to the ideas and perceptions of a single individual artist, but also because they reflect the wider cultural and social ideologies which he (or any other artist) was party to, protest otherwise though he (and they) might.

The academies were promoting a form of representation that was suffused with the mannerisms and idealisms of four hundred years of illusionistic painting since the Italian Renaissance. The relationship between the content of the picture and the way the images were depicted was unresolved. *A Son of the Empire*[10] shows a sturdy boy in a rural setting looking admiringly at a group of cavalrymen (in full dress uniform) riding out of the village (Ill. 6.1). The same year in which this painting was exhibited, the British state, embroiled in a bitter colonial war in South Africa, was shocked to find that its citizens were largely unfit for military service, because of widespread malnutrition and poor health care.[11] This painting depicts a reality that is illusionistically credible but which is constructed on a number of complex ideological assumptions. Everything *looks* real but it is a fabrication derived from synthesised observations of the real world. A profoundly influential debate took place in the literary world of nineteenth-century France in which this issue, the relationship between the depicted reality and the social reality, was widely discussed.

Emile Zola and Gustave Flaubert were both advocates of what Zola called the 'scientific novel', in which the artist simply recorded the social complexities of the cultural world in which they found themselves. Zola wrote extensively on the art of the Parisian salons and was a champion of Eduard Manet's *Le Déjeuner sur l'herbe* and *Olympia* when they caused so much scandal when first exhibited in 1866.

> You know what effect M. Manet's canvases produced at the salon. They simply burst the walls. All around them are spread the confections of the artistic sweetmeat makers in fashion, sugar-candy trees and piecrust houses, gingerbread men and women fashioned of vanilla frosting. This candy shop becomes rosier and sweeter, and the vital canvases of the artist seem to take on a certain bitterness in the midst of this creamy flood.[12]

Zola admired Manet's and Courbet's struggles to record the world as it was, in a language that they evolved as they progressed in their

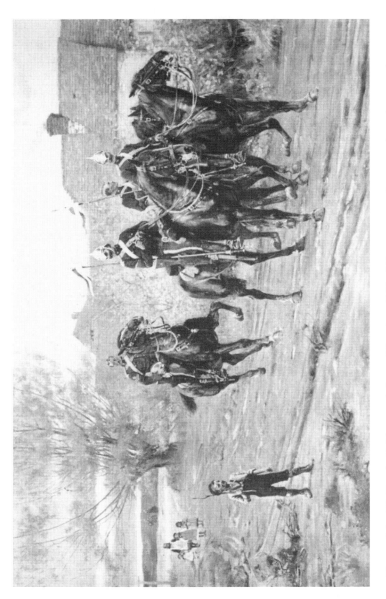

Figure 6.1 W. Frank Calderon, *A Son of Empire*, 1899. Oil on canvas. Present whereabouts unknown.

work, freeing themselves from the conventions of illusionistic paint-
ing. Zola talked of the 'joke' involved in believing that there is 'where
artistic beauty is concerned, an absolute and eternal truth'. He argued
that whilst nature remained constant, our interpretation of the
physical world was subject to change. 'Art is a human product', Zola
said, 'a human secretion; it is our body which sweats out the beauty of
our works. Our body changes according to climate and customs and,
therefore, its secretions change also.'[13]

The language that Zola uses is deliberately physical, unaesthetic, to
do with the corporeal rather than the spiritual. He wanted a form of
painting that responded to the conditions of the new age in Europe:

> Science is in the air, in spite of ourselves we are pushed towards the close
> study of objects and happenings. Similarly each of the strong individual
> talents that now reveals itself, finds itself developing in the direction of
> Reality. The movement of the age is certainly towards realism, or rather
> positivism.[14]

Almost contemporaneously the poet Charles Baudelaire was writ-
ing about another painter whom he considered to be the voice of what
he was to call 'Modernity' (the first time this word was used).
Constanin Guys painted scenes of contemporary Parisian life. Guys
had worked as a professional illustrator for illustrated journals of the
period. Baudelaire was taken with Guys's penchant for the crowd: the
painter, in Baudelaire's words,

> the lover of universal life, enters into the crowd as though it was an
> immense reservoir of electrical energy. Or we might liken him to a mirror
> as vast as the crowd itself; or to a kaleidoscope gifted with consciousness,
> responding to each one of its movements and reproducing the multiplicity
> of life and the flickering grace of all the elements of life.[15]

We should not, because of our familiarity with the imagery and
language of Modernism, ignore Baudelaire's metaphors here, with
their association with a dynamic energy, and the way Guys's art is
linked metaphorically with the imagery of a contemporary magic
lantern slide show rather than that of painting. Particularly though, it
is the relationship of the individual to the mass which makes
Baudelaire's review of Guys's work so pertinent, especially when
we compare his observations about the relationship of the individual
artist to what he calls 'universal life' with Zola's observations about
the artist's individual vision and its dialogue with the objective world.
We have evidence here of a new way of thinking about what

constitutes a depiction of the real world. It is a negotiated reality where convention is not dismissed (although many contemporary critics of the new way of looking at the world thought it had been), for the act of negotiation implies an acknowledgement of opposing views. This attitude towards what might constitute the real is derived from contemporary philosophic and scientific sources, but does not appear to break with tradition in as dramatic a way as other later aspects of visual art practice were to. This is important to bear in mind as we follow on with the discussion about 'realism' and 'naturalism', about the visual recording of the objective world. It is a side-track to simply align realism of this period with the development of photography. Photography aided artists of all styles, and continues to do so, but the intellectual struggle for objectivity, the debate about its purpose, is far more profound than the mechanics of its representation. The tussling with how much of the individual's personality is allowed to enter into that depiction makes the debate around these issues more dynamic than a simple discussion about the representation of objects in the visual arts and the closeness of their resemblance to their models in the real world.

The Impressionists, whose works are now familiar friends in many suburban front rooms, were once seen as ugly distorters of reality. (See Ill. 6.2.) Their subject matter, often banal landscapes and townscapes, views of ordinary people (in varying degrees) doing ordinary things – such as Gustave Caillebotte's 1877 painting of pedestrians on a wet street, *Paris: A Rainy Day* – was seen as inappropriate and insufficiently dignified for art. Thus Mary Cassat remained a largely isolated figure because her subject matter centred mainly around her domestic life. Her life and work were constrained by the circumstances of her gender and attitudes towards it in the arts, as exemplified by Zola's remark that 'Painting dreams is a game for women and children; men are charged with painting reality.'[16]

Such painters as Claude Monet and Camille Pissarro showed a relationship to scientific investigations into the nature of light and colour and their perception by the individual. Their version of reality was one based upon optical sensation, rather than the learned rules of formal representation derived from Renaissance practice. This is not to suggest that the Impressionists were without an ideological agenda. Auguste Renoir refused to exhibit with Pissarro because of Pissarro's socialist views, and Pissarro himself spent much time in ideological debate with his son Lucien, who worked in London and was an advocate of a socialist art achieved through the Arts and Crafts

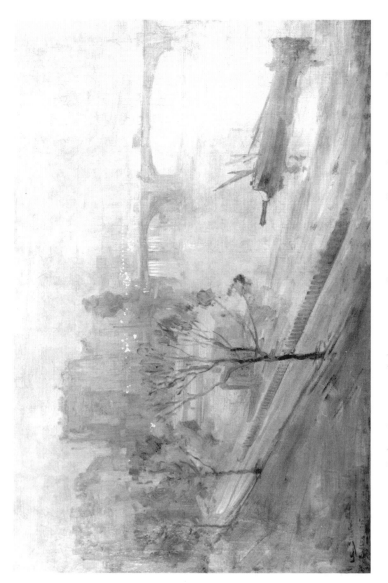

Figure 6.2 Arthur Streeton, *Chelsea*, 1905. Collection, Art Gallery of Western Australia.

movement. What does link the Impressionists and some Post-Impressionists though is a manipulation of depicted form that can be clearly demonstrated as having emerged alongside contemporary scientific investigations into the functioning of visual perception.

Michel Chevreul was a distinguished organic chemist who made a study of the effects of light and pigment, an expertise largely derived from his early employment at the Gobelin Tapestry dye works. He developed a theory of complementary colours which was adopted by painters from Eugène Delacroix to Georges Seurat who wished to increase the intensity of their colour. Indeed Seurat's style of colour application that he termed 'Divisionism' stems directly from Chevreul's subheading 'Imitation of Coloured Objects, with Coloured Materials in a State of Infinite Division' in his book *The Principles of Harmony and Contrast of Colours and their Applications to the Arts*. A further example of this parallel relationship[17] between formal pictorial methodology and scientific investigation is the phenomenon known as the Rood–Helmholtz insight. Both men were physicists, and essentially made the same observation about the perception of distance and its relationship with perceived planes. In 1861 Rood talked about the way in which if 'the mind is prevented from dwelling on distance, it is thrown back on the remaining element, colour; and the landscape appears like a mass of beautiful colour patches heaped up upon one another, and situated in a vertical plane'. Helmholtz observed in print some five years later as Eduard Manet was flattening the picture plane in his paintings: 'The first thing we have to learn is to pay heed to our individual sensations . . . the instant we take an unusual position, and look at [a] landscape with the head under one arm let us say, or between the legs, it all appears like a flat picture.' Helmholtz went further and observed that once freed from the learned conventions of understanding distance, the 'individual sensation' enabled colours to be read more brilliantly. Both men brought attention to bear upon the mechanics of seeing, ignoring the complexities of cultural association and asserting the visual excitement of looking at a level of pure sensation where meaning is put to one side. As Paul Vitz points out in his essay 'Visual Science and Modernist Art'[18] these insights that a decontextualised perception of a scene changes the appearance of colours making them brighter, flatter and less associated with distance has enormous parallels with Monet's observation that the painter should not think about the objects before him but 'think, here is a little square of blue, here an oblong of pink, here a streak of yellow, and paint it just as it looks to you, the exact

colour and shape'.[19] And Maurice Denis similarly remarked that 'it must be recalled that a picture . . . is essentially a plane surface covered by colours arrayed in a certain order'.[20]

Just as an understanding of light helped the Renaissance artist to portray the illusion of volume through tonal value and increase the credibility of the depicted image, so too an increased understanding of the fragmenting qualities of light aided the nineteenth-century artist. However just as the formalism of the Renaissance style led to idealisation and a disjuncture between the depicted and the real, so too the fragmentation of light in late nineteenth-century painting, rooted in an objective scientific phenomenon, led to the dissolution of a shared sense of understanding. The individual's ordering of the shimmering chaos of light is both a tremendous extension of the formal means of representing the world and a focusing exclusively upon the individual's 'unsocialised' vision. Raw visual information allows the world to become in Ernst Fischer's words 'no more than "my" experience, "my" sensation, not an objective reality existing independently from the individual's senses'.[21]

Fischer was a German Marxist critic whose book *The Necessity of Art* was written in the late 1950s at the height of the Cold War in Europe. His analysis can help us see two routes at the turn of the century for the objective representation of the visible world. One was the formal representation of light as characterised by the Impressionists and Post-Impressionists. This largely leads to the formalist experiment in which there is a fragmentation of social coherence as 'man's essence dissolved into light'.[22] The second route was the realism of Zola and Manet and other artists whose work emphasised the content over formal elements. Fischer points out that 'Zola, who revealed social misery with complete ruthlessness and laid bare the Second Empire down to its very entrails, refused for many years to draw political conclusions.'[23] This observation will lead us eventually into the identification of another variation on the objective representation of a culture through its art, the point at which objective neutrality ceases to be productive, when it is perceived as maintaining a status quo.

We have talked quite a lot in earlier chapters about the transgressive, disruptive element of Modernism – its refusal to accept old solutions for new times. In examining 'realism' we find that it too has a modernist cast, which is perhaps best expressed as 'critical representation'. To understand this concept and how it was to evolve we must return to Karl Marx and his ideas.

Marx argued that the cultural superstructure and the economic base were mutually dependent. By this he meant that cultural artefacts were linked all the time to the health and flexibility of the economy in which they found themselves. We can see already how the production of paintings is given a new light by this position. If we go back to the academies and their control over an artistic style and we use Marx's model we can see that the cultural superstructure – in this case the academy and its works – are tied inextricably in with the economic base. These works are made for a wealthy privileged art-buying class, and the subject matter that we have already discussed is a reflection of their world view. Reality and fantasy are constructed in such a way as to make the viewer content with the world. If the artists exhibiting at the academies had showed paintings of cultural discontent and industrial squalor, of economic exploitation, their market for such works would be small. However Marx conceded that the cultural superstructure had a degree of autonomy. If we follow our example through, we can see that it would be possible for artists to paint such subjects (and they did). Unpopular images of any sort had to painted by artists who were free of the market (such as Manet, Cézanne and Van Gogh who all had private incomes of varying degrees of affluence). If images were socially critical, they had to be painted in such a way as to lose their critical edge and become sentimental in their observations of social inequalities rather than challenge the cultural and political status quo. This happened in British academic painting with works by artists like Luke Fildes whose *Applicants for Admission to a Casual Ward* shows a queue of dispossessed urban invalids awaiting treatment at a city hospital's very disreputable back entrance. This relative autonomy of the cultural superstructure allowed for art production to act as a critique of events. Such art, to be acceptable, was never able to completely articulate the real causes of social injustice.

Engels talked of the triumph of realism. He was antagonistic towards art that adopted clearly readable 'socially progressive' positions as he thought this worked against the power of the art work to communicate, because its ideological purpose could be so clearly defined by those who opposed it as well as those who held similar viewpoints. The artistic effect of the work was forever destroyed by the artist's declaration of allegiance. 'Realism' on the other hand implied 'besides truth of detail, the truthful reproduction of typical characters under typical circumstances'.[24] What Engels is trying to define here is an art in which general objective observations can be

made through the organisation of particularly observed details. It is a juggling act between the individual and the universal, an act doomed to drop many balls.

It was in Russia at the turn of the century that the ideas about realism played with by Marx and Engels were picked up and developed most of all, particularly by Giorgi Plekanov. Plekanov was the founder of the Russian Social Democratic Party. He had an international reputation as an aesthetician and his *Art and Social Life*[25] published in 1912 was for two decades a key text for anyone interested in the idea of a 'realist' art. Plekanov argued that art for art's sake was the result of social alienation, the result of artists who were hopelessly at odds with their social environment. Equally he was pessimistic about the prospects of a purely utilitarian ideological art, echoing Engels by arguing that such a style was a style only, and could be constructed to serve the needs of a reactionary and oppressive society every bit as efficiently as a progressive one. Plekanov tried to codify Marx's and Engels's ideas, but his analysis was largely contemplative rather than radical. He was happy in applying a sociological analysis to art production, but found it difficult to provide a coherent Marxist critical aesthetic, which is unsurprising given the little attention that Marx paid to this area of cultural activity. Plekanov tried to organise the information available to him, but his ideas about 'realism' in a Marxist society were soon superseded by the acquisition of power by Lenin in the Revolution of 1917.

Lenin was suddenly required to take an active rather than a contemplative role with regard to the direction of culture. As we have seen, it was during his regime that the radical art and design of the Constructivists developed. His own views on art were quite conservative, and essentially he saw the main cultural drive in the new society as one of developing mass literacy. Lenin saw the role of art as *reflecting* the social, acting as a mirror to reality. Trotsky too talked of a work being 'truthful or artistic when the interpretation of the heroes develop, not according to the author's desires, but according to the latent forces of the characters and the setting'.[26] This emphasis upon the work of art to reflect natural phenomena and to mesh into the paradigms of realist illusionism was at odds with the activities of the radical Modernists of the newly formed Soviet Union. They were pursuing their course of disrupting the old social order and creating a cultural climate of formal artistic innovation. Whilst Lenin's regime was in power a variety of cultural voices was permitted, and although the Communist Party held very clear views

about what was good and bad art it remained on the edges of the debate as to the value of the new abstract language versus the realistic model. However in 1934 when the state apparatus was finally under the control of Stalin, the Soviet state formed a series of Unions for Art Workers – the Writers', Painters', Film Workers' and Composers' Unions. Membership of these unions was essential if an artist wished to have a public voice. It was in 1934 at the first Congress of the Writers' Union that the doctrine of Socialist Realism was adopted as official state policy. This congress is fundamental in the definition of a style considered 'suitable' for a socialist state. Often referred to as 'Socialist Realism' it is perhaps more accurately thought of as 'Stalinist Realism'. It was a system of thinking about imagery that was to monopolise the communist cultures in varying degrees until the late 1980s.

There were three keynote speeches given at the congress, by Maxim Gorky the novelist, Nicolai Bukharin, a Bolshevik theoretician, and A. A. Zhdanov, who was to be a key player in the administration of the new cultural approach. It was Bukharin who really gives the clearest idea of the new order:

> A new type of man is arising who knows the world in order to change it. Mere contemplation, mere portrayal of the objective, without elucidation of the motive tendencies, without reference to the practical alteration of the objective world are receding into the past. Hence socialist realism cannot base its views on the naturalism of Zola, who proposed to describe reality 'such as it is' and no more. Neither can it accept his other slogan, 'imagination is no longer needed'. Socialist realism dares to 'dream' and should do so, basing itself on the real trends of development.[27]

What is being described here is a form of idealisation, an idealisation of socialist ideology. Like all processes of idealisation it draws substantially from a repertoire of forms and concepts that enable it to be related to the real world. Gorky talked about the new style in terms of it 'abstracting from reality', of amplifying 'through the addition of the desired and possible', a 'rounding off' of the image. It does not take much of a conceptual leap to be able to apply these ideas to any number of paintings serving the purposes of a ruling class at any time during the history of the post-Renaissance. The only difference is in the conceptual purpose of the style. As Gorky defined it, there was an element of 'romanticism which underlines the myth' which would encourage a 'revolutionary attitude towards reality, an attitude that in practice refashions the world'.[28] We can see how this

style differs from the art of the academies only in its subject matter. Formally, it is similar. It was Zhdanov who made the most blunt observation: 'The truthfulness and historical exactitude of the artistic image must be linked with the task of ideological transformation, of the education of the working people in the spirit of socialism.'[29]

The new art of the Stalinist regime was deeply conservative in form. 'Formalism' was a term of abuse under Zhdanov's cultural administration, implying a sense of alienation of the artist from the triumphs of industrialisation and technological transformation taking place in the Soviet union. It is curious to see a society transformed by technology recording itself through such a resolutely traditional style. An example is Yuri Pimenov's *New Moscow* painted in 1937 (Ill. 6.3). The viewer is positioned in the back seat of a open topped car driven by a woman down towards the junction of Marx Prospekt and Pushkin Street. The street is busy with people and cars and new grey Stalinist skyscrapers loom behind the nineteenth-century neo-classical architecture of old Moscow. The picture is painted in a style redolent of Manet, giving Moscow the appearance of Paris. The narrative reading of the painting – of technology in the hands of women, of personal success, of a move from a traditional, rational neo-classical order to a new socialist one – is easy. But just as *A Son of Empire* was only a selected reading of reality, so is this painting. Socialist realism's demands for ideological and formal prescriptive readings were to affect Soviet cinema too. The montage style that had become synonymous with early Soviet cinema vanished, to be replaced with traditional narrative treatments of already successful novels. Eisenstein's later work was to become a victim of this policy.

'Socialist Realism' demanded an architecture that drew

> not just on discoveries of the front-line of science and technology, but also on the positive traditions of its own people . . . the innovator will create a work that is original, but that originality will have nothing in common with the pursuit of a difference 'at all costs' from anything already existing, or with the total liberty of being left to express merely personal tastes.[30]

Thus the formal radicalism of the Constructivists was abandoned in favour of an architectural style with historical reference, in which decoration and motifs reinforce the cultural expectations of the state. Architecture too was expected to be ideologically active. The consequence was an often baroque architecture, embellished with symbolic decoration (see Ill. 6.4). The winning entry[31] for the 'Palace of

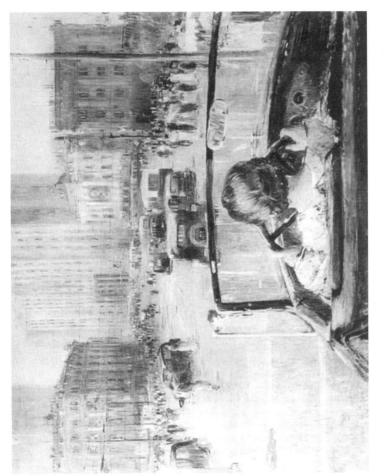

Figure 6.3 Yuri Pimenov, *New Moscow*, 1937. Collection, Tretyakov Gallery.

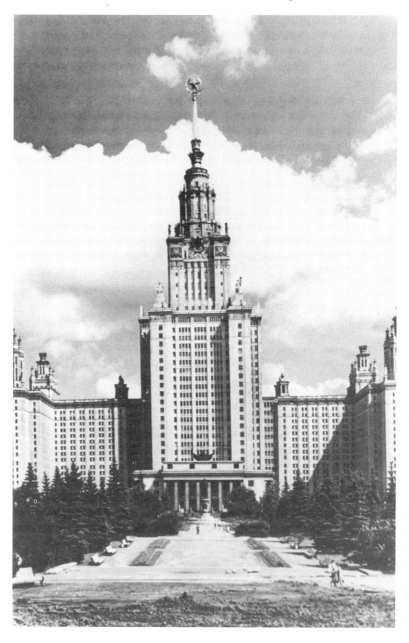

Figure 6.4 Moscow State University, 1949. L. V. Rudnov, S. Chernyshev,
 P. Abromisov, A. Khryakov.

the Soviets' competition of 1933 was a huge tiered neo-classical cylindrical wedding-cake of a building, surmounted by a vast multi-storey high statue of Lenin. It was never built. Realism in architecture, it seems, was about style and not necessarily about buildability. Indeed 'functionalism' had led, according to Professor Arkin, the Secretary of the Society of Soviet Architects, to a 'fetishism' of technique, that had raised 'the machine to an aesthetic ideal, which had led to the peculiar canons of a new formalism'. Modernism had been reduced 'merely to technical and biological factors, entirely ignoring such a question as the artistic effect and the artistic content of architecture. In this manner some [Modernists] arrived at a complete negation of architecture as an art.'[32]

Soviet 'Socialist Realism' was not the only move towards a supposedly objective recording of the modern world. In 1925 in Berlin there was an exhibition called 'Die Neue Sachlichkeit': 'the new objectivity'. It was an influential show of 32 artists that toured the major German cities. It was the first of a number of exhibitions, each with the same title. The title was a useful handle for a number of disparate artists not all painting in a similar style, but all dealing with the urban environment in a predominantly figurative way. Painters like Otto Dix and George Grosz were producing images that were uncompromising, harsh and critical. Their cool, controlled images can be considered post-Expressionist figurations – 'a first effort', as John Willet says, 'to adjust figurative painting to our own age'.[33] It was this environment which led initially to a specifically German debate about realism in the 'modern' arts, and which makes clear the dilemma of many socially and politically motivated European artists and designers. How did the imperative of the 'social command' affect the relationship between the aesthetic and the functional, between the authentic and the unauthentic? For an artist to fulfil the social command, Mayakovsky demanded they should be in the vanguard of class politics, doing all they could to destroy the myth of an apolitical art.

The debate centres round three main figures, with Bertold Brecht the poet and playwright, and the aesthetician György Lukács arguing for a realistic art of different sorts, and Adorno rejecting all realism as inadequate to the cultural task in hand. Lukács was Hungarian and spent the years from 1933 to 1945 in exile in Moscow. He was influenced by the ideas of Soviet Socialist Realism, but tried to develop them in a more sophisticated way. Like many who held his point of view, Lukács was antagonistic to the sort of realism espoused

by the *Neue Sachlichkeit* style. He disliked montage and the fragmentary episodic narrative that were substantially derived from Expressionism. Lukács wanted an art which linked the particular, the individual, with a wider social contextualisation. There was to be some sort of combination of the 'essential' and the typical. Lukács demanded an art that provided an image of reality in which the oppositions of appearance and essence, of the individual case and the general rule were resolved. The immediate effect of the work of art was to dissolve the oppositional elements into a resolved coherent whole, so that they would form 'an inseparable unity'.

The stylistic dislocations of the *Neue Sachlichkeit* artists' work meant that this inseparable unity never took place. The slippage between the objective resemblance of the world and, for example, Dix's representation of it, was such that the seamless combination of the particular and the general never takes place. Instead there is a dislocation, evidence of the alienation that the artist felt from his surroundings. Lukács thought that this alienation served only to further fragment an already ideologically distorted representation of the world. His view is one that is more idealist than materialist, though he does not share the Soviet theorists' demand for an overtly ideological programme for artistic production. He is also conservative in his approach to the past, unlike other critics of contemporary industrialisation who wished to abandon history. He viewed art as emerging from a critical tradition that needed preservation rather than destruction. 'The attitude of the modernists to the cultural heritage stands in sharp contrast to this', he says. 'They regard the history of the people as a great jumble sale [using] expressions like "useful legacies", "plunder" and so on.'[34] Another factor in talking about Lukács that we should bear in mind (for he was to be very important as a cultural theorist in Eastern Europe after the Second World War, helping to some extent to free those visual cultures from the stranglehold of Zdhanovite ideas) is the way in which he held that a simplistic economic critique of capitalism and its industrial processes was a futile one. What he thought was more important was to examine the way in which commodification in an industrial state determined consciousness and hence the ideological outlook of a culture. He saw that relationships within an industrialised culture were relationships between objects rather than people. This is why, in his view, an industrialised capitalist culture is dysfunctional. Cultural conversations are conducted via the objects that people own or aspire to own. The *exchange* value of objects is greater than their *use* value.

By now we should be familiar with this critique of the modern industrialised state, where the creation of objects is often seen as unrelated to their functional role and to the labour of the person who has made them. The symbolic role of the object for the consumer is valued above this instead. Lukács's views were to change marginally through his career but fundamentally his position is best discovered in *History and Class Consciousness.*[35]

Brecht was engaged in the sort of cultural production that Lukács was unhappy about. Despite their both being Marxists, their views about the practice and use of art, similar in some respects, differed in others. Whilst Brecht was not a painter, his views on realism and on abstract art are valuable indicators of a generally held position amongst artistic advocates of the European left at the time. Brecht valued the act of dislocation that the work of art could produce – he was not interested in the notion of 'intensive totality' that Lukács was so concerned about. In his own work he used the devices of style and form to distance and objectify the content of the work of art in order to focus the audience's attention on what he was saying. He wanted the radical modern art work to force the viewer into making decisions about the information presented. In this way Picasso's *Guernica*, which uses Modernist form to describe the destruction of the town by Fascist forces during the Spanish Civil War of 1935–36, creates a cultural dialogue not of ideological solutions, but demonstrable problems. It provides no emotional catharsis for the viewer, but gives the viewer a problem, the answer to which has to be sought in the real world. In this sense it is realistic, it recognises the constraints of reality and the role of the painting.

Brecht wanted an art which encouraged a critical consciousness about the political and cultural environment in which people found themselves. He was happy to disrupt the complacency of naturalism and its tendency to close argument, to constrain understanding rather than open it up. Unlike many of the socialist realists who emphasised the role of the artist in presenting cultural information, Brecht focused his attention on the audience reading and acting upon the information presented to them. To achieve this Brecht talked about 'distanciation' (*sic*). This is sometimes called more elegantly, if not accurately, 'the alienation effect': removing the art work just enough from reality to provoke questioning in the audience. The French cultural theorist, Roland Barthes, recognised this as an important point in the move towards the emancipation of the reader from the art work. He talked of Brecht offering the work to the viewer 'for criticism, not for

adherence'. There is no final meaning in Brecht's work according to Barthes, 'nothing but a series of segmentations each of which possesses a sufficient demonstrative power'.[36] (This reading of the relationship between the artist, the work and the audience, so important in postmodern culture, will be examined in a following chapter.)

Brecht, despite his differences with other advocates of a Socialist Realism, was still opposed to much of the formalism of Modernist works. His position with regard to non-objective painting is clearly articulated:

> I see that you [left-wing abstract painters] have removed the motifs from your paintings. No recognisable objects appear there any more. You reproduce the sweeping curve of a chair – not the chair; the red of the sky, not the burning house. You reproduce the combination of lines and colours, not the combination of things. I must say that I wonder about it, and especially because you say that you are communists, going out to reconstruct a world that is not habitable.[37]

Brecht was happy with ambiguity, happy with dislocation provided it served a communicative role. As far as he was concerned much of what was considered radical Modernist painting was simply as impotent as much of the bourgeois idealism that it was supposedly replacing.

> I hear you say: 'With our tubes of oils and our pencils, we can only reproduce the colours and lines of the things, nothing more.' This sounds as if you were modest men, honest men, without pretences. But it sounds better than it is. A thousand examples prove that one can say more about things with tubes of oils and pencils, that one can communicate and expound more than simple solids with lines and colours.[38]

Brecht's stance on this matter, that it is possible to talk about tangible things, and that talking about things is more effective in facilitating change, does not take account of the exploratory, experimental nature of much avant-garde work. He values radical works for two reasons: because they are committed to the process of change, and because they attempt to facilitate this through their content. Formal experiment in itself is, in this argument, worthless. In opposition to this Adorno, whose ideas about mass culture we have already examined in some detail, became increasingly insistent that the only way in which the artist could challenge the status quo, the only way in which the artist could insist on a voice that was individual

(and already we are at odds with much of what has been discussed previously, for as we have seen, the individual artist's voice was not necessarily of prime concern to the socialist realists) was to create works so unsettling that they could never be fully assimilated by a society. But, after the atrocities of the Second World War Adorno argued that there was no art that could fully comment on or comprehend the full horrifying complexity of political reality. In his essay 'Commitment' Adorno said that he had 'no wish to soften the saying that to write lyric poetry after Auschwitz is barbaric', but at the same time he acknowledged that rather than be crushed by such circumstances such scenarios demanded 'the continued existence of art . . . it is now virtually in art alone that suffering can find its own voice, consolation, without being betrayed by it'.[39] Adorno was concerned that any language that is used to convey aesthetic information antagonistic to a cultural system can ultimately be absorbed and turned against the original comment, trivialising it. He comes close to acknowledging that meaning is almost impossible to control. As an example he talks of the work of art being read alternatively to its intention.

> The so-called artistic representation of sheer physical pain of people beaten to the ground with rifle-butts contains, however remotely, the power to elicit enjoyment out of it. The moral of this art – not to forget for a single instant – slithers into the abyss of its opposite.[40]

Adorno argues for a continuing struggle to find an oppositional language that is never codified, that forever transgresses and refuses assimilation into cultural life. Such an art of course can never be a means of mass communication and relies heavily upon an idea of an emancipated and articulate avant garde who are somehow morally superior to the system in which they find themselves. This is a scenario full of troublesome issues, but which should not necessarily be dismissed simply because of its unresolved nature, for it was the avant garde's ability to disrupt and disorient that caused the Nazi Party in Germany in 1937 to instigate two art exhibitions. One promoted a contemporary neo-classical naturalism, 'The Great Exhibition of German Art', and the other ridiculed contemporary Modernism as the product of 'art criminals' and 'cretins',[41] 'The Exhibition of Degenerate Art'.

In both Mexico and the United States 'realism' was to play a significant role in the practice of painting. In Mexico a didactic realism was to be an important part of the work of Diego Rivera,

José Orozco and David Sequeiros. Rivera was educated in Paris, Orozco drew from German Expressionism. All three artists integrated their European-originated styles with aspects of a Mexican folk art and a monumental realism and used their paintings, largely in fresco form, as a narrative in which the oppression of the working class was exposed. Their work was politically motivated, engaging in a critique of contemporary industrial society. They saw their art as rooted deep in a collective tradition. In the manifesto of the Mexican Syndicate of Technical Workers, Painters, and Sculptors Mexican folk art was valued because it was seen as emerging from 'the people', it was collective, and with their declared aim to socialise artistic expression it was seen as a potential too to destroy 'bourgeois individualism'.[42] We have met these sentiments before, and the solution itself has conceptual similarities with the Arts and Crafts movement in its location of a collective style in a national tradition.

The realist movement in the United States came from a similar source, a sense of national cultural identity. However this turned out to be a double-edged thing, in one way liberating, in another becoming a vehicle for right-wing national chauvinism. Thomas Eakins (1844–1916) was educated in Paris where he was impressed and influenced by Manet's style. Back in Philadelphia he encouraged his students to paint the culture that was around them, rather than rely on formal aesthetic models from Europe. The Eight, or as they are sometimes known because of their urban subject matter, the Ashcan School, were a group of painters who painted the urban environment initially of Philadelphia and then New York at the turn of the century. They tried to establish an American approach to painting – open, direct and immediate in their response to the world.

Early Modernism in America was not entirely successful, and with the onset of the depression the influence of The Eight was important in supplying a model seen as appropriate to the new social conditions. Part of what were called the 'American Scene' painters, who specialised largely in naturalistic genre painting, was a group called the Regionalists. The main voice of this group was Thomas Hart Benton, who, opposed to the internationalism of Modernism, wanted an art rooted in the rural heartlands of America. The Regionalists were suspicious of the big cities and the role they played in breaking down an established cultural order rooted in the agrarian. Benton's paintings were crude idealised contemporary views. Antagonistic to modernist formal experiments, he thought that only by participating in the reality of American rural culture could artists find forms in which

Americans would find an opportunity for genuine audience involvement. Opposed to the crass melodrama of Benton is the work of someone like Edward Hopper, whose cool, detached, psychological view of urban American life paints a more credible version that subsequently, whilst rooted in a particular circumstance, has a resonance in any city environment. A demonstration perhaps of Lukács's idea of 'intensive totality'.

The Federal Art Project was an American government-funded scheme that continued from 1934 to 1943. During the lifespan of this scheme, nearly five thousand artists were employed on public art projects, most of them using a realistic style. Many of the artists engaged by the federal authorities played an active role in politics, and a group called the Social Realists formed the Artists' Congress of 1936. It was an organisation of around 300 artists and designers whose prime intent was to use their work as a vehicle for anti-Fascist propaganda. The styles used by this group were less that of Socialist Realism and more that of the Neue Sachlichkeit painters. As Barbara Rose points out, the 'realism' of the American Social Realists came not from a painterly or theoretical base, but 'directly from the graphic tradition of magazine illustration and poster art'.[43] In this way perhaps they were more 'American' than those artists who attempted to affect an 'Americanness'.

What links a notion of realism in Nazi Germany, the Soviet Union and the United States is a grandiose scale and declamatory self-importance that makes a comparison possible between Vera Mukhina's ten-metre-tall stainless steel sculpture *Worker and Collective Farm Girl* of 1937 (Ill. 6.5), and Gutzon Borglum's presidential *Mount Rushmore* sculpture of 1941. They are about identity rooted in a group culture. They have their differences. The first is contemporary, concerned with working people in active pose, made in a high-technology material, expansionistic and originally designed for the Soviet Pavilion in the 1937 Paris World Fair; the second historical, showing a ruling elite *in situ* in a natural setting, introverted and isolationist. But the differences are not as strong as their similarities. Both are 'naturalistic', idealised in form, ideological in character, and they have as slim a grasp of the subtleties of human existence as the next example of the relationship between realism in modernism that we shall examine – the art of China immediately after the Cultural Revolution.

In 1966 Mao Tse Tung instigated the Cultural Revolution. It was an attempt to further change the culture of China (a Communist state since the success of the revolution of 1949) from the cultural super-

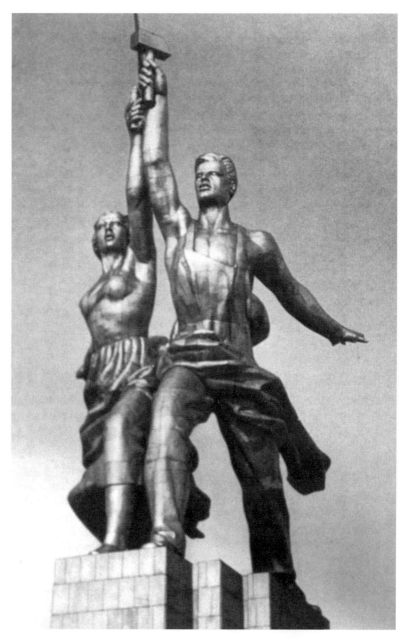

Figure 6.5 Vera Mukhina, *Worker and Collective-Farm Woman*, 1937.

structure rather than the economic base. As we saw earlier in the chapter, Marx argued that the cultural superstructure had a relative autonomy but was always linked to the base. Mao attempted to transform the cultural superstructure, to change all aspects of education, literature and art that did not 'harmonise' with the base. As far as the visual arts were concerned, his attempt to create a truly mass peasant culture resulted in a curious art. The chaos caused by the Cultural Revolution was eventually controlled through the use of the military, and two important exhibitions from the early 1970s show a society transforming itself through mass technology, and by the use of the collective. These are ideas fundamental to early Modernism, and it is curious to see them portrayed in a mixture of peasant, traditional and socialist realist styles.

The first national art show after the excesses of the Cultural Revolution had been curbed was in Beijing in 1973, 'Peasant Paintings from Huhsien County'. In the introduction to the catalogue,[44] a brief anonymous essay tells us that the works are by 'people's commune members – women, youngsters and old people, party secretaries, production team leaders, militia company commanders and accountants. They are all pathbreakers in production and at the same time an advance force in culture.' This may well be the case,[45] and even if it is an ideological pretence it demonstrates a cultural position in which an untutored realism is valued above an imposed academic model. What is interesting with regard to our debate here is the relationship of the imagery used to communicate the process of the beginnings of a mass industrialisation programme. The first image shows us a landscape panorama, *Huhsien County's New Look* by Tung Chen-yi, in which a train thunders through the middle of the town as smoke-plumed factory chimneys signify production. Other images show mass-produced tractors being driven away (*Buying Iron Oxen* by Hsieh Chang-chang) and tractors feature prominently as key images in the traditional landscape. *The Motor's Roar* by Li Keh-min shows a bank of portable irrigation pumps and the *Brigade Pumping Station* by Wu Sheng-chin shows a complex of newly built buildings. The next show, 'Graphic Art by Workers in Shanghai, Yangchuan and Luta'[46] held in 1974, shows further images of industrial production. *Another New Lathe for Our Village*[47] shows an enthusiastic community gathering round a newly delivered lathe, and *The 300-Ton Trailer Truck Joins the Front Lines of Transport*[48] shows a similar celebration but on huge urban scale, as three trucks are paraded in front of the celebrating masses.

These images, whilst dependent upon an array of 'realist' formal means of representation, traditional Chinese painting and a socialist realist style acquired in the 1950s with Soviet help, are nevertheless images of a culture in transformation to a modern industrial society. The content of these images reflects an understanding of the modern world, an internationalisation of industrial culture that demands by its very nature a particular cultural response. The concern with the mass, with the collective, and with mass production and the industrial artefact, are all issues we have encountered previously. (See Ill. 6.6.)

We have seen how realism can be approached from two routes, that of content and that of form. Both are relative because both are subject to ideological interpretation. All we can really talk about is the *struggle* for objectivity that took place during the period covered during the course of this chapter. This struggle for objectivity has not diminished.

Realist practices continue. The American sculptor Duane Hanson uses high-technology materials to cast 'lifelike' representations of ordinary people who are dressed in real clothes and given real consumer accessories. These deadpan simulacra reflect back to us a decontextualised version of our commodity society. They stand clad in their shoddy, gaudy clothes, like laboratory specimens for examination. Fumio Yoshimura's *Motorcycle* of 1973 is a perfect replica of a motorcycle carved in wood. It is lifelike but useless, a machine without function, a dialogue between handcraft and machine culture, an object in which the idea of 'truth to materials' is up-ended and questioned.

The photograph, since its inception a vehicle for deception and lies as well as truthfulness, has since the development of digitised electronic imagery taken on an extended armoury of devices to further dupe us into thinking that its representations are real. By recording the visual world as electronic information, it is possible to simulate the world and build these simulations into images of the real so easily, that what was once gasped at on the movies is now possible for any customer at any photographic store. Scanned into a computer and then digitised, domestic photographs can be edited in increasingly sophisticated ways. The Canadian artist Jeff Wall creates huge constructed pieces in which seamlessly montaged fabrications are presented as 'real' records of the world. This illusionistic process self-reflexively calls into question the issue of photographic realism and challenges our notions of 'mechanical' objectivity and 'truthfulness'.

Figure 6.6 Sui Kei-Min, *Sunrise at the Refinery*, 1972. Woodcut.

In his book *Super Realism* (a name coined during the 1970s in the USA and Europe to describe a new sort of realism, based almost exclusively on the vision of the world provided by the photograph, now usually referred to as 'photographic realism'), Edward Lucie-Smith talks of the disapproval that realist illusionism provokes, because it is associated with everything that originally resisted the changes of Modernism, and asserts that if examined, the new realism 'is undoubtedly modernist, both in many of its attitudes, and in its chosen technical devices. Yet on the other hand it does seem to represent a revolt against modernist elitism, a desire for an art which everyone can understand.'[49]

Inherent in this statement are two issues: the new cultural world of the postmodern, and the crisis of Modernism that caused its reevaluation to take place. It is this point of transition from the modern to the postmodern, from European cultural dominance to American cultural dominance, that the next chapter will begin to address.

Chapter 7

High Modernism? Or Modernism in Crisis?

The end of the Second World War (1939–45) saw a Europe of devastated cities and tens of millions dead. At the heart of European culture was the awareness that it had witnessed the most appalling atrocities, that had only finished when the United States added to the catalogue of horrors by using the atom bomb to destroy Hiroshima and Nagasaki in Japan. Logistically, and morally, Europe could no longer claim to be the centre of global communications and its colonial infrastructure, whilst theoretically intact, was destined for disintegration. The Modernist desire for a functional rationality had been reduced to the ability to dispassionately commit mass murder; the desire for liberation through technology had ended in the industrial efficiency of the Nazi death camps like Auschwitz. Far from the Futurist vision of cultures ultimately cleansed by war, the culmination of the Second World War, first in Europe and then in South East Asia, simply led to further global, lower-level armed conflicts, as relationships between the United States and the USSR turned into an ideological struggle called the Cold War.[1]

The United States emerged from the war as the most powerful military power in the world, with an industrial infrastructure untouched by bombers or invading troops (Ill. 7.1). The cultural consequences of the shift of political power from Europe to the United States were enormous. New York was to become a global cultural centre. The issues we have already examined – the dialogue between the individual and the collective, between function and styling in objects and architecture, between the original and the reproduced work of art, between high and low art – all were to become central to American culture. In the examination of the art and design of America these debates can be viewed ambivalently, either as an affirmation of the triumph of Modernism – in Modernism's

139

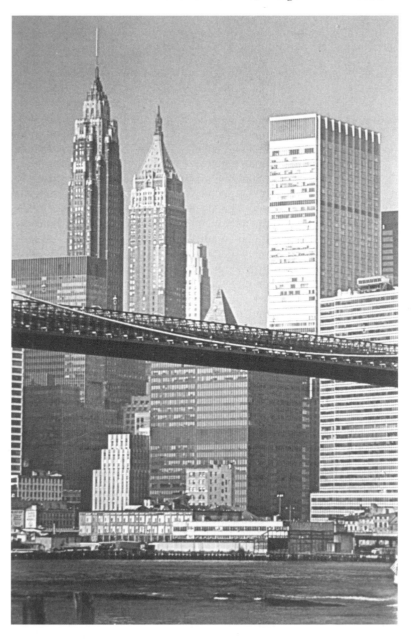

Figure 7.1 New York, the paradigm of the modernist city.

adoption as the global style promoted by the world's dominant power – or as an indication of its ultimate inability to transform culture in the way that it once seemed able to do. Modernism was half-heartedly adopted by a politically right-wing state which was characterised by its own President Eisenhower as an industrial–military complex. Like most cultural circumstances of course, the American situation was all of these issues combined.

Another culture was emerging into global consciousness, which was also engaged in a process of reconciling itself to Modernism, and that was Japan. Like the United States, Japan was the recipient of a European Modernism in the 1930s that it attempted to make relevant to its own immediate cultural concerns. Unlike the United States however, Japan had been devastated and traumatised by a war which had destroyed its economic infrastructure. Parallels can be drawn in the relationship of these two cultures' negotiation with modernism as a set of imported cultural ideas. What makes the relationship still more complex is postwar Japan's position as a client state of America.

European Modernism had sought to transgress, to discard old values and to present a new path forward. Inherent in this set of ideas was the notion of the avant-garde. This concept from military jargon, where it was used to describe the process of elite troops surveying and securing new territory, was taken up by the French intelligentsia in the nineteenth century to describe the process they were engaged in, of surveying and mapping out new cultural territory. This implies a group activity, a coherent and planned strategy, but part of this process of avant-gardism came to be, as Rosalind Krauss remarks,

> that the avant-garde artist above all claims originality as his right – his birthright so to speak. With his own self as the origin of his work, that production will have the same uniqueness as he; the condition of his own singularity will guarantee the originality of what he makes.[2]

Krauss's observation exposes the dynamic between the group and individual definitions and actions of an avant-garde. The avant-garde artist can be considered as working within a social framework of expectations, but we can also see that the avant-garde artist is considered unique and individual, offering a personal vision as a means for cultural advancement. (This fits very closely with our previous examination of a universalist and individualist vision of Modernism.) The dialogue between these two versions of the one activity is well-illustrated in American culture of the 1940s and 1950s,

and Japan in the 1960s. In essence the debate is about how far an individual conception of the avant-garde can dislocate itself from a wider social environment and still be considered avant-garde. This is especially problematic when the individual artist and designer is practising in an environment in which the new is valued as an essential part of consumption, and when individual expression in the visual arts is valued above the social function of designed objects.

The year of the start of the Second World War in Europe saw Clement Greenberg publish an article in the journal *Partisan Review* called 'Avant Garde and Kitsch'.[3] In this article he laid out what can be seen in retrospect as the conditions for the new American avant-garde. In some ways his position was parallel to Adorno's, in that both felt that the role of an avant-garde was essential to ensure the continuance of a worthwhile culture in opposition to the values promoted by a mass-produced culture. It was this mass-produced culture that Greenberg characterised as kitsch:

> Kitsch is mechanical and operates by formulas. Kitsch is vicarious experience and faked sensations. Kitsch changes according to style, but always remains the same. Kitsch is the epitome of all that is spurious in the life of our times. Kitsch pretends to demand nothing of its customers except their money – not even their time.[4]

This exposition ties in closely with the ideas of European Marxists and their rejection of a delusory, capitalist mass culture that seems to demand nothing, yet in fact drains all independence from the consumer. But whilst Adorno and others wished for an avant-garde that was critical, disruptive, and interceded in the relationship between the consumer and the producer of mass culture, Greenberg argued for an avant-garde that was removed from that debate, producing art that was self-referential, and engaged in an attempt to detach itself from 'that welter of ideological struggle which art and poetry find so unpropitious'. In Greenberg's opinion only an 'avant-garde culture' could keep 'culture moving in the midst of ideological confusion and violence'. As far as Adorno and similar thinkers were concerned it was the creation of that ideological confusion and violence that made the work of art an avant-garde work.

If we further examine Greenberg's position we find the curious circumstance of an avant-garde art being proposed whose function is to maintain a status quo, to protect what has been achieved against further corruption by a system that was antagonistic towards its aims. This is a substantial development from the position of many Euro-

pean Modernists who saw themselves as breaking free from main-
stream culture and inventing a new visual language. Here we have a
realisation that a new language has already been established which
needs protection against further attacks. Modernism is considered by
Greenberg to be a valuable part of a 'traditional' culture supported by
an educated elite. For Modernism to continue to disrupt the social
status quo would be to destabilise the conditions in which it (both art
and the educated elite) was allowed to grow. The further destabilisa-
tion of mainstream culture could be increased either by capitalist
kitsch, or by totalitarian demands for realism. By placing the em-
phasis upon the need for art to avoid a social or political struggle and
disenfranchise the audience for such an art, Greenberg implies a
helpless alienation of the artist, who becomes powerless to act to
transform culture, solely dependent upon what Mark Rothko called
the 'silence and solitude' of being an artist in a, hopefully benign,
capitalist society.

We have already seen in a previous chapter how Barnett Newman
talked of Abstract Expressionism 'reasserting man's natural desire for
the exalted, for a concern with our relationship to the absolute
emotions', of it freeing the artist from 'the impediments of memory,
association, nostalgia, legend, myth, or what have you, that have been
the devices of Western European painting',[5] and we have examined
how this position was held by many of the New York painters of the
1940s and 1950s who were attempting to create an art that was
universal in its appeal. Although there was never any group manifes-
to, nevertheless it is possible to trace in the writings of the artists of
the New York School a general feeling that the expression of the
culturally unmediated individual in art put the artist, and his or her
audience, in touch with some sort of 'essential self'. This sits snugly
with the idea of the avant-garde artist being original, embarking on a
personal creative journey, and this viewpoint further enabled Green-
berg to make the jump from a socially conceived avant-garde to an
idea about art-making that was concerned solely with its own
intrinsic formal concerns. The culturally unmediated individual is
seen as expressing a 'universal truth' – expressed in a language
unconnected to those culturally controllable languages that aim for
the replication of the visible world.

The Abstract Expressionist artists of the *New York School*[6] that
Greenberg became a spokesperson for – 'the immediate future of
Western Art, if it is to have a future, depends on what is done in this
country'[7] – might seem less culturally transgressive than their Euro-

pean counterparts of thirty years previously, with their concerns for a personal expression using a set of pictorial concerns already largely established. But because of their generally 'left' politics, and because of the political climate in the United States at that time their work was seen as being culturally problematic. Overseas, the American state promoted these artists as representatives of the individualist freedoms available in the United States; at home they were reviled, and many, such as Barnett Newman and Ad Reinhardt, had FBI files opened on them as possible political subversives.

The wider reading implied by this – that these paintings could be read differently according to the cultural context that they found themselves in – implies a cracking of the Modernist edifice of a universally understood transcultural art and design practice linking all industrial states. Here we have a scenario in which a cultural super-structure, based on an economy in essence identical to those of Western Europe, was producing art objects, superficially similar to those produced in Europe, which operated in a completely different way depending on where they were viewed. The conclusion has to be that far from breaking with the past, and in the process creating a set of cultural values from scratch, Modernism had merely supplemented a variety of cultures. Far from creating a new culture, Modernism was a set of formal devices to be used within existing cultural structures. Despite the illusion that Modernism was 'universal', it was as easily manipulated as any other art and design style.

This previous point can be illustrated by an examination of the cultural environment from which the American avant-garde emerged. There are a number of contradictions that we can explore. First, there is the notion of a national art, that was also stylistically 'international'. Second, there is the idea that it was an art of the unfettered individual that was encouraged and controlled by the state and its cultural organisations.

The Marshall Plan (the funding programme by which the United States government ensured economic and thus political stability in postwar Western Europe) ran in tandem with other government-sponsored programmes like the United States Information Service.[8] The brief of this organisation was to assist the funding of private cultural ventures overseas. It was through this means that the Abstract Expressionists were seen in Europe (and also in South America) as representing the voice of a new culturally internationalist America. In the United States, however, the work of the New York School was not universally approved. In the atmosphere of the anti-

Communist 'witch hunts' of the period, a leading voice of the institutional political right of the United States government, Congressman Dondero, recognised the transgressive role that Modernism had played in prewar Europe. As the atmosphere in the United States became increasingly politically restrictive, he spoke in the House of Representatives that

> the evidence of evil design is everywhere, only the roll call of the art contortionists is different. The question is, what have we, the plain American people done to deserve this sore affliction that has been visited upon us so directly; who has brought down this curse upon us; who has let into our homeland this horde of germ-carrying art vermin?[9]

In an atmosphere in which Pablo Picasso was refused entry into the United States (1950) and Charlie Chaplin was deported from it (1953) because of their affiliations with the Communist movement, it is not surprising that Abstract Expressionism was seen as potentially radical and destabilising.

This is what makes Clement Greenberg's critical writings on Abstract Expressionism so interesting. There are so many issues that he could have addressed in the painting of this period. The artists themselves talked of the political contradictions they found themselves embroiled in. The United States had been culturally enriched by the influx of refugee artist and designers from the 1930s on, and Jackson Pollock talked of the way that they brought 'with them an understanding of the problems of modern painting' and how the 'idea of an isolated American painting . . . seems absurd to me'.[10] Newman talked of his paintings being an assertion of freedom, repudiating dogmatic principles, and if they were read metaphorically 'it would mean the end of all state capitalism and totalitarianism'.[11] These artists are relating their work to a particular social context, but in writing about contemporary American art, Greenberg does not address the ideas of the artists (whether evident, successful, or not) in the works. Neither does he discuss their relationship with their cultural and social environment, with the substantial exception of claiming Pollock as the archetypal American painter.[12] This in itself is a strange contradictory assumption from a critic who argued that all painting should aspire to flatness and concern itself solely with formal issues. His criticism is one free from cultural reference, rooted in the perceptual logic of the viewer's relationship to the picture plane. What role does national chauvinism have in an ideology that encourages painting to become autonomous, so much so that it becomes

'an entity belonging to the same order of space as our bodies; it is no longer the vehicle of an imagined equivalent of that order . . . it compels us to feel and judge the picture more immediately in terms of its all over unity?'[13] We have already seen how in taking this stance and reading the art of the 1950s and 1960s purely in terms of form and its problems, Greenberg disconnects art practice from a social reality on one hand whilst, as we can now see, he perpetuates on the other a complex ideological stance about the position of such an art, locating its perceptual universality within American culture. For whatever reasons and contradictions, Greenberg's advocacy of a formalist position was a major contributor to the crisis in Modernism. Greenberg was responsible for a vision of an 'international' Modernism that was 'universal' because it had disconnected itself from relating to a world outside of its formal components. Such a conception of Modernism can be seen as a floating element in the cultural superstructure, *apparently* disconnected from the economic base.

Another part of this process of 'universalising' culture was the appropriation of Asian philosophical ideas in the work of some of the American painters of this period. The American form of Modernism of the 1940s and 1950s was eager to acquire (perhaps 'colonise' is a better word) Japanese and Asian aesthetic ideas just as the European model acquired and assimilated the objects of its African and Oceanic colonies at the beginning of the century (see Chapter 4). Greenberg was unhappy about the suggestion that Franz Kline and Mark Tobey were influenced by ideas outside of his linear history of painting derived from Europe, and his constructed version of the evolution of a 'flat' art derived from the Impressionists. 'Kline's apparent allusions to Chinese or Japanese calligraphy encouraged the cant already started by Tobey's case,' he wrote, 'about a general Oriental influence on "abstract expressionism" . . . The sources of their art lie entirely in the west.'[14] This statement denies (for reasons one has to consider are related to his concerns to establish an *American* art) a complex interrelationship with Asian culture that was profoundly influential in the postwar United States.[15]

It was the work of Jackson Pollock that acted as the catalyst for Modernist painting in Japan. As in the United States, artists in Japan had been aware of aesthetic changes in the art of Europe and many of them sought to translate its value into Japanese culture. The most productive assimilation had been that of Surrealism in the 1930s which allowed both a means of criticism of the Japanese state through metaphor, and an escape from its realities. During the last years of the

Second World War the Japanese Interior Ministry Police Protection Bureau investigated those artists using the Surrealist style, concerned that the style was overtly associated with the international Communist movement. Fukazawa Ichiro, who had used his art to criticise the Imperial State (for example *Oxen* of 1936 which made oblique reference to the Japanese military annexation of Manchuria) was forced to publicly recant the political possibilities of Surrealism on his release from arrest. Until 1951 when Pollock's work was shown,[16] the dominant avant-garde style in Japan was a politically conscious Surrealist art. Pollock's work was the cultural base upon which Yoshihara Jiro was able to legitimise his break from this style, and launch into an investigation of a purely experimental, individual art practice associated with the Gutai group. The group were formed around a journal, *Gutai*, which published for ten years. The group used multi-media and performance pieces to explore and experiment with the notion of unrestrained cultural expression. Because of this, the group is seen as being Japan's first foray into international modernism. If we look at Yoshihara's writing then his views seem close to those of Greenberg:

> We have always thought – and still do – that the greatest legacy of abstract art is the opening of an opportunity to create, from naturalistic and illusionistic art, a new autonomous art, a space that truly deserves the name of art.[17]

Yoshihara is arguing for an art freed from a social reality, subject to its own laws. We have to ask ourselves at this point two questions. Has the pivotal role of the Gutai group in introducing Japan to contemporary 'avant-garde' art been identified as pivotal because it indicates a break from a political art? And who has identified the pivotal nature of this cultural phenomenon? We can go some way towards answering this last question by examining the current key text in the English language on Japanese art, the catalogue to the exhibition 'Japanese Art After 1945'.[18] In it we can read that Yoshihara's role in introducing Japan to an 'international' art practice 'reflected the progressive idealism of American cultural diplomacy in the 1950s'.[19] We can see that what is pivotal here is an understanding of how ideology informs our cultural stance. The entry of Japan into an 'international' art community is also the entry of Japan into a closer cultural dialogue with the United States.

By the 1970s, what had been avant-garde in America in the 1950s had become mainstream practice in most capitalist societies, with

American artists like Ken Noland and Frank Stella (Ill. 7.2) creating works that 'affirmed two-dimensionality more literally than any cubist dared, relying more exclusively than ever before on flat areas of colour to create shape and space'.[20] In order for such critical observations to escape accusations of banality, and in order for such paintings to have a purpose, if not a meaning, theory became increasingly important in trying to justify and understand increasingly reductive works.[21] Such works (and it is possible to include minimalist and conceptual works under this general heading) were largely without a market, dependent upon a support system of art

Figure 7.2 Frank Stella, *Polar Co-ordinates for Ronnie Peterson VIII*, 1980.
 Screenprint. Collection, Art Gallery of Western Australia.
 © Frank Stella, 1980/ARS. Reproduced by permission of
 VI$COPY Ltd, Sydney 1997.

journals and cultural institutions for an audience. Whilst the support of avant-garde journals had always been the case for the European avant-garde visual art of the first half of the century, what substantially differed in the USA and Western Europe of the second half was the support of institutional galleries for such work. The 'radical' work of art was bought by art museums and galleries, almost instantaneously negating its newness and whatever socially transgressive qualities the work may have had. What was seen superficially as an international avant-garde practice was not really that, but a practice centred around a cosmopolitan clientele for such works. Such a style was neither avant garde nor truly international. It was rather a style used in metropolitan cities within the American sphere of cultural influence.

In Chapter 5 we briefly mentioned the view that Pop Art can be seen as a reaction against the elitism of International Modernism. Pop Art was a term coined by the British critic Laurence Alloway to describe that art which drew from the shared visual experience of the inhabitants of the big capitalist cities of the period. The tradition of using imagery from the mass media is one that was fundamental to early Modernism – poets and painters were thrilled by the vigorous potency of the crude industrial images they saw around them. The Dada artists used such imagery to lampoon bourgeois life and to disorientate its participants. Pop Art can be seen as an extension of some of the aspects of Dada, though to talk of it as an avant-garde art in terms of a socially concerned art, a transgressive art, is to over-dramatise it. Its sometimes ambiguous critiques of consumer society were slight, often more nostalgic than sardonic. Its own popularity as a commodity meant that it was destined for absorption into mainstream culture. Claes Oldenburg's appropriation of consumer goods, like his *Clothespin* of 1976, a thirteen-metre clothes-peg in Centre Square, Philadelphia, becomes whimsical decoration for the urban environment. His alteration of the scale of everyday objects, his contradiction of their material quality, his placement of them in incongruous settings, whilst potentially unsettling, remains controllable. Jasper Johns's use of imagery from the American flag to alphabets and rulers is more to do with using these objects to comment on art practice itself rather than on the objects' place in contemporary culture or the relationship of high and low art, between the avant-garde and the kitsch. It is Andy Warhol, as we have seen, whose dispassionate, ironic and sometimes mocking images of American life can be seen as serving a critical function.

The line between 'high' and 'low' art was being constantly eroded. The absorption of the radical into the mainstream was a double-edged phenomenon. On one hand, any critique could eventually be recontextualised by a dominant ideology and gain a modified meaning. On the other hand the mass media were being enriched as an arena of visual communication by increasingly sophisticated designers whose work was seen as commensurate with that of painters. Graphic designers like Lester Beall took the ideas of the Constructivists into corporate America for such clients as the International Paper Company and Saul Bass took Bauhaus experiments into text and image and placed them into Hollywood film credits like those of *West Side Story*. Design ideas originally formulated to transform the industrialised world were slowly being absorbed into economic production. But just as in the realm of art practice where the ideas of Modernism became not oppositional but part of the establishment, so too the ideas originally meant to *transform* design practice were simply becoming part of an armoury of styles available to the designer.

The dilemma of design in the USA during the 1950s is perhaps best represented by that of the car industry. Henry Ford was responsible for the mass-produced car. The Model T Ford was a ubiquitous object in America, the most manufactured car in the world. It made Ford the world's leading industrialist and the world's second richest man by the end of the 1930s. At the start of the 1930s millions of cars were on American roads, but their design was still similar to that of the Model T – they were essentially motorised carriages. Until the entry of the USA into the Second World War in 1941 when production was turned over to the military, a concerted attempt was made by some Modernist designers in America to find a fitting form for the motor car that would match its function. The designer Walter Teague, an eager advocate of a Constructivist-style Modernism in America, was enthusiastic in thinking that the car, like the airplane, was a functional object designed for performance and utility before anything else. To his Modernist mind,

> where the automobile has come into common use, it has enormously expanded the orbit of the individual . . . [It has] . . . had the effect of emancipating millions of people from confinement to locales and circumstances in which the accidents of fortune deposited them and allowed much greater latitude in locating industries and planning communities . . . if we assume that the aim of human progress is the freeing of the

individual from irrational restraints, so that he can plan and conduct his life under ethical compunctions alone, then the automobile provides one important phase of his emancipation.[22]

In his own designs for the motor car, Teague envisaged a form that facilitated all-round vision for the driver, had extra seating capacity and built-in bumpers, with as little projection from the main body as possible in order to adapt the form to 'air flow'. His 1938 designs resembled the cockpit of an aircraft (Ill. 7.3). He had little time for the 'inexcusably haphazard collections of unrelated parts' that constituted the motor companies' designs. He lamented that each year saw further cars produced 'with distortions and excrescences, discordant proportions and awkward lines, faults of balance and accent . . . still far from that sleek ovoid shape we believe will be their ultimate form'. By 'we' in this passage he is naturally referring to like-minded Modernist designers rather than the automobile manufacturers or the automobile-buying public. He is of course adopting the position of an avant-garde designer confronted with 'kitsch'.

It was not until 1949 that Detroit turned back to car production from armaments as its primary product. In this year the Ford Motor Company produced only its fourth style change in nearly half a century, the Custom Crestline. The 1950 version of this car was to restore Ford's postwar fortunes (one million Ford motor cars sold in that year alone), and unlike the mass-produced cars of previous years, where options as to appearances were limited, the designer George Walker introduced a new concept – that of customising. The basic car was available in a variety of options – any number of two-tone coloured bodies, with a choice of vinyl roof finishes and interior decoration. In effect we are seeing for the first time the devising of a programme that gives the mass-produced object the illusion of individuality, or, if we are to be more correct, gives the consumer the illusion that the mass-produced object that he or she has consumed reflects his or her individuality. This radical marketing move separates once again the ideas of the pre- and postwar world.

Walter Teague's vision of the car and its use was not the same as George Walker's. Teague's vision was a Modernist one. The car was a functional object that should enable its owners to further emancipate themselves, to take control of the world. It was an object that was a means to a greater social end. This social end was to be achieved through 'the creation of a rational order, convenience and rightness, so that the physical organisation of life becomes a facile aid to mental

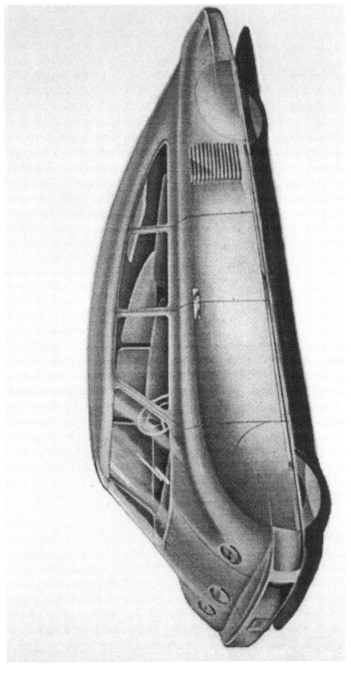

Figure 7.3 After Walter Teague, prototype design for rear-engined car, 1938.

freedom, and a source of satisfaction instead of an irritation and a defeat'.[23] Walker's view of the car, in the absence of written evidence, can be assumed to be one of an end rather than a means; it becomes a device that enables the Ford Motor Company to grow whilst it provides a service in exchange. It is not unfair to question the equity of that use exchange given that '1950 Fords had a reputation for being loosely built and leaky'.[24] But this would be to miss the point, for the use exchange was secondary to the symbolic exchange – the car, and we can substitute just about any designed object at this point, had acquired a meaning *beyond* its use function. The object was seen to talk about the consumer's status and individuality. This industry-mediated concept of identity was what worried Adorno so much when he talked of individuals having a false sense of individuality constructed for them in a mass capitalist culture.

In tandem with the development of 'conspicuous consumption' (a term coined by Veblen to describe the phenomenon of the acquisition of symbolic value through an object) was the idea of planned obsolescence (see Ill. 7.4.) 'Design', in the sense that we have seen it applied to the postwar American car industry, as a signifier of status, was something that was used in the 1930s in the United States to stimulate demand for consumer goods during the economic depression. Once the designer is removed from the modernist design ideal of being a facilitator between the user and the object, he or she then becomes someone who merely 'styles'. We have already seen the dilemma that the dialogue between function and style caused in Europe in the 1930s. However, if style alone is the criteria by which the object is designed and manufactured, then it follows that there is an urgent need to constantly replace that object when its styling ceases to signify. Thus there is a constant need for novelty, for renewal of, and change in, the object's designated status. Planned obsolescence takes this idea one stage further and incorporates the idea of the physical disintegration of the object. Objects are made cheaply because they are not intended to last; their styling decrees this. Objects are not made to be repaired but to be discarded. Victor Papanek says in his book *Design for the Real World* published in 1969 at a point at which American industry was still globally preeminent: 'for a quarter of a century American national administrations have proclaimed their tacit approval or enthusiastic support of this system'.[25] The consequences of this approach to design and consumption are twofold. First, raw materials are seen as infinite rather than finite in their availability; this assumption then takes design back into the social as

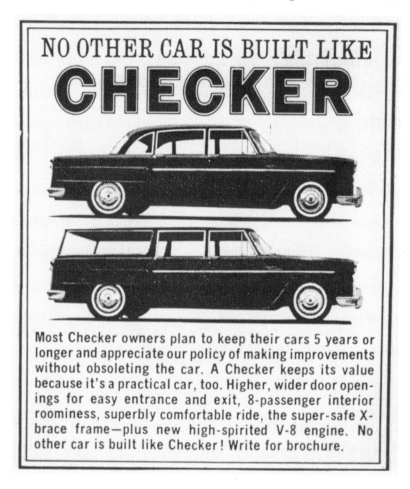

NO OTHER CAR IS BUILT LIKE

CHECKER

Most Checker owners plan to keep their cars 5 years or longer and appreciate our policy of making improvements without obsoleting the car. A Checker keeps its value because it's a practical car, too. Higher, wider door openings for easy entrance and exit, 8-passenger interior roominess, superbly comfortable ride, the super-safe X-brace frame—plus new high-spirited V-8 engine. No other car is built like Checker! Write for brochure.

Figure 7.4 Checker cars: doomed for failure in an age of planned obsolescence. Checker cars advertisement, 1967.

design becomes an environmental issue. Second, we find ourselves in exactly the same position as that diagnosed by the Arts and Crafts advocates of the 1890s. Mass production has provided us with shoddy inappropriate goods. Papanek sounds suspiciously like John Ruskin when he says, 'That which we throw away, we fail to value.' He goes on to make the point that there are further pragmatic reasons to

confront this approach to design: 'When we design and plan things to be discarded, we exercise insufficient care in designing or in considering safety factors.'[26] In support of his argument, Papanek quotes the figure that in 1969, General Motors in the United States was recalling one out of seven automobiles it made for functional design modifications, simply because these vehicles had gone into production insufficiently conceptualised and developed.

Increasingly in the industrialised world of the United States and Europe during the 1960s, there was a growing sophistication of production technology. The majority of the population had their basic needs for food, shelter and clothing met. The production of the sort of consumer goods we have been talking about differed from the sort of heavy industry that had made societies wealthy before. The industries involved in the production of such goods can be characterised as 'value-added' industries. This terms denotes the difference between the cost of raw materials and the price of the finished product. Few of these industries are tied to specific locations by their demand upon special resources. Because of this the development of such industries favours the larger cities because of their immediate access to consumer markets. This was to have enormous effects on the way that cities, and the architecture in them, were to develop.

Production and communication became two driving forces for the metamorphosis of the prewar *cities* into postwar *metropolitan areas*. Electricity's use in communication (radio, TV, telephone) expanded city boundaries by stretching immediate communication out of the city centre into surrounding regions. The motor car was also a key component in the conceptual change of the city's organisation. It not only increased personal mobility, but also led to increased flexibility in rapid short-distance transportation of industrial goods. The motor car expanded the city's boundaries by reducing the social and physical isolation of communities outside the old city's boundaries. This is intimately linked with the growth of consumer goods. Consumers can travel from one end of the metropolis to the other in search of goods, service people can move rapidly backwards and forwards fixing cars, washing machines and TVs. A new kind of industrial society was being developed in the United States, one that was to became a model for the newly developing, increasingly important industrial states like Japan, Taiwan and Korea. Such a consumer-based culture is often refered to as 'late-capitalist'.

A designer whose career culminated in the postwar culture of the United States but who was opposed to its values was Buckminster Fuller. Fuller was unimpressed by the fashionable phrase 'industrial designer' as it came to be used in the United States. As far as he was concerned it was an invention of the marketing executive rather than the art and design or engineering communities. In Fuller's 1950s narrative fable these executives announced in 1927 that

> this is very easy; there's a new invention called the airbrush. We will use it in our advertising work. Pictures of the automobiles are going to appear to be advanced – but as pure camouflage. The changes will be as superficial as fashion changes, but people will think they are looking at a new car . . . this superficial rather than fundamental design function will be effected by a new industrial showman to be called an *industrial designer*.[27] (Fuller's italics)

It is clear that Fuller was not enamoured of the society he found himself in. In design terms he was very much a Modernist, valuing the idea of form following function, where the functional acquires an aesthetic value of its own stemming from the logic of its efficiency. He was responsible for designing a number of experimental objects in a high-profile but financially unsuccessful early career, from the Dymaxion Car (1934), a three-wheeled, rear-engined prototype that never went into production, and the Dymaxion Dwelling Machine (1944), a prefabricated aluminium house commissioned by the United States Airs Corps, designed for mass production after the war, but which never passed the prototype stage. What made Fuller an international figure however was the geodesic dome which he patented in 1951 (Ill. 7.5). This was a lightweight engineering structure that enabled the spanning of huge areas. The first commission was from the Ford Motor Company in 1953 which wanted a circular structure with a diameter of 28 metres to span a courtyard at their headquarters. The success of this first commission[28] led to further commissions, with Fuller's most prestigious being the design of the United States Pavilion for the 1967 Montreal World Fair, a spherical structure 75 metres in diameter and 40 metres high. The real importance of Fuller's design though was the relationship between the minimal structural and material input related to the distances spanned. The geodesic dome's low cost and structural integrity made it applicable to many extreme weather and social conditions. Fuller's main patron was the United States Defence Department, as well as industry, which valued the lightweight easily transportable structures.

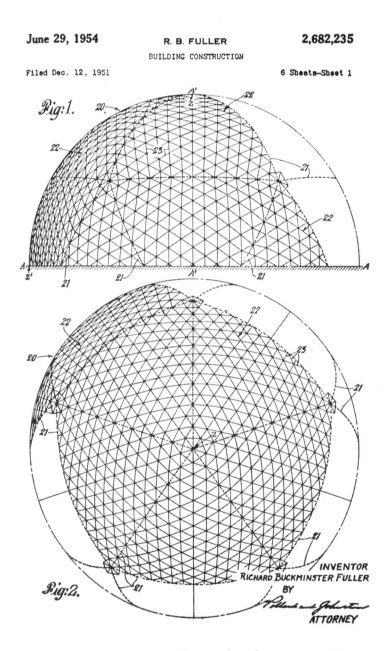

June 29, 1954　　　R. B. FULLER　　　2,682,235

BUILDING CONSTRUCTION

Filed Dec. 12, 1951　　　　　　6 Sheets—Sheet 1

Figure 7.5　Buckminster Fuller, geodesic dome patent, 1954.

In many ways these domes are the perfect Modernist structure. Purely functional, purely geometrical, easily erected and low-cost, they are a stripped-down and elegant development of the beginnings of prefabrication first seen with Paxton's Crystal Palace.

Mainstream architecture in the growing metropolises continued the dialogue established between cutting-edge technology and a search for an appropriate style. Whilst the Empire State Building by Shreve, Lamb and Harmon (1932) dazzles still in its technological brilliance, its styling was parochial and derivative of mainstream decorative devices. It was Hofmeister, Corbett and Hood's (1939) Rockerfeller Centre that matched American technical expertise with European issues of styling, with its playing with structure rather than decoration for visual effect, and with its disposition of buildings played off against a series of planned open spaces around the complex of buildings. In domestic architecture Frank Lloyd Wright had already reconciled the issues of technology, materials and styling in a way that both borrowed from contemporary practice and enriched it. Falling Water (1936) saw Wright use stone and reinforced concrete together in a domestic structure cantilevered over a waterfall in a woodland setting. His masterpiece of industrial building was the Johnson Wax Building (1949) in which he stamped a series of circular and curvilinear forms over the entire building from floor plan to office fixtures. The building is sleek and authoritative, its style closer to fashionable corporate anonymity than the functional anonymity of mainstream Modernism.

The style of the American cities was increasingly influenced by the European designers that had emigrated to the United States immediately before the war, and others who simply practised in the affluent society of postwar America. America gave these architects, among them Eero Saarinen, who designed the General Motors Technical Institute and Walter Gropius who designed the Graduate Centre (1950) at Harvard University, the opportunity to put their ideas into practice on a scale not possible to them in Europe. Whilst the styles might well have been considered European in origin, their physical expression made them American. Mies van de Rohe's Lake Shore Drive, Chicago (1951) typifies this postwar 'International' Modernism. These 26-storey twin towers, with their glazed elevations, are unadorned structures, their visual effect emerging from the careful articulation of the structural elements in an elegant rectangular surface grid. Perhaps the greatest symbolic building of the period was the group of architects[29] under the direction of the American architectural

team, Harrison and Abramovitz, who designed and built the United Nations Headquarters (1947–50) in New York. This collaboratively designed building, with its Secretariat building, an elegant, minimalist tower block, has come to represent a form of internationalism, but one centred culturally and physically in North America.

In Europe the cities, many devastated by wartime bombing, grew in a different way. Affected by cars in the same way as the cities of the United States they became larger, and their scale became influenced by that of the turning circle of the average car, but they still had at their core some of their old historical structures. New buildings were smaller than their American counterparts, although using the same 'international' style. Arne Jacobsen's Jespersen Office Block (1956) in Copenhagen displays the elegant simplicity of an undecorated curtain-walled building, but unlike its American contemporaries is only seven storeys high. Europe had to wait until 1960 for its first 30-storey building, the Pirelli Building, built in Milan by P. Nervi and Gio Ponti.

This stylistic architectural Modernism, high-quality in the city centres, shoddy and economically driven in the cities' outskirts, created an urban environment that was increasingly similar no matter which city the traveller found himself in. Cleveland or Manchester, industrial post-war cities had increasingly more similarities than differences. It was no longer to the built environment that individuals looked for identity, but substantially to the act of consumption of goods. The cities became places of consumption – they had always been so but now it was a *mass* consumption of commodities. As early as the beginning of the twentieth century Georg Simmel had analysed the effect of the urban environment upon the individual. Simmel argued that the city encouraged the development of an individualistic outlook rather than a collectivist one. This, he argued,[30] was re-inforced by the dependency of individuals upon one another within the city. The need to rely on others in order for the city to work means that individuals are viewed as role occupants; this leads to feelings of anonymity as people as well as things are seen and treated as representatives of classes or categories. In order to counteract this process the individual struggles for an independent voice, the irony being that the only vehicle that the individual has to express that need are the goods and services that reduce his or her individuality in the first instance.

Throughout the postwar years in North America, Western Europe and Australia, the consumption of commodity objects was increas-

ingly used to establish cultural identity. Information also became commodified, through news journals such as *Life* and *Picture Post*, and commercial radio and television stations. A complex representation and reflection of social and cultural environments were sold to a mass audience. Ideology was not disseminated through state propaganda as was the case in the 'Eastern Bloc' countries (those states with variants of socialist regimes), but through the voluntary purchase of commodities.

The French writer Guy Debord, editor of *Internationale Situationiste* from 1958 to 1969, a journal which analysed and encouraged the disruption of capitalist society, coined the phrase 'society of the spectacle'. He and others agreed with Lukács's proposition that the commodity was becoming an object for passive contemplation, which was a crucial device in the subjugation of the individual's consciousness. The 'spectacle' he talks about is the consumer society, and in his analysis this culture of consumption 'presents itself as something enormously positive, indisputable and inaccessible. It says nothing more than "that which appears is good, that which is good appears".'[31] That this proposition should be questioned is undeniable. The metropolis according to Debord is 'capitalism's seizure of the natural and human environment'. The 'dictatorship of the automobile . . . has been stamped into the environment with the domination of the freeway'. 'International Modernism', the legacy of the struggle to find a radical new voice for the new conditions of the industrial age is reinterpreted in this way as a mass programme of oppression: 'the same architecture appears in all industrialising countries . . . a suitable terrain for the new type of social existence which is to be implanted there'. That 'social existence' is one of consumption, the dehumanisation of personal relationships, and the degradation of the environment.

So, in Debord's analysis the programme of Modernism which aimed at physical and intellectual liberation has facilitated the opposite conditions, a similar conclusion twenty years later to that of Adorno's *Dialectic of Enlightenment*. Increasingly the role of objects becomes less important than the ideas associated with them, and as the motor car can be seen as a symbol of the postwar world, the changes slowly taking place in that motor car-driven, late-capitalist society can be characterised as the commodification of knowledge and the consumption of information. As Debord summarises it:

The complex process of production, distribution and consumption of knowledge already gets twenty nine per cent the yearly national product in the United States . . . in the second half of this century culture will be the driving force in the development of the economy, a role played by the motor car in the first half of this century and by railroads in the second half of the previous century.[32]

By culture, Debord means the whole of the cultural superstructure including the mass media and not just what is traditionally associated with the fine arts. As the media mould and form cultural expectations, they feed off their own cultural constructions, creating what Debord characterises as the 'advertised' rather than the 'real'.

Knowledge is more and more a commodity, and the notion of an avant-garde art practice less able to sustain itself. We have seen that Greenberg wanted an avant-garde practice in order to secure formalist aesthetics against the encroachment of the commodification of society, and that Adorno wanted an avant-garde to challenge and disrupt those values. Debord argues that the avant-garde is no longer viable because that culture which allowed its continued existence has disappeared. Its structures and values have vanished in a new world where 'culture becomes nothing more than a commodity' and where 'it must also become the star commodity of the spectacular society'.

If all cultural information is commodified and commodifiable then how can anything be said which critiques that culture? But if everything is commodifiable, then any viewpoint must have a market somewhere. Surely the possibility of a multitude of different voices is a good thing rather than a bad thing. Why should it be necessary for there to be one collective voice for cultural expression? For this is what Modernism inferred for some with the 'international' style in the visual arts. If anything can be said, and everyone has a voice, then how do we know what to value as a culture? These problems emerged from the contradictions of Modernism becoming a dominant ideology, and it is the articulation of these problems that the next chapter addresses.

Chapter 8

After Modernism? Or Developing Modernism?

This chapter is concerned with the shift in cultural direction in the visual arts in the last third of the twentieth century. We have seen that the Modernist world of the 1930s was different from the Modernism of the 1960s. Social, cultural and technological differences were the result of Modernist thinking and in turn created new conditions which Modernist ideology was unable to resolve. (For far from being a styleless functional and rational design process, Modernism can be seen in many circumstances to be a stylistic simulation of that.) In many Modernist objects stylistic coding suggested a rational, functional reading whilst a wider contextual reading shows the opposite. Images and objects may appear on occasions to transgress the status quo, to be avant-garde, but again a contextualisation of such images and objects shows their incorporation into mainstream ideological thinking. The fundamental contradiction of all recent Modernist practice is that of the new incorporated into the ordinary; of progress made static.

This realisation of the inadequacies and failures of Modernist thinking is often referred to as 'Postmodernism'. I am reluctant to credit the term with too much importance because it implies a new coherent body of thinking. It is perhaps more accurate to talk about postmodernisms. If we do this then we are able to talk of a variety of conceptual threads that constitute new ways of looking at the world in art and design that have emerged from Modernism in transition, and also emerged in opposition to aspects of Modernism. It is worth paying a brief conceptual visit back to revolutionary Russia at this point to provide us with a review of the artistic processes of Modernism.

The Russian Formalists, OPOYAZ, an association of linguists and literary historians who worked together in the early years of the

Soviet Union, can provide us with a way of understanding what is happening in modern art and design. Essential to their understanding of the role of art was the idea of *ostranenie*, of 'making strange'. This notion provides for an artistic process that disrupts and destabilises everyday perception, allowing for the assimilation of new ideas and the rejection of old ones. A new culture can thus be 'designed' to replace the old (and equally designed) culture. For this approach to work, there needs to be a clear understanding about the relationship between form and content, how the way something is said can change the content of information communicated. There also needs to be an understanding of how the forms of art allow for an audience to be made party to the way in which an art work is made and communicated. This objectification of the work of art demands a permanent self-consciousness and a continuous need for change.

The dilemma is how we choose to interpret this approach. On one hand OPOYAZ provides an easy way to justify a formalist approach, that there is an internal logic to art-making and that new styles and forms emerge as part of an autonomous self-regulating system, disconnected from a social reality. The other interpretation is perhaps more complex and thus more compelling. This interpretation takes the notion that 'forms or styles emerge in revolt against the old, but not as their antithesis so much as a reorganisation, a regrouping, of permanent elements',[1] but then goes beyond that self-enclosed system and relates the formal elements to a total meaning. Thus Roman Jakobson, a Russian *émigré* and part of what is known as the Prague School, developed the idea that the context of the artistic utterance was as important as the formal codes in which they were expressed. In this way the formal code itself acquires a social meaning and the idea of a fixed meaning vanishes completely. This helps explain why the forms of a Kandinsky painting do not communicate the same things when used to decorate a cup and saucer. It opens the way to an understanding that the artist can never communicate exactly what he or she wants because the meaning of images and forms alters according to circumstances, and provides a route to artistic expression in which the metaphor and parody become acknowledged as key devices once again. Not only does this idea legitimise the use of figuration, for many Modernists an anathema because of its academic associations – it also helps to explain the potency of Dada and Surrealism, and the efficacy of montage, and provides a way into reinvesting art-making with a social meaning that pure formalism had flushed away. We shall be coming back to these issues in a number of

oblique ways during the course of this chapter as we attempt to understand postmodern attitudes.

When did Modernism stop? We need to be very careful when examining this point, for two reasons. The first is that we have seen that in essence Modernism started in the Enlightenment. Its evolution was long and therefore its slow mutation into something else will be just that, slow and mutating. Second, we must acknowledge that what is *after* Modernism for some cultures is not for others. The process of transgressing a traditional culture takes different cultures different lengths of time because of historical circumstances. We must be very wary of talking about a contemporary 'postmodern world', when what we are referring to is a small part of global culture (essentially Europe and North America) that has evolved away from industrial manufacture. There is more industrial production and manufacture than ever before in the world, but it is largely centred in Asia: Taiwan, China, Japan, Korea. To many in what we call 'Western'[2] cultures these other cultures are invisible, and yet they contribute substantially to a 'Western' conception of the world formed through the consumption of commodities.

So when did Modernism turn into something identifiably different from that which it had been? Jean-Luc Godard's film *Weekend* (1967), where a couple with murderous intent negotiate an enormously long traffic jam, is a useful symbolic reference point. This catastrophe of the motor car might be one point at which the postwar Modernist dream is exposed for the illusion it was. Charles Jencks, as Andreas Huyssen notes,[3] 'dates modern architecture's symbolic demise July fifteenth, 1972, at three thirty two pm' when Minoru Yamasaki's Pruitt–Igoe mass housing scheme in St Louis was intentionally destroyed as unlivable in. This is not strictly true because Jencks talks of modern architecture's repeated 'mythical "death"' announced over a ten-year period, between 1965 and 1975, when it became increasingly clear that the solution to social problems could not be solved by functional technology alone. Social design requires an understanding of social context. The destruction of some mass housing and its redesign in the Western world was an attempt to deal with the problems caused by the failures of Modernism when used as a stylistic base for shoddy mass production, with its cheap materials, poor design, and lack of space. We can talk of a slow understanding that: first, the supposed functionalism of Modernist *stylistic* design was an illusion, and second, that technology alone was only half the design equation. Both style and technology have to be brought

together in a social context. That context in early avant-garde Modernism was revolutionary change. We have seen how that social context was to change with the absorption of the avant-garde into mainstream cultural life after the Second World War.

In formal terms, the architectural language of Postmodernism is clearly read. Instead of the reductive, minimalist style of Modernism, Postmodernist architecture is noticeable by its mixture of styles. Architects draw from the repertoire of historical styles available to them and use them in order to convey a new sense of cultural significance. Why do buildings need to be significant? Largely in order to distinguish their function, and also their social status. This is the dialogue we have observed in Modernist design, the dialogue between use and ideology. It is possible to say that the ideology of Modernism was one of anonymity, of what was perceived as 'style-lessness'. The ideology of postmodern design is one of decoration and variety. In a great deal of post modern architecture the question of social function is still not addressed. The Pruitt–Igoe project was destroyed not because it was not decorative but because it was insufficiently developed as a social design. Perhaps another key point in the awareness of postmodern architecture was the 1980 Venice Biennale in which the exhibit *Strada Novissima*, a dummy street of façade architecture, focused attention on the new style's dependency upon colour, ornament, decoration and symbolism.

The critic Ihab Hassan formulated a list of contrasting qualities that he saw as representing the differing qualities of Modernism and Postmodernism generally.[4] His pairings are open to criticism for their inconsequentiality at the very least, but he does enable us to see how aspects of Modernism are perceived to have changed. The 'Purpose' of Modernism is contrasted by Hassan with the 'Play' of Postmodernism; Modernism's 'Design' with Postmodernism's 'Chance'; 'Hierarchy' with 'Anarchy'; 'Centring' with 'Dispersal'. These conceptual pairings and their potential, but limited, worth as tools for criticism can be illustrated by a look at some architecture of the late 1970s and early 1980s.

The American skyscraper had always presented design difficulties. From the Gothic-styled Woolworth Building of 1913 to the Art Deco-styled Empire State Building of 1932, these buildings were essentially decorated technology, modern in functional technology but not in their styling. It was the late 1930s that brought a European Modernist conception of styling to American architecture, so to talk of Philip Johnson's AT&T Building (1982) with its Chippendale top as an

example of Postmodernism is to make clear the difference between the reductive styling of Modernism compared with the playfulness of the postmodern, but to reduce the debate to a particularly simplistic level. In the canon of skyscraper design Johnson's form fits snugly in with a standard solution of how to distinguish one skyscraper from another – decorate the top splendidly.

Michael Graves's façade remodelling of Marcel Breuer's Whitney Museum[5] design, with its quotations from a variety of 'modern' architectural styles from the turn of the century on, is perhaps an easier approach into the difference between the modern and the postmodern. It quotes from the past, albeit a recent one, and combines a number of disparate stylistic elements within the one design conception. It is an ironic, historicist design, entirely appropriate to a museum, but it is a purely symbolic design. The function of the building – to display art – has already been conceived and operated upon. Substantially, what Graves is doing is designing a storefront. This is nothing new in the history of architecture, but significantly different from Modernist architectural ideas to remark upon it.

This 'façade' architecture, making buildings significant through their immediate visual coding, is well-illustrated by the façades on buildings built for the Best supermarket chain in the United States in the mid 1970s. These designs by the SITE Inc. group which disrupt architectural language – façades appear to be crumbling, walls are unfinished – might superficially appear to be questioning architectural language, but ultimately, like much of Pop Art with which it can perhaps be best equated, the criticism it levels is amusing but slight. The architect James Stirling's design for the Stuttgart Neue Staatsgalerie of 1984 does a similar thing. Holes are evident in the immaculate stone masonry of the exterior, the blocks that should fill them lie on the ground beneath them, the building becomes illusionistic and metaphorical.

We have introduced a new notion here along with the idea of an increased formal vocabulary, that of criticism, or commentary. It is difficult to try and extricate this idea of critical coding from formalist decoration in much architecture of the late twentieth century. Architects like Frank Gehry in the United States, Gunter Behnisch in Germany and Kazuo Shinohara in Japan play with architectural conventions, incorporating the style of Modernism, but disrupting its pretensions to timelessness and stasis, and presenting instead a seemingly precarious Manneristic vision of it. Behnisch's Hylosar

Institute Building of 1987 for the University of Stuttgart has awkwardly pitched roofs, window frames that are irregularly sized and not at right angles to supporting walls. It has a tension between architectural signifiers of permanence and impermanence, between the illusion of structural integrity and collapse. It achieves this effect not through a logical and rational exposition of the building's function, but with a manipulation of significant building codes. So, a wall that leans does not convey stability, even if we know intellectually that it is an illusionist device and is merely decorative rather than structural.

A critique of cultural expectation – what should a building look like? – is delivered within the language of Modernist architecture, using its codes to comment upon itself. This is a development of the formalist ideas we have seen. The supposed intrinsic logic of formalism is being critiqued by its own devices. Jencks calls this 'double-coding'. Double-coding is an ironic use of codes which exploits contradictory meanings. Perhaps the most readily accessible example of this rests in René Magritte's *Ceci n'est pas une pipe* (This is not a pipe), where a painted image of a pipe is paired with the title as an inscription of equal status. One code (the painted image) presents illusion as a reality to us, the other (the written word) destroys that illusion. An uneasy equilibrium between illusion and fact, truth and lie is created.

Robert Venturi and Denise Scott-Brown's book *Learning from Las Vegas*,[6] which in essence argues for a legitimisation of architectural kitsch, enabled a further extension of this idea of parodic dialogue. Within the wider cultural view that we are taking it could be said that Venturi was enabling architecture to enter into the cultural dialogue that painting and sculpture had already undertaken in Pop Art. What were traditionally separate, the 'high' and the 'low' aesthetic aspects of architecture, were brought together and combined in an architectural style as far removed from that of Walter Gropius's, as Pop Art's was from Piet Mondrian's. Charles Moore completed his *Piazza d'Italia* in New Orleans in 1980. It is an indiscriminate mixing of classical motifs and other decorative devices, of neo-classical façades highlighted with neon. Depending upon one's critical stance, it is either excitingly theatrical, or can be seen as merely playing with, rather than critically investigating, how architectural styling communicates.

Double-coding, parody and pastiche are all devices seen to be increasingly used throughout all art and design of the late twentieth

century. The Modernist artist or designer of the 1920s and 1930s was often attempting to deal in absolutes – standardising form, universalising visual language. Compared to this struggle for one language, double-coding opens up a new outlook on how design communicates. Once again we are moving away from the assumption that it is the use value, the functionality, of the designed object that gives it meaning, and we get closer to the idea of the object communicating through codes which are entirely dependent upon context for their reading. This in itself need not be a problem for the designer who wishes to disrupt expectations, although as we have seen in the contemporary culture of the new, in which the novel is relished, critical ideas can quickly become absorbed into the mainstream. Ettore Sottsass and his design group Memphis created furniture that in the early 1980s was astonishing in its playful distortion of Modernist principles, using colour and pattern to underpin a wayward decorative use of geometric forms. Synthetic laminates and high-pitched colour, combined with a deliberately dysfunctional design, created impractical objects that implicitly attacked the hierarchy of 'taste' derived from Modernist design. What was once radical is now of course simply another generic style in any large furniture store.

Modernism strove to break with the past, to abandon tradition and immerse itself in the future. The act of decorating design historically, as some postmodern architects have done, can negate that, but the social contextualisation of design through historical reference can enable an increasing functionality. Much Modernist-derived mass housing, for example, failed to take into account the fact that the humanist aspirations of rationality, order and cooperation are not inherent in culture but learnt, and that those qualities are necessary for cooperative living. In addition there was a separation of ideological outlook between those working in the cultural superstructure and those working in the economic base. On one hand there was the need for collective approaches to living, on the other the encouragement of individualism through consumption. Contextualisation could be seen as a way of increasing the functionality of modernist design, but there is another aspect surrounding contextualisation which makes it *anti* rather than *after* Modernism.

Rather than acknowledge the complex scenario of contemporary culture, some critics have argued that what is necessary to solve the crisis in art and design is a restitution of what existed before Modernism. To do this a historical contextualisation of architecture must take place. Why? Because, as Peter Fuller observed, Postmodern-

ism has no commitments, it takes up a situational position in which no one idea, or style, is inherently better than any other.[7] Leon Krier also demands a coherent architectural style that is premodern. His architectural schemes are centred around an almost complete rejection of Modernism's ideology and methodology. He has returned to the idea of all architecture contextualised by a conception of town planning and architecture based on the teachings of the nineteenth century Beaux Arts. In his drawings of urban plans and vistas we are presented with a world in which Modernism has vanished, 'traditional' forms (that is, largely neo-classical forms) are reinstated, and even traces of modern technology are reduced to drawings of biplanes circling the cities below. He is either nostalgic, or visionary, or both, depending upon the ideological stance of his critics.

Fuller came to his analysis of Postmodernism through a careful reading of Morris and Ruskin, arguing that the way to solve the design crisis was through a return to nature as the guiding principle for design. Essentially Fuller rejects the aims and ideals of Modernism, but does not really analyse the conditions that are current and that have created the multifaceted use of cultural signifiers, within and without art practice. On the other hand, Jean-François Lyotard can provide us with a succinct summary of our contemporary condition that makes it clear that the anti-modern stance is doomed because of its oversimplification of the problem.

> Eclecticism is the degree zero of contemporary culture: one listens to reggae, watches a western, eats McDonald's food for lunch and local cuisine for dinner, wears Paris perfume in Tokyo and 'retro' clothes in Hong Kong; knowledge is a matter for TV games. By becoming kitsch, art panders to the confusion which reigns in the taste of the patrons. Artists, gallery owners, critics and public wallow in the 'anything goes'.[8]

Within this culture of many codes, and a constant changing of context, anything is permissible and nothing can be said. We have discussed the contemporary problem of the avant-garde under such circumstances, where every utterance is listened to and immediately absorbed by the society it is criticising. This is why the premodern solution is so attractive to many because it implies a stability and order that Modernism has eroded. Such a solution, however, both ignores the enormous amounts of information that exist in contemporary culture, and wishes to retreat from the complexity that Modernism has created. Another French philosopher, Jean Baudrillard, talks of the way in which public and private cultural space have

vanished in an oversaturation of meaningless communication. There is no longer a public or civic 'space' which was so central to the conception of a universalist, collectivist Modernism. Rather there are 'gigantic spaces of circulation, ventilation and ephemeral connections'.[9] Much is said within the cultural 'spaces' of our institutions and the mass media, many ideas discussed, but no conclusions are drawn, no decisions made. There is too much information for us to process and make sense of and we are trapped in a world of second-hand experiences, dependent upon media representations of the world rather than our own first-hand experience – what Baudrillard calls 'simulacra'. The shopping mall becomes emblematic of the new culture's arena for dialogue, a controlled space filled with commodities. Its public, civic, and egalitarian aspect is an illusion. It is a simulation of a shared public space (for it closes at five and then the space reverts back to its owners) and its egalitarianism is based on the acquisition of the mass-produced object. The shopping mall, a place where 'in the ideology of progress the new is king',[10] is now the main arena for social and cultural exchange rather than the Enlightenment's legacy of museums, libraries and galleries. As publicly, so too privately, where (as Adorno already intimated in the 1940s) the commodity and its signs have dominated private space, and the individual is identified by what he or she consumes. Lyotard talks about this period of mass consumption in the 'western world' as a 'period of slackening'.[11] Baudrillard argues that 'socialisation by ritual, and by signs is much more effective than socialisation by energies bound to production'.[12] Inherent in both these views is the tacit acknowledgment (but not necessarily a condoning one) that what is sometimes called the 'project', or 'meta-narrative', of Modernism has collapsed into confusion; that the idea of a unified, transparent and understandable rational culture has been proven to be an idealistic myth.

This view of the failure of Modernism is contested by Jürgen Habermas. He sees Postmodernism in the arts as *anti*modern in all its aspects, the playing with styles merely a historicist sham. With this stance, Fuller and Venturi, so different in approach, are put together as the antithesis of Modernism. Habermas does not see Postmodernism being an extension and development of the modern but a reaction against it. He talks of modernism as 'An Incomplete Project'.[13] Postmodernism with its adoption of a variety of styles, through its uncritical liaison with mass art to enrich its language, is seen by

Habermas to have sacrificed the 'tradition of modernity'. A curious phrase the more one thinks about it.

Habermas sees Modernism under assault from 'old conservatives', those like Fuller and Krier; from 'neo-conservatives', the practitioners of Postmodernism's mix and match styling; and from the 'young conservatives' who advocate the rise of the notion of subjectivity. Subjectivity, the quest for some sort of individualistic, essentialist experience and understanding, which was fundamental to Expressionism and to Surrealism, is the key to understanding much postmodern art practice. According to Habermas such advocates of a subjective approach to the world 'claim as their own the revelations of a decentred subjectivity, emancipated from the imperatives of work and usefulness, and with this experience they step outside the modern world'. A key figure in understanding this 'remove into the far-away and the archaic'[14] is Jacques Derrida.

Derrida and Lyotard are amongst those thinkers who base their viewpoint substantially upon that of Nietzsche, rather than Marx. They reject systems that prioritise the collective, universalist, objectifying approach to understanding the world and instead concentrate upon the individualistic, subjective viewpoint. Generally their position, and the ideas they propagate, can be summarised in this way: if the individual is unable, as an individual, to change the structures of the society around him or herself, then the language of the dominant ideology at least can be disrupted and destabilised. This is really the focus of their approach. It leads to a fundamental questioning of the idea of a central or fixed point to culture and its ideology. What it does not supply is an alternative set of principles.

If we think about how the idea of context suddenly makes the notion of a universal style a nonsense, and we then carry that idea through to wider cultural politics, then this can demonstrate why Derrida is important. He suggests that there can be no 'centre' because all meaning is relative. 'Deconstruction' is the term used by Derrida to describe the process of continual criticising of dominant ideas. Deconstruction does two things. It destabilises the idea of a linear cultural programme of events, and it further destabilises the role of the producer of art works.

The notion of Modernism is based around the idea of a sequential and logical progress. It defines achievable goals such as socially acceptable mass housing. The very notion of an avant-garde, as we have previously discussed in Chapter 7, implies both group activity

and a coherently controlling opposition against which the avant-garde pits itself. Derrida's approach is to fragment the centre's credibility by 'deconstructing' its objects and ideas. Deconstruction is a process by which texts (and they can be images and objects as well as written texts) are examined in terms of their reference to other things, what Derrida calls 'intertextuality'. His argument is that there can never be an ending in the process of referring to things, that meaning is always slipping away the more we try to pin it down. The more artists may struggle to represent the object in front of them, for example, the more information they put down on the canvas, the more the viewer can say: 'this artist's style is (or isn't) like A's'; 'the picture reminds me of a similar object I once saw'; 'B used the same object but as a metaphor for another issue'; or 'I read a book that spoke of that object which is used here as a visual image'. All these observations arise from the artist's attempt to make a thing known, but which ultimately opens up questions rather than closes them down. The American painter David Salle and the German Sigmar Polke both create paintings that draw from this perceived cultural inability to say one thing clearly. On their canvases a collection of images, in different styles from different sources, are spread out. A complex dialogue is created, both within the picture's own narratives and images, and within the cultural context from which the images were originally drawn. Such painting (and the work of Jeff Koons whose work is about the recontextualisation of consumer artefacts in a high-art environment, developing and perhaps mocking Duchamp's own sardonic art) can be said to be substantially based in the approaches established in Pop Art. What makes it subtly different is that there is an obvious struggle with the complexities of communication; 'meaning' is never arrived at but constantly deferred. According to this point of view, the constant deferral of meaning, it is impossible to ever have a definitive representation of the world, because all that signs can do is refer to other signs, leading us on into an ever increasing communicative confusion.

To look at works of art this way is to question the central role of the artist as an individual with something original to say. Roland Barthes talked of this in his essay 'The Death of the Author'. In it he argues that the text is something that is given meaning by the individual who interprets it, rather than something on to which the author (or artist) imposes a single meaning. 'We know now that a text is not a line of words releasing a single "theological" meaning (the message of the author-god) but a multi-dimensional space in which a

variety of writings, none of them original, blend and clash. The text is a tissue of quotations drawn from the innumerable centres of culture.'[15] There is nothing the creator of a work of art can do to take away the many associations that imagery may have for the reader of it; nothing can alter the fact that the associations of imagery resonate across cultures. Traditional attitudes to originality (and avant-garde practice) are threatened by this. The very idea of a cohesive, linear modern culture is threatened by this. It is this mind-set, and the cultural significance of mass commodities, that creates Baudrillard's 'gigantic spaces of circulation, ventilation and ephemeral connections'.[16] It is these circumstances that allow us to say: 'what does Modernism mean by what it says? Does it actually say what it means to? If the individual can be rendered speechless, incomprehensible, then surely, so can a body of thought.'

Habermas would probably agree with the last sentiment, the questioning of Modernism. After all it was Adorno who first identified the double-sided, schizophrenic aspect of Modernist culture in *The Dialectic of Enlightenment*. Where Habermas parts company with Lyotard, Baudrillard, Derrida *et al.* is that he sees Modernism as a body of thought that can still be in opposition to the culture around it, rather than remain in its mutated form as its dominant ideology. He sees that dominant ideology as a commodified shadow of a more radical and demanding Modernism.

Habermas talks of a contemporary *post-avant-garde art*. His view is that the failure of the postwar Modernist avant-garde (which is irrefutable no matter what one's ideological standpoint) has given rise to a practice characterised by the juxtaposition of styles, which either draw on the formalist languages of the avant-garde, or on the inheritance of realistic or political–didactic styles and literatures. Habermas sees this practice as *deconstructionist*, but like many Marxists is reluctant to see it as signifying the end of Modernism. He rather views the process of post-avant-gardism as a transitional period, in which its failures and strengths can be reassessed. He sees deconstruction as postponing a decision about the completion of the 'project of Modernism' rather than indicating its total collapse. Habermas's argument is reminiscent of OPOYAZ. Their analysis of the development of cultural forms and their significance, their notion of a clear understanding about the relationship between form and content, that an understanding of the forms of art allows an audience to be made party to the way in which an art work is made and communicated, still hold. The objectification of the work of art

demands a permanent self-consciousness and a continuous need for change, but related to an external cultural reality. This objectification of the work of art requires a social contextualisation that deconstruction cannot provide, as it sees all signs and codes as independent of cultural contact, forever floating and reassembling themselves at the demand of the individual reader. This is the difference between the alienation effect of Brecht which we examined in Chapter 6, and 'deconstruction'. Brecht had a clear vision of the wider issues at stake which art should address, and whilst he provided no answers, and encouraged the abandonment of an authorial voice, he nevertheless encouraged a cultural engagement that had a distinct ideological agenda.

Another voice which would reinforce the view that deconstruction encourages a superficial reading of cultural structures and the objects and images in them, is that of the American Fredric Jameson. His most influential text is most probably *Postmodernism, Or, the Cultural Logic of Late Capitalism*.[17] One of Jameson's key concerns is that the commodification of ideas has influenced the notion of history itself. The commodification of past historical styles, through their indiscriminate use in cultural production, has taken significant codes out of their chronological context and rendered them impotent and meaningless in a perpetual 'present'. This fragmented 'present' blinds us to the political reality of the collapse of the nation state, with its defined and autonomous cultural values, and the evolution of a new power base constructed around transnational corporations and their culture of commodification. His view, like that of Brecht and other Marxists, presupposes a belief in the didactic role of art, an art that enables, rather than plays.

Deconstruction has *theoretically* allowed the monolith of a 'Modernist', 'technological' ideology to be broken up. The idea of multiple readings makes it *theoretically* impossible for a single cultural voice to be heard. But one must temper this insight from the cultural superstructure with the realities of the economic base. We have already seen that the commodification of both things and ideas had fragmented the notion of a fixed *cultural* centre; especially so in capitalist society where the stability of culture is an impossibility when so much is dependent upon constant consumption of goods, services and ideas. Simultaneously, in acknowledging this fact, we must be aware that a single ideology, that of capitalist consumption, is still very powerful. The technology of communication also means that it is increasingly difficult to control information and cultural debate. The collapse of

the socialist bloc in Eastern Europe in the late 1980s was as much due to information about alternative strategies becoming available to its citizens with the increasing accessibility of foreign mass media, and the presentation of those ideas in attractive visual formats, as it was to do with the fundamental flaws in its own totalitarian structures.

For many women, Modernism's voice has always been one that is patriarchal, technological and oppressive – the voice responsible for the terror of the twentieth century. Feminism is only one of a number of previously marginalised ideologies that have found a new voice through deconstruction. A writer like the Bulgarian writer Julia Kristeva, now based in France, argues for the potentially radical role of the questioning of the single voice. She theorises that there are marginal 'languages' (or signs, or codes) that can be used to oppose the dominant ideology in a disruptive and destabilising way. She uses psychoanalysis as the basis for her argument and links her views primarily, though not exclusively, to gender. For Kristeva the collapse of traditional languages of representation must lead to a weakening of traditional gender roles.[18] Language, she argues, is patriarchal and expresses the concerns of those men who constructed the culture around us. If new languages, new forms of expression representing ideas that remain unspoken, can be found and can be created, then a new understanding of the world can be constructed. What makes her stance widely applicable to the visual arts is her view that all cultural production is the result of a constant dialogue between systems of representation. In an oppressive society signs and codes become so fixed they become atrophied. This stability of language must be broken for it to acquire new ways of expressing meaning and to become enriched. This is an analysis very close to the Modernist stance of OPOYAZ, and of course requires an avant-garde to put it into operation.

So what makes her important? Surely we have examined enough cultural politics to realise that the avant-garde is not feasible in a late-capitalist, postmodern world? The answer perhaps lies in the way that Kristeva allows a new ideological agenda to be picked up by artists. She is providing an alternative possibility to be expressed, she is interrogating, digging for meaning, rather than deconstructing and saying there is none.

This is a crucial point when one tries to evaluate the work of contemporary artists. The initial contradiction is that if we are familiar with their work, then they must have become part of Debord's spectacle. Does that mean they have nothing to offer? When

we look at Cindy Sherman's elaborately staged photographs either of herself as generic film star, or of dismembered plastic female dummies, are we to read them as a feminist interrogation of sexual oppression and role stereotyping or a deconstruction of it? Is there an ambivalence about the imagery? Can its reading be ambiguous? If so has it been incorporated into a commodity-based mainstream? The same critique can apply to the work of Gilbert and George and Anselm Kiefer. When Gilbert and George show their large photo-pieces, huge wall-sized constructions rich in homo-erotic imagery, are they interrogating or deconstructing notions of masculinity? Is their work avant-garde or simply decorative? Their work is shown in major national galleries from the UK to Russia. Does this mean that they have been so deeply absorbed into a system that they are no longer communicating anything about sexuality?[19] Does the absorption of their images by a wider culture mean that the issues they are dealing with are resolved? In Kiefer's pictorial analysis of Germany's Nazi past, how easy is it to understand what is being said? Do the complex set of symbols, signs and codes he uses in his pictures of desolate landscapes and enigmatic architectural interiors interrogate that past, or deconstruct it?

The answers to these questions hinge on many issues, most of all on the ideological position of the viewer and the context in which the images are seen. This takes us round in circles, but what can be addressed is whether such imagery is part of the Modernist meta-narrative of progress and rationalisation, or whether it is something outside it. The question can be phrased in a number of ways. Does the exclusion of issues like sexuality from the body of visual work of early Modernism show the impoverishment and failure of Modernism? Is it only the fragmentation of the structures of Modernism that has allowed space for such debates to take place? If Modernism is a radical project of the Enlightenment, then in order to enrich itself it must take on new cultural issues as they emerge. It is as much the cultural stasis that Modernism originally set itself against, not just Modernism, that causes the blockages of cultural oppression.

An emphasis on Modernism was part of the cultural structure that pre-Second World War European colonialisation, and the postwar American version of it, imposed on its client nations. In exchange for a vision of a 'global' culture, the indigenous culture of colonised nations was reduced to an illustration of the exotic, and placed in museums as ethnological rather than aesthetic objects. Homi Bhabha's book *Nation and Narration*[20] proposes a post-colonial response

to Modernism that must be seen as being part of that dialogue between form, content and context that is so important.

European colonial authorities marginalised subject national cultures and imposed their own aesthetic values upon them. The British used Sir Edward Lutyens to design New Delhi in India in the 1920s, and in Vietnam between 1925 and 1945, the Ecole Supérieure des Beaux Arts d'Indochine created a generation of artists who looked to the Paris School as the model for painting. Bhabha suggests a way of post-colonial societies coming to terms with this legacy, which simultaneously connects these cultures to a global ideology and negates their own traditions and histories. He talks of cultural peripheries rewriting the history and fiction of the centre, of a sort of 'counter-modernity'. This counter-modernity critiques both Modernism and the traditional, creating a synthesised culture drawing from both. It implies, like the gender identity politics in the old colonial countries, a critical avant-garde that can reinvest cultural language with a new potency, translating and rehistoricising what is already in existence as raw material for new creations.

How does Bhabha's process of developing a counter-modernity differ from the process of deconstruction? It differs because it implies the construction of an alternative to the dominant, colonial cultural structure. It supplements and attempts to change cultural value, and does not subscribe to the idea of the constantly deferred meaning. It is a difficult artistic process, because the utopian internationalism of Modernism has to be weighed against the problems of national chauvinism. But the destruction of the internationalism of utopian Modernism, and its less utopian offspring, transnational capitalism,[21] is the only way in which peripheral cultures can have a voice. It is a dialectical process that relates form to context. It implies a representation of traditional, pre-colonial works of art as having value beyond the exotic, and it implies the reappropriation of a formal 'universal' language to communicate that fact.

The Chinese painter Wang Guangyi does this at a most obvious level with his painting *Criticism – Marlboro* (1992) in which 'heroic' images from the period of the Cultural Revolution are combined with the brand names of the trans-national corporations that have budgets bigger than many nation states. Kanya Charoensupkul makes reference to the political turmoil of 1992 in Thailand in *Flag: May 1991/2*. Read in context, the gestural marks across the red, white and blue bands make reference to the Thai flag and actions of the 'barbarians dressed in green uniforms'[22] but detached from its political context

this could be a piece of lyrical abstraction. The dialogue between the nation and the global, the relationship between the abstract and the particular, are brought together in paintings like these and combined with an ideological glue. These paintings examine and present a clear cultural commentary, using visual signs with multiple meanings, creating cultural narratives laid over the form of Modernist visual language.

The role of individual national cultures in challenging cultural oppression is double-edged. The programme of utopian universalism is negated by it, but unless it is negated the diversity of voices in our global culture and within our localised communities cannot be heard. But without a common language, how do we communicate? The insidiousness of the visual language of the commodity is easily acquired as a global currency. The same mass media images can be consumed in any country with access to television.

This is why post-colonial theory has such important contributions to make in developing multicultural societies like Australia's and Canada's. Both nationalism and capitalist 'internationalism' attempt to override the very real divisions and conflicts of interest within any culture, to give an acceptable myth of unity where none exists. Bhabha talks of a 'third space' in which it is possible to envisage the development of a debate between ethnicity and what we have been calling commodity culture. In rejecting the idea that cultures are simply unregulated textual play, or have some sort of essential being rooted in nationalism, Bhabha opens up a way for the artist to try and create culture again. The British cultural commentator Stuart Hall makes the point that history and a sense of place are important in establishing cultural identity but that we also 'need to understand and revalue the traditions and inheritances of cultural expression and creativity. And, in that sense, the past is not only a position from which to speak, but it is also a necessary resource in what one has to say.'[23] In this way the past ceases to be the corpse-like burden as Apollinaire characterised it, but rather becomes the base from which further *progress* can be made. A multicultural society and its artists and designers have to acknowledge race, class, gender, ethnicity and their relation to power and privilege. The Australian painter Gordon Bennett does just that, creating works in which the imagery of a Western artistic tradition is interlocked with and opposed to that of his Aboriginal culture. The relationships between history and geography and race are negotiated on the canvas, as they are in the work of Alan Cruikshank. He uses digitised technology to create a record of

what never existed in order to question history, montaging Aboriginal and Asian individuals into incidents of Anglo-Australian history (Ill. 8.1). The Australian artist Hou Leong goes a step further, montaging his own Asian face in advertisements for archetypal Australian products, ironically enough usually brand-identified commodities of transnational corporations. He creates a dialogue between commodity-constructed forms of identity and their relationship with cultural reality.

While these works contribute to a debate in the cultural superstructure, their impact on the economic base that sustains capitalist globalism is of course another matter, for the development of technology and its effect on the thinking and work of artists and designers has not abated. The last chapter of this book attempts to identify the ways in which *fin de siècle* twentieth-century culture is preparing for the next century.

Figure 8.1 Alan Cruickshank, 'The Arcanum Museum: Ross and Keith Smith, Pioneer Aviators', 1996. Digital cibachrome. Collection, Art Gallery of Western Australia.

Chapter 9

Coda

The last chapter examined the cultural superstructure's response to the changing material circumstances of the contemporary culture that it helps to create and needs to interpret. In this brief coda to the book I wish to look at the circumstances that are current in the economic base and which look set to influence art and design practice as we go into the twenty-first century.

After the shrinkage of the global dominance of Euro-American Modernism (although it is still premature to talk of its collapse) the space left by its retreat is being slowly filled by powerful transnational corporations whose commodity products seem to fill every corner of the globe. The breaking down of 'the centre' identified by deconstructionists and Postmodernists is an illusion; the centre of ideological power has simply mutated to fit new circumstances. What *is* new is the recognition that the modernist programme of progress has been shifted in its course to suit the very structures which it initially set out to control and socialise. Far from being the logical conclusion of a linear path of cultural progress, it has become clear that the history of Modernism is constituted by a complex network of cultural relationships. Personal identity, which had previously been subsumed under a demand for a universal or collective identity, has become an important issue, not least to counter the illusory version of individualism that has been provided by the mass consumer society. Cultural groups previously operating on the periphery of the dominant culture are increasingly able to have a voice; but so many voices are speaking, so much is permitted after Modernism's successful transgression of traditional social constraints, that little is heard. Ideological motivation for the production of art and design, once essential to the formation of Modernist society, for a period quiescent, has once again become an important factor in a socially motivated art practice.

The dominant cultural view of a benign technological globalism has provoked an oppositional response in some artists and designers

who in their own lived experience have come to understand that the media duplication of the world produced for our consumption, distorts and corrupts our relationships with the world and with each other. An understanding of environmental design is fundamental to a reconfiguration of our understanding and subsequent guidance of our culture. Over the past thirty years it has slowly become apparent that natural resources are finite, and that controlled production and consumption are necessary to preserve the integrity of the world (an example of this is the way in which the use of CFC gases in consumer products has been directly related to the damage in the ozone layer in the southern hemisphere). We must not be under any illusions that the cultural intelligentsia have forced the pace on making manufacturers come to terms with what we know as 'green' design issues. Social development was forced on the British industrial cities of the nineteenth century because disease and squalor were starting to impinge on the quality of life of the ruling class in an increasingly destabilising way. Manufacturers are aware, and privi-leged affluent nation states too, that increased production and con-sumption are causing instabilities which are affecting their own security. It is in the interests of self-preservation that states and corporations are toying with ideas of the sustainability of resources. Ideas about planned obsolescence in the manufacture of goods are being replaced with notions of repairability, disposability is being replaced with recyclability. The economic base, if we can anthro-pomorphise it for a moment and endow it with a sentience all its own, is undergoing a slow transformation in order to ensure its perpetua-tion.

Design is essential to the success of this project, but its parameters need to be drawn by those in the cultural superstructure in order to shift the paradigm towards a rationality suited to long-term human advantage, rather than short-term economic stability. Design is a process of closure, of finding solutions to problems. If we have learned anything in the last century it is that closure can be oppressive and destructive. Design has to solve problems but in a cultural atmosphere of flexibility. It must be able to tolerate, accommodate and build on change. Design needs a programme of counter-moder-nity all of its own, a programme which allows it to negotiate style with function. Victor Papanek talks of the designer 'reaching a state of inner grace through the act of helping others'.[1] Whilst one may quibble with the essentialist language, it is indisputable that to assist in the construction of a socially progressive world is more productive

than to collaborate with the structures that are party to its destruction. This observation goes well beyond the reductive utilitarian view that a successful design economy means happy consumers, and happy consumers mean a successful design economy.

We must remember that designers are responsible for poor quality housing, motor cars that maim and the production of very efficient products like military hardware, as well as ecologically sound, rammed earth, energy-conserving homes, and artificial limbs. It is important to remind ourselves of the task the ideologically motivated designer who wishes to promote social well-being is up against. As I write, at the end of the 1990s, carbon emissions from fossil-fuel burning continue to rise, so too does motor vehicle production. These facts do not suggest a new post-industrial world. Instead they indicate a world increasingly industrialised and increasingly contributing to the problems of the industrially alienated individual first identified in the middle of the nineteenth century in Britain. It would cost around ten billion Australian dollars on top of what is already spent on education globally to give every child in the world a primary school education. Yet this figure is less than one per cent of the annual global arms budget. It is hard to see the social logic in this, and such a figure defies dismissal as a piece of liberal humanist sentimentality. The designer has to face full on the ideological problem of how closely he or she wishes to be engaged with 'a wasting, squandering, abusive industrialisation'.[2]

The global communications system and its interrelationship with the new technologies is also an arena for constructive engagement for the visual arts. But before we even switch on our computer and start to use the internet, for example, there are already a number of preconceptions about what it is, how it works and what it is for. Unless these issues are understood, its cultural and technological context unravelled by the artist and designer using it, it too will act not as an enabling mechanism but a constraining one like traditional technology.

The first notion we need to address is the internet as a decentralised and non-regulated information network, one that has no central base and no owner. The internet is a multitude of interconnected local, national and international communication networks, linking anyone with a computer, a modem and a telephone line. But we also need to acknowledge that its origins lie in the heartlands of the industrial–military complex of the United States, that its driving force was the US Defense Department's desire for a decentralised communication

system capable of withstanding nuclear assault during the height of the Cold War, and that its basic software programming was refined by the same generation of computer programmers that headed the commercial personal computer revolution. Why should this be important? For the same reasons that Fredric Jameson reminds us in his writings, that a Postmodernist notion of deconstructive cultural play and intertextuality is built upon an oppressive and environmentally destructive transnational global economy; that the soft underbelly of Postmodernism is 'blood, death and horror'.[3] We need to constantly remind ourselves that our cultural superstructure is built on an economic base; this fact will never go away.

The internet is frequently conceived of as a neutral medium for the display of computer imagery on web sites. It is often regarded as an abstract global entity, totally independent, egalitarian, and presenting a readily accessible parallel 'virtual' universe. In it, we are told, the world is offered to us in the form of information. We need to address this issue before we can go any further and start looking at the way in which the internet is of positive use to artists and designers because ultimately it has a bearing on the way that their practice may operate.

Just how global is the internet? Well, reasonably global if one assumes that globalism is just about the random distribution of objects over the world's surface. However, if we look more closely at this notion of how the net is distributed then it becomes less of an indicator of the liberation of technology and communication, and more of an indication of how that technology actually reinforces a set of dominant cultural ideologies that control everything else. The net demands a certain competence in technological material. It is impossible to contact anyone who does not have a phone line in place (unless of course they have an alternative high-technology system). If we then transfer this idea to global low-income communities, then it becomes clear that rather than being an instrument of enablement, the net is simply another layer of technology that controls and dominates rather than elucidates. To use the net one has to comply with the dominant technological paradigm.

No one really knows for certain how many users of the net there are, but they grow daily and at the time of writing, numbers like sixty million and growing are often used. A cybernetic nation. But a small one, a mere one per cent of a global population predicted to be over six thousand million by the year 2000. What we have emerging is a profile of a minority of the world's population who are already operating in areas of technological privilege, itself a minority area.

Within this technological profile these users then conform to a certain economic profile. The technology needed to gain access to the internet demands a level of income which may be seen as modest in terms of middle-class industrial and post-industrial societies, but which is nevertheless impossible in the majority of the world's population. The narrowness of the postmodern, post-industrial world view is quite disturbing when we step outside of its parameters. Far from a new world of free information that we as readers/consumers access and turn into expressions of ourselves, we have a minority high technology culture, still being used to perpetuate the ideas and social attitudes of a dominant capitalist class. The postmodern notion of transculturalism, of a breaking down of cultural prejudice and ideological barriers, is a fantasy. Rather, what we have is a multitude of choices within limited areas that reflect the dominance of transnational capital.

If the users of the internet cannot place themselves culturally, then they are in danger of misinterpreting their particular cultural status. Post-colonial Australia often identifies itself as geographically marginalised from a supposed global culture. The reality is that internet users anywhere are slap bang in the middle of a privileged elite whether they like the values inherent in that elite or not. If we think about other information systems linking societies in the past, the user of the internet operates within an ideologically restrictive information network closer to that created by the monks and monasteries of medieval Europe than that of the egalitarian free public library system of the nineteenth century.

What are the benefits available to those artists and designers desperate to shake off the feeling that somehow they are separate from the next person, city, state, country – somehow isolated from the centre of a global culture? In terms of cultural institutional information, the internet provides access to any number of libraries and collections and information-gathering about the location of art and the discussion of it. It is enormously exciting to visit the cybernetic shadows of collections like the Andy Warhol Museum, and the Getty Collection, but this information is still second-hand, still elsewhere, still constituted as a centre. Whilst it is liberating to know that the reproduction of imagery is available to us, it is mediated and not the original. Does this matter? We have seen that what Walter Benjamin called the 'aura' of art works is dissipated by reproduction and this is a liberating phenomenon, to be emancipated from the tyranny of the individual object and its traditional institu-

tional control mechanisms such as the gallery. But at the same time the individual aesthetic object does have particular and distinct qualities that in a world largely dominated by mediated imagery become increasingly important.

In the past, artists and designers on the geographical periphery of Modernism were either dependent upon leaving their own culture to study in the 'centres' or reliant upon photographic information in journals to 'connect' them with an international avant-garde. In our current conditions of course, the idea of an avant-garde is problematic; we are now supposedly living in a perpetual present of recycled, deconstructed information, and the internet is an example of that. But another aspect of the reality of the internet is that to be connected to it is to be part of the ideological centre – the irony being that the centre is now fragmented and dissipated over a wider geographical area and range of media than ever before.

It is almost within the grasp of the periphery (whether that be geographical, racial or sexual) to establish a electronic international voice of its own, and to be heard on equal terms with what has often been considered the privileged voice. I say almost, because it is clear that state authorities do not like the idea of information they perceive as undesirable given free rein. Currently this concern in the USA is directed towards sexual material on the net, but if one aspect of communication is deemed controllable, the precedent has been established that *any* information can be controlled. If this is the case then there still remains that invidious hierarchy of privileged fact.[4] The net is certainly aiding the free, dispassionate, dispersal of information but it should not be a foregone conclusion that this will always be the case. Mediation between us and the world always works in an insidious way. Both the commodification of information and its control by the state create stoppages in the flow and exchange of ideas.[5] These ideas are sometimes lost anyway in the sheer quantity of information that is available to us – so much information that it is almost impossible for us to correlate and use it constructively, other than to acknowledge that it is there.[6]

Are we forever compromised by any interaction with technology? Just as dominant ideologies attempt to colonise us, so too there are things within its control mechanisms that we in turn can exploit (the socialist cooperative movement after all evolved from the strictures of monopoly capitalism). The internet provides a powerful tool for interpersonal communication. It allows a wider cultural conversation than ever before. It is possible to build a complex series of contacts

with like-minded people that previously would have been unthinkable. Ideas can be bounced backwards and forwards over continents, and cultural networks established in days rather than months. It is possible to write a letter in the morning to a friend in Ireland, read the reply over lunch in Australia, and respond to that by afternoon tea. By the end of a week, debates that might take months using traditional means of communication can be drawn to a close. This widening of discussion can only be liberating, but with the proviso that it is still only part of the complex of human interaction, and that the negation of physicality involved in this process is especially problematic when we are dealing with a practice like the visual arts, where content is continually in dialogue with the physical forms of its representation.

The art produced by artists using the new electronic media has been characterised as a movement away from the private and into the public realm.[7] 'Burning the Interface', an exhibition of artists' work on CD-ROM held in Sydney in 1996, was the first international review of the state of such electronic arts. The images themselves are less important than the cultural structures that surround them and their collective presence in the show. The idea of these images as part of 'a collective intelligence of hyperlinked activity . . . where the oral tradition is being redeveloped',[8] is a humanisation of the electronic arts, and at odds with the view of the electronic media as oppressor. In this remark we can see an ideologically driven attempt to reclaim technology as a tool for the cultural superstructure. Ironically enough it echoes the debate of the Arts and Crafts movement a century earlier, in its emphasis on a collective culture rooted in first-hand, unmediated, experience. It is possible to see a utopian project for the electronic media as a means for unmediated global communication, but this has to be tempered with the reality that the hardware and software of the new technologies are industrial commodities and controlled at the source of production.

Is it ever possible to assess the success of a cultural project? Is there a point at which we can identify the successes and failures of art and design practice? It depends upon our criteria of assessment, which in turn depends upon our ideological position. This book has attempted to describe this process. If there is any conclusion it is that the separation of the image/object, in whatever form this may take, from the cultural environment in which it is created is to destabilise and deprive the object of its full meaning.

Notes

Chapter 1

1. A. Briggs (1965) *Victorian Cities*, Pelican, p. 89.
2. We shall be examining the ideas and influence of Marx in more detail later on in the book, particularly in Chapter 6.
3. W. Pater (1980) *The Renaissance*, University of California Press, pp. xx–xxi.
4. See E. Poynter (ed.), (1880)*Text Book of Art Education*, Law, Searle & Rivington.
5. See J. Burckhardt (1937) *The Civilisation of the Renaissance in Italy*, George Allen & Unwin.
6. S. Dresden (1968) *Humanism in the Renaissance*, W.U.L., p. 55.
7. Pater (1980) *The Renaissance*, p. xxi.
8. B. Berenson (1950) *Aesthetics and History*, Constable, p. 24.
9. G. W. F. Hegel (1959) 'Philosophy of Fine Art', in M. C. Beardsley (ed.), *The European Philosophers from Descartes to Nietzsche*, Random House, p. 639.
10. C. Dickens (1970) *Dombey and Son*, Penguin, p. 290. First published 1848.
11. See R. Redgrave (1853) 'Report on Design', *The Illustrated Magazine of Art*, vol. 1.
12. J. Ruskin (1901) 'The work of Iron in Nature, Art and Policy' in *The Two Paths. Lectures in Art and its Application to Decoration delivered in 1858–9*, George Allen, p. 205.
13. G. Debord (1970), *Society of the Spectacle*, Black & Red, p. 12.
14. See T. More (1965) *Utopia*, Penguin.
15. E. P. Thompson (1980) *The Making of the English Working Class*, Penguin, p. 884.
16. O. Wilde (1963), 'The Soul of Man under Socialism', in *The Complete Works of Oscar Wilde*, William Collins, p. 381.

Chapter 2

1. J. Ruskin (1905) *The Stones of Venice*, George Allen, vol. 2, p. 172.
2. M. Mather (1898) *John Ruskin, his Life and Teaching*, Warne, p. 25.
3. W. G. Collingwood (1900) *The Life of John Ruskin*, Methuen, p. 170.
4. J. Ruskin (1901) *The Two Paths, Lectures in Art and its Application to Decoration Delivered in 1858–9*, George Allen, p. 137.

5. See W. Morris (1892) 'Preface' to J. Ruskin, *The Nature of the Gothic*, Kelmscott Press.
6. N. Pevsner (1991) *Pioneers of Modern Design*, Penguin, p. 22.
7. C. Ashbee (1887) *Private Journal*, 4 December.
8. See W. Lethaby (1922) *Form in Civilisation: Collected papers on Art and Labour*, Oxford University Press.
9. B. H. Jackson (ed.) (1950) *The Recollections of T. G. Jackson*, Oxford University Press, p. 218.
10. G. Moore (1893) *Artistic Education in England and France*, Walter Scott Publishing, p. 64.
11. Pevsner *Pioneers of Modern Design*, p. 112.
12. R. Fry (1937) 'Art and Socialism' in *Vision and Design*, Pelican, p. 67.

Chapter 3

1. H. Meyer (1926) *The New World*, quoted in D. Sharp (ed.) (1975) *Form and Function*, Crosby Lockwood Staples p. 109.
2. H. Muthesius (1907) *The Meaning of the Arts and Crafts*, quoted in Sharp, *Form and Function*, p. 39.
3. H. Muthesius (1904) *Das Englishe Haus*, Wasmuth.
4. Muthesius, *The Meaning of the Arts and Crafts*, quoted in Sharp, *Form and Function*, p. 39.
5. See H. Muthesius (1975) 'Propositions' in C. Benton (ed.), *Documents. A collection of source material on the Modern Movement*, Open University Press.
6. H. van de Velde 'Counter-propositions', in Benton, *Documents*.
7. 'Extracts from the Werkband Debate', in Benton, *Documents*.
8. D. Burnham quoted in C. Tunnard and H. H. Reed (1956) *American Skyline*, New American Library, p. 144.
9. D. H. Kahnweiler (1949) *The Rise of Cubism*, Wittenborn, Schultz. p. 25.
10. G. Apollinaire quoted in H. Spencer (1969) *Pioneers of Modern Typography*, Lund Humphreys, p. 14.
11. F. T. Marinetti (1908) *The Foundation and Manifesto of Futurism*, in U. Apollonio (ed.) (1973) *Futurist Manifestos*, Thames & Hudson, p. 24.
12. Curiously enough, the objects of technology often had feminine attributes thus Marinetti talks of 'large-breasted locomotives'.
13. A. G. Bragaglia (1912) *Fotodinamica Futurista*, in Apollonio, *Futurist Manifestos*, p. 38.
14. J. Pierre (1969) *Futurism and Dada*, Heron Publishers, p. 19. Pierre goes on to make the point that the Futurists 'intuitive' rather than 'intellectual' understanding of the events around them, their 'basic complicity with capitalism' led to their easy assimilation into, and compliance with, the Italian Fascist state.

15. Einstein published his *Theory of Relativity* in 1905, and whilst it has a specific scientific purpose, it also had more general aesthetic and metaphorical consequences.
16. Carlo Carra, 'From Cezanne to Us, the Futurists' in H. B. Chipp (ed.) (1968) *Theories of Modern Art*, University of California Press, p. 304.
17. Ibid., p. 305.
18. U. Boccioni (1912) *Technical Manifesto of Futurist Sculpture*, in Apollonio, *Futurist Manifestos*, pp. 51–65.
19. G. Balla, F. Depero (1915) *Futurist Reconstruction of the Universe*, in Apollonio, *Futurist Manifestos*, p. 200.
20. It is tempting to see this whole manifesto as an enormous joke. Without doubt it is a bombastic and provocative piece designed to aggravate bourgeois sensibilities. Whether it was intended to be a parody of futurist megalomania its impossible to ascertain.
21. 'Colours no longer sufficed. Objects began to be introduced into pictures. At one exhibition, Larionov put some objects and paints around a ventilator. The ventilator was electric; it was switched on, started running, and the artist stood in fascination before a painting which had absorbed movement'. V. Shlovsky (1974) *Mayakovsky and his Circle*, Pluto Press, p. 21.
22. Quoted in C. Gray (1962) *The Great Experiment: Russian Art 1863–1922*, Thames & Hudson, pp. 136–7.
23. Shlovsky, *Mayakovsky and his Circle*, p. 23.
24. Quoted in C. Lodder (1983) *Russian Constructivism*, Yale University Press, p. 76.
25. N. Punin, *Tatlin's Tower*, first published as a leaflet in 1920, and then in 1922 in *Vesch/Gegenstand/Objet*, the international Constructivist journal. In S. Bann (ed.) (1974) *The Tradition of Constructivism*, Thames & Hudson, p. 14.
26. N. Punin, article in Iskusstvo Kommuny, March 1919. In C. Benton, T. Benton and D. Sharp, (eds) (1975) *Form and Function*, Open University Press, p. 87.
27. V. Tatlin, T. Shapiro, I. Meyerzon and P. Vinogradov (1920) *The Work Ahead of Us*, quoted in Bann *The Tradition of Constructivism*, p. 12.
28. L. Trotsky (1924) 'Revolutionary and Socialist Art' in Benton *et al.*, *Form and Function*, p. 101.
29. Editorial from *Blok* (Warsaw), no. 6, quoted in Bann, *The Tradition of Constructivism*, p. 103.
30. P. Mondrian quoted in P. (1969) *De Stijl*, Studio Vista, p. 57.
31. T. van Doesburg quoted in Overy *De Stijl*, p. 57.
32. Mondrian quoted in Overy, *De Stijl* p. 93.
33. Le Corbusier was the pseudonym of Charles Eduard Jeanneret, his book *Vers une architecture* (1923) was very influential in disseminating Modernist architectural ideas. He produced schemes for mass housing,

town planning, and symbolic buildings such as churches, all of which
gained him, and his ideas, enormous influence.

34. N. Pevsner (1960) *Pioneers of Modern Design*, Penguin (2nd edn 1949,
 published by the Museum of Modern Art, New York).
35. Ibid., pp. 214–16.
36. L. Moholy-Nagy (1922) 'Constructivism and the Proletariat' in Benton
 et al., *Form and Function*, pp. 95–6.
37. Ehrenburg quoted in J. Willet (1978) *The New Sobriety. Art and Politics
 in the Weimar Period*, Thames & Hudson, p. 119.
38. Other Bauhausbücher edited by Gropius and Moholy-Nagy were Piet
 Mondrian (1925) *New Design*, Theo van Doesburg (1925) *Principles of
 the New Art*, Lázló Moholy-Nagy (1925) *Painting, Photography, Film*,
 Wassily Kandinsky (1926) *Point and Line to Plane*, Kasimir Malevich
 (1927) *The Non-Objective World*, Albert Gleizes (1928) *Cubism*, and
 Lázló Moholy-Nagy (1929) *From Material to Architecture*.
39. H. Meyer quoted in J. Willet (1978) *The New Sobriety*, p. 121.

Chapter 4

1. First published in Germany in three instalments (1883, 1884, 1885).
2. 'Not "Mankind", but Superman is the goal.' F. Nietzsche (1927) *The
 Philosophy of Nietzsche* Modern Library, Aphorism 1001.
3. Ibid., Aphorism 1000.
4. S. Mallarmé *Crisis in Verse*, in A. Hartley (ed.) (1970) *Mallarmé*,
 Penguin, p. 165.
5. G. A. Aurier (1893) 'Essay on a New Method of Criticism', in H. B.
 Chipp (ed.) (1968) *Theories of Modern Art*, University of California
 Press, p. 88.
6. M. Denis (1890) 'Definition of Symbolism', quoted in R. Goldwater and
 M. Treves (1945) *Artists on Art*, Pantheon.
7. O. Redon (1909) *Suggestive Art*, quoted in Chipp, *Theories of Modern
 Art*, p. 117.
8. Letter from Gaugin to August Strindberg, 5 February 1895, ibid., p. 83.
9. Letter from Gaugin to Charles Morice, April 1903, ibid., p. 86.
10. Letter from Gaugin to August Strindberg, 5 April 1895, ibid., p. 82.
11. P. Gaugin (1903) 'Avant et Après', ibid., p. 84.
12. E. Munch 'Art and Nature', ibid., p. 114.
13. J. Ensor (1923) 'Les Ecrits', ibid., p. 111.
14. N. Pevsner (1960) *Pioneers of Modern Design*, Penguin, pp. 68–88.
15. This and the following quotations are from W. Kandinsky (1947)
 Concerning the Spiritual in Art, Wittenborn Schultlz, first published
 in Germany in 1912.
16. H. Poelzig (1931) 'The Architect', in D. Sharp (1975) *Form and
 Function*, Crosby Staples Lockwood, p. 58.

17. Ibid., p. 60.
18. A. Behne (1919) 'Glass Architecture', ibid., p. 78.
19. M. Duchamp, in L. Lippard (1971) *Dadas on Art*, Prentice-Hall, p. 43.
20. See T. Tzara (1918) *Dada Manifesto*, ibid.
21. R. Huelsenbeck (1920) 'En Avant Dada', in Chipp, *Theories of Modern Art*, p. 377.
22. J. Heartfield in Lippard, *Dadas on Art*, p. 127.
23. This and the following quotations are from Breton's 'First Surrealist Manifesto', in L. Lippard (1970) *Surrealists on Art*, Prentice-Hall, p. 10.
24. 'The Second Surrealist Manifesto', ibid., p. .27.
25. M. Ernst (1934) *What is Surrealism?*, ibid., pp. 134–5.
26. See D. Craven (1993) *Myth Making in the McCarthy Period*, Tate Gallery, where this theme is examined in detail.
27. B. Newman (1948) 'The Sublime is Now', in Chipp *Theories of Modern Art*, p. 553.
28. 'Abstract, Representational, and So Forth.' in C. Greenberg (1961) *Art and Culture*, Beacon, p. 133.

Chapter 5

1. We need to remind ourselves at this point however, that the Modernist vision of international urbanisation was not a fully global one, but one that encompassed just Europe and America.
2. M. Ray (1935) 'On Photographic Realism' in C. Phillips (1989) *Photography in the Modern Era*, Museum of Modern Art, New York, p. 57.
3. E. Kallai and A. Renger-Patzsch (1929) 'A Postscript to Photo-Inflation/Boom Times', ibid., p. 141.
4. V. Santholzer (1925) 'The Triumphant Beauty of Photography', ibid., p. 309.
5. A. Rodchenko (1928) 'The Paths of Modern Photography', ibid., p. 259.
6. Perhaps the earliest of these is Frank Mottershaw's *A Daring Daylight Burglary* filmed for the Sheffield Photo Company in the UK in 1903.
7. S. Eisenstein (1929) 'Film Form' in G. Mast and C. Cohen (eds), *Film Theory and Criticism*, Oxford University Press, p. 123.
8. Phillips *Photography in the Modern Era*.
9. Ibid., p. 211.
10. V. Stepanova (1973) 'Photomontage', ibid., p. 235.
11. F. Weil quoted in R. Wiggerhaus (1994) *The Frankfurt School*, Polity Press, p. 12.
12. W. Benjamin (1979) *One Way Street and Other Writings*, New Left Books.
13. We have already established that the whole process of industrialisation and its effects, cultural and social had been examined by John Ruskin in nineteenth-century Britain.

14. W. Benjamin (1970) 'The Work of Art in the Age of Mechanical Reproduction' in *Illuminations*, Fontana, p. 223.
15. In T. Adorno and M. Horkheimer (1986) *Dialectic of Enlightenment*, Verso. First published 1944.
16. Wiggerhaus *The Frankfurt School.*
17. Adorno and Horkheimer, *Dialectic of Enlightenment*, p. 154.
18. Ibid., p. 140.
19. Ibid.
20. Ibid., p. 141.
21. Ibid., p. 142.
22. Ibid.

Chapter 6

1. This is of course an ideological assumption as powerful as any other.
2. In Lewin's case the recording of the flora and fauna of the new colony of New South Wales in Australia.
3. It is perhaps worth pointing out that the academies represented the mainstream view of painting; a dominant ideological view of how the world was. It was this view of course that Modernism rejected, but we must remember that the academies were powerful institutions in moulding attitudes.
4. W. Bouguereau (1885) 'In Defense of the Ecole Des Beaux Arts' in R. Goldwater and M. Treves (1976) *Artists on Art*, John Murray, p. 287.
5. Ibid.
6. *Royal Academy Pictures 1899*, Cassell & Co.
7. W. L. Wylie ARA.
8. George Leslie RA.
9. M. Denis (1912) 'Theories 1890–1910' in E. G. Holt (ed.) (1966) *A Documentary History of Art*, Anchor, p. 511.
10. W. Frank Calderon.
11. 'The Boer War caused national alarm at the poor physical quality of recruits, and an inter-departmental Committee on Physical Deterioration was set up in 1903–4 to investigate and propose remedies.' K. W. W. Aikin (1972) *The Last Years of Liberal England*. Collins, p. 76.
12. E. Zola (1866) 'M. Manet' in Holt, *A Documentary History of Art*, p. 384.
13. Zola (1866) 'Present day Art', ibid., p. 381.
14. Zola (1866) 'The Realists in the Salon', ibid., p. 385.
15. See C. Baudelaire (1964) *The Painter of Modern Life and Other Essays*, Phaidon.
16. Zola (1866) 'The Realists in the Salon'.
17. The following quotes and observations are drawn extensively from P. C. Vitz 'Visual Science and Modernist Art: Historical Parallels', in

C. Nodine and D. Fisher (1979) *Perception and Pictorial Representation*, Praeger.

18. Ibid.
19. Ibid.
20. Ibid.
21. E. Fischer (1963) *The Necessity of Art*, Pelican, p. 75.
22. Ibid.
23. Ibid., p. 77.
24. L. Baxadall and S. Morawski (eds) (1973) *Marx and Engels on Literature and Art*, International General, p. 115.
25. G. Plekanov (1957) *Art and Social Life*, Progress Publishers.
26. L. Trotsky (1933) 'Historical Objectivity and Artistic Truth', in P. Siegel (ed.) (1970) *Leon Trotsky on Literature and Art*, Pathfinder Press, p. 93.
27. D. Laing (1978) *The Marxist Theory of Art*, Harvester Press, p. 40.
28. Ibid., p. 37.
29. Ibid., p. 41.
30. I. Matsa (1944) 'Traditsiya i novatorstvo' in C. Cooke (1993) *Socialist Realist Architecture*, MUP, p. 87.
31. Boris Iofan with Vladimir Shchuko.
32. D. Arkin 'Architecture' in C. Holme (ed.), *Art in the USSR*, Studio, p. 18.
33. J. Willet (1978) *Art and Politics in the Weimar Period*, Thames & Hudson, p. 116.
34. G. Lukács 'Realism in the Balance' in F. Jameson (ed.) *Aesthetics and Politics*, Verso, p. 54.
35. G. Lukács (1971) *History and Class Consciousness*, Merlin. First published in 1923.
36. R. Barthes (1977) *Image, Music Text*, Fontana, p. 72.
37. B. Brecht 'On Non-objective Painting' in B. Lang and F. Williams (eds), *Marxism and Art: Writings in Aesthetics and Criticism*, Longman.
38. Ibid.
39. T. Adorno (1980) 'Commitment' in F. Jameson *Aesthetics and Politics*, p. 188.
40. Ibid.
41. A. Hitler (1937) 'Inaugural speech: The Great Exhibition of German Art' in H. Chipp (ed.) (1968) *Theories of Modern Art*. University of California Press, p. 474.
42. Manifesto issued by the Mexican Syndicate of Technical Workers, Painters, and Sculptors, 1922, in B. Myers (1956) *Mexican Painting in Our Time*, Oxford University Press.
43. B. Rose (1967) *American Art Since 1900*, Praeger, p. 107.
44. *Peasant Paintings from Huhsien County* (1974) Foreign Languages Press.
45. Personally I think the works show strong evidence of skilled 'academic' hands, that have mastered complex representational skills.

46. *Graphic Art by Workers in Shanghai, Yangchuan and Luta* (1976) Foreign Languages Press. This too suggests that the images are those of 'amateur worker, peasant and soldier artists' but further scrutiny of the text shows the able hands of 'art workers' who have been attached to various factories.
47. Jen Shang-yung 'Art worker of the Talien Machine Tool Plant'.
48. By Ho Ting-lung, Yang Nan-jung, Hsueh Chi-ching and Chai Pen-sham.
49. E. Lucie-Smith (1979) *Super Realism*, Phaidon.

Chapter 7

1. This in itself is a dangerously eurocentric phrase. The war was 'cold' for the US and Europe but it was a 'hot' one for Korea and Vietnam.
2. See R. Krauss (1986) *The Originality of the Avant-Garde and other Modernist Myths*, MIT Press.
3. 'Avant Garde and Kitsch' in C. Greenberg (1965) *Art and Culture*, Beacon.
4. Ibid., p. 10.
5. B. Newman (1948) 'The Sublime is Now' in H. Chipp (ed.) (1968) *Theories of Modern Art*, University of California Press, p. 553.
6. See M. Tuchman (1970) *The New York School*, Thames & Hudson.
7. C. Greenberg 'The Situation at the Moment' in S. Gilbaut (1983) *How New York Stole the Idea of Modern Art*, Chicago University Press, p. 169.
8. In the 1950s to be renamed the United States Information Agency.
9. G. Dondero (1949) 'Modern Art Shackled to Communism' in Chipp, *Theories of Modern Art*, p. 497.
10. Quoted in M. Tuchman (1970) *The New York School*, p. 117.
11. Ibid., p. 112.
12. See Gilbaut, *How New York Stole the Idea of Modern Art*, University of Chicago Press, for a full analysis of this Americanisation of Modernism.
13. 'Abstract, Representational, and so forth' in Greenberg, *Art and Culture*, p. 137.
14. 'American-Type Painting', ibid., p. 220.
15. 'David J. Clarke has established that his popular fad for "Oriental thought" swept a whole generation of American artists from the mid-1940s to the mid-1960s.' B. Winter (1994) 'Japanese Thematics in Post-war American Art' in A. Munroe (ed.) *Japanese Art After 1945*, Abrams, p. 57.
16. At the 1951 Third Yomiuri International Exhibition.
17. J. Yoshihara (1955) 'Gutai Art Manifesto' in Munroe, *Japanese Art After 1945*, p. 370.

18. The Guggenheim Museum, and the San Francisco Museum of Modern Art 1995.
19. A. Munroe 'To Challenge the Mid-Summer Sun:The Gutai Group' in Munroe *Japanese Art After 1945*, p. 98.
20. B. Rose (1975) *American Art Since 1900*, Thames & Hudson, p. 207.
21. See T. Wolf (1975) *The Painted Word*, Bantam for a particularly vitriolic set of observations about this issue.
22. W. Teague (1948) *Design This Day*, Studio, p. 210.
23. Ibid., p. 99.
24. B. Laban (1982) *Chrome. Glamour Cars of the Fifties*, Orbis, p. 14.
25. V. Papanek (1971) *Design for the Real World*, Thames & Hudson, p. 77.
26. Ibid.
27. B. Fuller (1959)' The Comprehensive Man' in J. Meller (ed.) (1970) *The Buckminster Fuller Reader*, Cape, pp. 333–4.
28. 'The Ford directors and stockholders at the meeting and the thousands of tourists who came to see it were enchanted by the Rotunda Dome. Seen under the clear fibreglass cover against the blue of the sky, the lacy network of concentric rings balancing compressional and tensional forces in elegant mathematical perfection of structure had the ephemeral grace of a gigantic spiderweb.' A. Hatch (1974) *Buckminster Fuller*, Crown, p. 200.
29. Which included Oscar Niemeyer and Le Corbusier.
30. See K. Swolf (trans.) (1950) *The Sociology of Georg Simmel*, Free Press.
31. G. Debord (1970) *Society of the Spectacle*, Black & Red, p. 12.
32. Ibid., p. 193.

Chapter 8

1. T. Hawkes (1983) *Structuralism and Semiotics*, Routledge, p. 72.
2. West of what? The East? Where does the East start? West of America? Is North America east of China? 'West' and 'East' are eurocentric constructions in this context.
3. 'Mapping the Postmodern' in A. Huyssen (1986) *After the Great Divide*, Macmillan, p. 178.
4. See M. Rose (1991) *The Post-modern and the Post-industrial*, Cambridge University Press, p. 49.
5. Whitney Museum, New York, Graves additions were made between 1985 and 1987.
6. R. Venturi, D. Scott-Brown and S. Isehour (1972) *Learning from Las Vegas*, MIT Press.
7. See P. Fuller (1988) *Theoria; Art and the Absence of Grace*, Chatto & Windus.
8. J.-F. Lyotard (1986) *The Postmodern Condition: A report on Knowledge*, Manchester University Press, p. 76.

9. J. Baudrillard (1985) 'The Ecstasy of Communication' in H. Foster (ed.) *Postmodern Culture*, Pluto, p. 130.
10. 'Shopping', in J. Fiske, B. Hodge and G. Turner (1987) *The Myths of Oz. Reading Australian Popular Culture*, Allen & Unwin, pp. 104–5.
11. Lyotard, *The Postmodern Condition*, p. 71.
12. J. Baudrillard (1988) 'Symbolic Exchange and Death' in *Selected Writings*, Polity Press.
13. J . Habermas (1985) 'Modernity – An Incomplete Project' in H. Foster (ed.), *Postmodern Culture*, Pluto.
14. Ibid., p. 3.
15. R. Barthes (1977) 'The Death of the Author' in *Image, Music, Text*, Fontana.
16. Baudrillard, 'The Ecstasy of Communication', p. 130.
17. See F. Jameson (1991) *Postmodernism, Or, the Cultural Logic of Late Capitalism*, Verso.
18. See T. Moi (ed.) (1986) *The Kristeva Reader*, Blackwell.
19. In her review of queer theory, that body of thought which deals with the cultural perception of stances towards, and of, gays and lesbians, Annamarie Jagose remarks 'does queer [as a term of disruption used by the gay and lesbian community against its oppressors] become defunct the moment it is an intelligible and widely disseminated term?' (A. Jagose (1996) *Queer Theory* University of Melbourne Press). This seems to summarise the dilemma of ideological art in late capitalist culture very well – the constant fear of mass appropriation of information held exclusively by oppositional groups. Once assimilated nothing changes, just nomenclature.
20. See H. Bhabha (1990) *Nation and Narration*, Routledge.
21. See 'The Culture of Nations' in R. Williams (1983) *Towards 2000*, Chatto & Windus.
22. A. Poshyananda (1994) 'The Development of Contemporary Art in Thailand' in C. Turner (ed.) *Tradition and Change, Contemporary Art of Asia and the Pacific*, University of Queensland Press, p. 104.
23. S. Hall (1991) 'Ethnicity, Identity and Difference' in S. Gunew and F. Rizvi (eds) (1995) *Culture Difference and the Arts*, Allen & Unwin, p. 62.

Chapter 9

1. V. Papanek (1995) *The Green Imperative*, Thames & Hudson, p. 7.
2. J. Seabrook (1997) 'A World to be Won', *The New Internationalist*, no. 287.
3. See F. Jameson (1991) *Postmodernism, or, The Cultural Logic of Late Capitalism*, Verso.

4. Even the benign paternalism of the Australian Federal Government's *Creative Nation* funding of a series of regional multimedia centres, dedicated to the support of good practice using the new media, still requires a process of application for funding and support and its subsequent validation. The Cooperative Multimedia Centre programme was announced in October 1994 as part of the Federal Government's *Creative Nation* policy document. The Government intends to fund the development of up to six Cooperative Multi-media Centres, committing up to $56.5 million over nine years.

5. J.-F. Lyotard (1987) *The Post Modern Condition: A Report on Knowledge*, Manchester University Press, p. 76.

6. J. Baudrillard (1988) 'Fatal Strategies' in *Selected Writings*, Polity Press, pp. 189–90.

7. See D. Kerekhove (1995) *The Skin of Culture: Investigating the New Electronic Reality*, Somerville House Publishing.

8. M. Legget (1996) 'CD-Rom: The 21st century Bronze' *Burning the Interface*, Museum of Contemporary Art, Sydney, p. 41.

Index

Index 203